ICONS

HR Giger

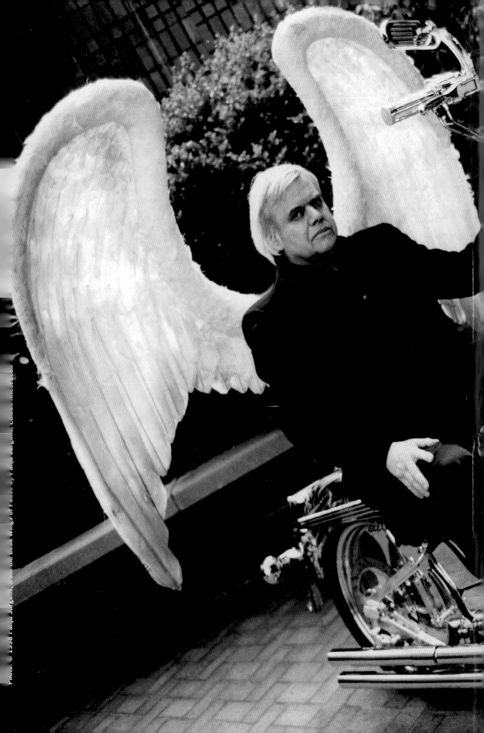

HR Giger

TASCHEN

KÖLN LONDON LOS ANGELES MADRID PARIS TOKYO

For Carmen

Special Thanks to
Ronald Brandt and Wolfgang Holz

Thank You:
Albert America, Bijan Aalam, Fam. Abati, Sonja Altmeppen, Erwin Ammann, René Appenzeller, Carlos Arenas, Axel & Bebe, Thomas Badian, Leslie Barany, M. Barras, Hans and René Bartholdi, Marietta and Silvio Baviera, Sandra Beretta, Biella, Mia Bonzanigo and Charly, Kelly Brill, Günter Brus, Evelin and Boris Bühler, François Burland, Chr. Bussard, Catcha, Restaurant Le Chalet, Etienne Chatton, Whitney and Joe Coleman, Annie and Roger, Marius and Anton Cottier, Com & Com, James Cowan and Crew, Fam. Dado, Jonathan Davis and Korn, Thomas Domenig, Fam. Doner, Jim Duff, Karl Erni, Mylène Farmer, Dana Frank, Fido, Ernst Fuchs, Fuse Gallery, Galerie Arkham, Barbara Gawrysiak and Ella, Alex Generalis, Maria and Michael Geringer, Globulle, Eric Gobet, Dorli Goldner, Karen Golightly, Fam. Sergius Golowin, Bernard Grimaldi, Fam. Grof and Sparks and GTT, Les Gruériens, Roman Güttinger, Sandra Hathaway, Tobi Hauser, Ingwar Hegland, Ruedi Hofmann, David Hochbaum, Marlyse and Richi Huber, Herbert M. Hurka, Gebr. Jäger, David Jahn, Panja Jürgens, Brigitte von Känel, Josef Kiblitzky, Joseph Klein, Fred Knecht, Viktor Koen, Paul Komoda, Kunsthaus Zürich, HH Kunz and Marion Albiez, Enrico Lanella, André Lassen, Ingrid Lehner, Steve Johnson Leyba, Lightpoint, Jürgen Lindhorst, Eli Livingston, Oliver Ludwick, Fam. Marcelo Lopez, Betty Lutz, Mad Max, Todd McFarlane, Fam. Michael Messner, Albert Michel, Tom Miles, Judith Morf, Jonathan Mover, Müggi, Harold Mulder, Alexander Osbourne, Liliane Perroud, Paul Peterhans, Boris Peterka, George Petros, Sämi Peyer, Polich Artworks, Pro Helvetia, Thomas Riehn, Daniel Rieser, Rolf Romer and Maya, Shade Rupe, Sibylle Ruppert, Megan Rush, Carmen Scheifele and Maria del Carmen Scheifele, Paul Schönenberger, Axel Schönfelder, Martin Schwarz, Susanne Seiler, Sascha Serfezoe, Sica, Willy Spiller, Iris and Carl Suter, Louis Stalder, Walo Steiner, Stephan Stucki, Angelika and Benedikt Taschen, Tjalle, Paul Tobler, M. Tomasini, Knut Toften, Kimberly Toth, Hans Tribolet, Urs Tremp and Armando Bertozzi, Marc Adrian Villas, Mona Uhl, Wälle, Marianne and Bruno Weber, Rolf Weber, Susi and Edgar Wind, Hanspeter Witmer, Wurster AG, Patrick Zufferey.

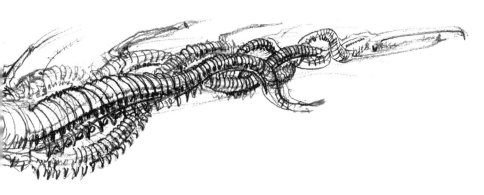

Contents Inhalt Sommaire

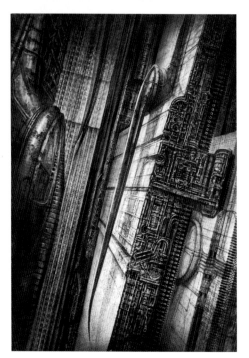

New York City VIII, Work No. 358, 1980.
Acrylic on paper, 100 x 70 cm

There is a crack in everything.
That's how the light gets in.

"Anthem", © 1992 Leonard Cohen.
Stranger Music, Inc.

Dear Carmen,

I am back in New York two full days now, but my thoughts are elsewhere. I can't shake the memories of the time I spent with Giger, Megan and you in Zurich, nor of our night at the Giger Museum. I am suspended in a strange limbo between jet lag and separation anxiety, and overwhelmed by a strong desire to make sense of all I witnessed and experienced in Switzerland.

Our overnight stay in Gruyères was planned as a special New Year's celebration for the four of us. Thank you. It was that and much more. Standing in the middle of the *Spell Room*, my eyes were opened for the first time to what must be Giger's daily waking dream as custodian of these powerful artifacts. Until that night, I did not make that connection or grasp the real significance of his paintings, the key to *The Mystery of Château St. Germain.*

Although he is their creator, Giger's life bears little resemblance to his paintings, and neither do they reflect any aspect of his real person. He is a seer of the first order, yet he seems as surprised as anyone at what is hidden, in plain sight, within them. It's a wonder that he has not gone mad.

With you as my guides, that morning I arrived at the Gates of Hell. I stood spellbound by the revelation that beyond the four panels, in a world parallel to our own, reside all our private demons and caged monsters of our nightmares. The Temple paintings are windows from our world to the Other Side and, for me, a visual confirmation that it really exists. The four "living tableaux" depict a hierarchical system, a sinister royal court of jesters, mutants, demons, of trapped and tortured souls, ruled by powerful high priestesses who preserve the barrier be-

tween their reality and ours. In an uneasy truce, they share their sovereignty with their slave and master, the lord of evil, a funny-looking – though not to be underestimated – misshapen goat-like entity. The *Spell Room* is the "big picture", the place where we confront the faceless demons we may have met before, never suspecting their true origins, thinking, perhaps, that they were a figment of mankind's collective subconscious, our fear of the unknown, of tomorrow morning.

Another, more chilling, possibility is that these paintings are not windows but mirrors, reflecting the harsh realities of our own world and lives: manifestations of the malevolence that mankind is still up against, the rolling clouds of approaching darkness, the persistence of an ancient bedrock of wickedness beyond the restraints of civilization. Only human, but undaunted, inquisitive, Giger has cracked the door to steal a glance beyond. By committing to paper what he saw, spewed forth in a whirlwind of paint from the tip of an airgun, he unwittingly unleashed a new force in the world. Did he feel the chill, I wonder, as it rushed past him, as I felt it then, and still do?

These were my thoughts, in the early hours of January 3rd, as I gazed first at Giger's spellbinding creations and then, over my shoulder, at you, Giger and Megan, as I groped to understand how and why we arrived there, together, in the first place.

It is no accident that our paths converged. We've been moving inexorably towards the same light and towards each other from the day we were born. As different from each other as we all are, in one way, we are very similar. As confident game-players and strong believers in unseen entities, we resist the simple solution. We are hesitant to accept the possibility that our quest may end and begin in another human being.

We were dropped into this world, in coun-

tries far away and decades apart, yet, encoded in our psyches, there has always been a keen awareness of a lost key, the existence of a great power, the missing piece to our own puzzle, somewhere on the planet for us to find. It is one explanation of our separate journeys, the forces that have attracted and driven us, of the trials to which we have willingly subjected ourselves in the course of the explorations within ourselves and out in the world.

Whether the beast is within or on the other side, Giger is the Gatekeeper, or, to co-opt an image, the brave little boy with his finger in the dike. And we, his all too human family, along with his friends and fans, are his armies of the night, summoned to his side to help hold back the tidal flood as he sketches our course from bitterness to compassion, from ashes to the stars.

Leslie Barany, NYC
January 7, 2002

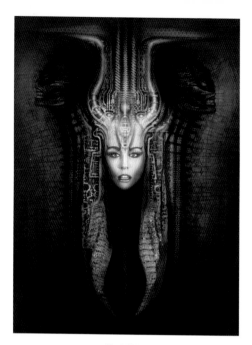

Kim I, 1981.
Acrylic on photo, 120 x 90 cm.
Concept and photo by Leslie Barany, overpainted by HR Giger

There is a crack in everything.
That's how the light gets in.

(In allem ist ein Riss,
so kommt das Licht herein.)

"Anthem", © 1992 Leonard Cohen.
Stranger Music, Inc.

Liebe Carmen,

Nun bin ich schon zwei volle Tage zurück in New York, aber meine Gedanken sind anderswo. Ich kann die Erinnerungen an die Zeit, die ich mit Giger, Megan und Dir in Zürich verbrachte, nicht abschütteln, auch nicht jene an die Nacht im Giger-Museum. Ich befinde mich in einem seltsamen Schwebezustand zwischen Jetlag und Trennungsangst, ich bin überwältigt von einem starken Verlangen, allem, was ich in der Schweiz miterlebt und erfahren habe, einen Sinn zu geben.

Unser Besuch in Gruyères war als spezielle Neujahrsfeier für uns vier geplant. Danke. Er war das und noch viel mehr. Als ich mitten im *Spell Room* stand, wurden meine Augen zum ersten Mal dafür geöffnet, was Gigers täglicher Wachtraum als Hüter dieser machtvollen Artefakte sein muss. Bis zu jener Nacht hatte ich diese Verbindung nicht gemacht, hatte auch die wirkliche Bedeutung seiner Bilder, den Schlüssel zum *Geheimnis des Château St. Germain*, nicht erfasst.

Obwohl er ihr Schöpfer ist, zeigt Giger wenig Ähnlichkeit mit seinen Bildern, und diese spiegeln auch keinen Aspekt seiner wirklichen Person wider. Er ist ein Seher erster Ordnung, doch scheint er ebenso überrascht wie wir alle von dem, was sich so offensichtlich in ihnen verbirgt. Es ist ein Wunder, dass er nicht verrückt geworden ist.

Mit Euch als Führern bin ich an jenem Morgen an den Toren der Hölle angekommen. Ich war fasziniert von der Entdeckung, dass hinter den vier Panelen, in einer zur unseren parallelen Welt, all unsere eigenen Dämonen und eingesperrten Monster unserer Albträume wohnen. Die Tempelgemälde sind Fenster aus unserer Welt zur anderen Seite, für mich sind sie die visuelle Bestätigung, dass diese andere Welt wirklich exi-

stiert. Die vier »lebenden Bilder« stellen ein hierarchisches System dar, einen unheimlichen Königshof mit Narren, Mutanten, Dämonen, mit gefangenen und gefolterten Seelen, beherrscht von machtvollen Hohepriesterinnnen, welche die Grenze zwischen ihrer Realität und der unseren aufrecht erhalten. In einem unsicheren Burgfrieden teilen sie ihre Souveränität mit ihrem Sklaven und Meister, dem Herrn des Bösen, einem komisch aussehenden – jedoch nicht zu unterschätzenden – missgebildeten ziegenähnlichen Wesen. Der *Spell Room* ist das »Gesamtbild«, der Ort, wo wir unseren gesichtslosen Dämonen entgegentreten, denen wir schon zuvor begegnet sind, ohne deren wahre Herkunft zu erahnen, da wir vielleicht dachten, sie wären eine Ausgeburt des kollektiven Unterbewussten der Menschheit, unsere Angst vor dem Unbekannten, vor dem nächsten Morgen.

Es besteht eine andere, beunruhigendere Möglichkeit, dass diese Bilder nicht Fenster sind, sondern Spiegel, welche die harsche Wirklichkeit unserer eigenen Welt und unserer Leben zurückwerfen: Manifestationen der Böswilligkeit, der die Menschheit noch immer gegenübersteht, die dräuenden Wolken nahender Dunkelheit, die Beharrlichkeit eines alten Grundgesteins der Schlechtigkeit außerhalb der Einschränkungen der Zivilisation. Giger, auch nur ein Mensch, aber kühn und wissbegierig, hat die Tür einen Spalt weit aufgebrochen, um einen Blick dahinter zu erhaschen. Indem er das, was er sah, zu Papier brachte, herausgeschleudert in einem Wirbelwind von Farbpigmenten aus der Spitze seiner Spritzpistole, hat er unabsichtlich eine neue Macht in der Welt freigesetzt. Ich frage mich, ob er den Schauer auch gespürt hat, als sie an ihm vorbeirauschte, genau wie ich damals und auch jetzt noch.

Dies waren meine Gedanken in den frühen Morgenstunden des 3. Januar, als ich zuerst Gigers faszinierende Schöpfungen ansah und

dann, über meine Schulter, Dich, Giger und Megan, als ich zu verstehen versuchte, wie und weshalb wir dort überhaupt zusammengekommen waren.

Es ist kein Zufall, dass sich unsere Wege trafen. Wir haben uns seit dem Tag unserer Geburt unerbittlich auf dasselbe Licht und aufeinander zu bewegt. Und so verschieden wir voneinander sind, sind wir uns doch auf eine gewisse Weise sehr ähnlich. Als sichere Mitspieler, die stark an unsichtbare Wesenheiten glauben, widerstehen wir der einfachen Lösung. Wir zögern, die Möglichkeit zu akzeptieren, dass unsere Suche in einem anderen menschlichen Wesen enden und beginnen könnte.

Wir wurden auf diese Welt gebracht, in weit entfernten Ländern und durch Jahrzehnte getrennt, und doch ist in unserer Psyche das starke Gewahrsein eines verlorenen Schlüssels einkodiert, der Existenz einer großen Macht, des fehlenden Teils unseres eigenen Puzzles, das irgendwo auf diesem Planeten darauf wartet, dass wir es finden. Dies ist nur eine Erklärung unserer getrennten Wege, der Kräfte, die uns angezogen und angetrieben haben, der Prüfungen, denen wir uns bereitwillig unterworfen haben während unserer Nachforschungen in uns selbst und draußen in der Welt.

Ob das Biest in uns drin ist oder auf der anderen Seite, Giger ist der Türhüter, oder, um ein Bild zu übernehmen, der tapfere kleine Junge, der mit dem Finger das Loch im Deich zuhält. Und wir, seine allzu menschliche Familie zusammen mit seinen Freunden und Fans, sind seine Armeen der Nacht, an seine Seite gerufen, um die Flut zurückzuhalten, während er den Kurs skizziert von der Erbitterung zum Mitgefühl, von der Asche zu den Sternen.

Leslie Barany, NYC
7. Januar 2002

HR Giger with Leslie Barany and Birth Machine Baby.
Limited edition of 23 in bronze or aluminum, 53 x 22 x 22 cm.
Photo: © 1993 Dana Frank

There is a crack in everything.
That's how the light gets in.

(Il y a une fissure en tout
Par où la lumière s'introduit.)

"Anthem", © 1992 Leonard Cohen.
Stranger Music, Inc.

Chère Carmen,

Je suis de retour à New York depuis deux journées entières, mais mes pensées sont ailleurs. Je n'arrive pas à chasser de ma mémoire le temps que j'ai passé avec Giger, toi et Megan à Zurich ni notre nuit au Musée Giger. Je reste suspendu dans un étrange état intermédiaire entre décalage horaire et angoisse liée à la séparation et suis envahi par un puissant désir d'exprimer tout ce dont j'ai été témoin et que j'ai vécu en Suisse.

Nous avions prévu que notre nuit à Gruyères serait notre façon à nous quatre de célébrer le Nouvel An. Merci. Ce fut bien cela, mais bien davantage encore. Lorsque je me suis retrouvé dans la salle de *Spell*, mes yeux se sont pour la première fois ouverts sur ce qui doit être le rêve éveillé quotidien de Giger en tant que gardien de ces puissantes créations. Jusqu'à cette nuit, je n'avais pas fait le lien ni compris la signification réelle de ses peintures qui nous donnent pourtant la clé du *Mystère du Château Saint-Germain*.

Bien qu'il en soit le créateur, la vie de Giger ne ressemble en rien à ses peintures qui ne reflètent pas non plus le moindre aspect de sa propre personnalité. Il est en fait un prophète de premier ordre même s'il semble surpris comme tout le monde par ce qui se cache visiblement à l'intérieur des peintures. C'est un miracle qu'il ne soit pas devenu fou.

Vous avez été mes guides lorsque je suis arrivé ce matin-là aux Portes de l'Enfer. Je suis resté figé sur place par la révélation que derrière les quatre panneaux, dans un monde parallèle au nôtre, résidaient tous nos démons personnels et autres monstres prisonniers de nos cauchemars. Les peintures du Temple sont des fenêtres donnant de notre monde sur l'Autre Côté, et, à mon

avis, aussi la confirmation visuelle de son existence réelle. Les quatre «tableaux vivants» représentent un système hiérarchique, une sinistre cour royale peuplée de bouffons, de mutants et de démons, d'âmes prises au piège et torturées sous le règne de puissantes Grandes-Prêtresses qui préservent la barrière entre leur propre réalité et la nôtre. Pendant une trêve bien incommode, elles partagent leur souveraineté face à leur esclave et maître, le Dieu du Mal, une entité drôle – même s'il ne faut pas la sous-estimer –, difforme et ressemblant à un bouc. La salle de *Spell* est un «grand tableau», un endroit où nous nous trouvons en présence de ces démons sans visage que nous avons éventuellement déjà croisés, ne soupçonnant jamais leur vraie origine et pensant peut-être qu'ils n'étaient qu'une fiction du subconscient collectif de l'humanité, notre peur de l'inconnu, du lendemain matin.

Une autre possibilité, plus inquiétante, serait que ces peintures ne représentent pas des fenêtres mais des miroirs reflétant les dures réalités de notre monde et de nos vies; des manifestations de malveillance contre lesquelles l'humanité se bat toujours, des nuages enroulés d'une obscurité menaçante, un vieux fondement persistant du Mal, au-delà des contraintes de la civilisation. Giger, seulement humain, mais résolu et curieux, a forcé la porte pour jeter un regard furtif vers l'au-delà. En transposant sur le papier ce qu'il a vu, rejetant par la pointe de son aérographe un tourbillon de peinture, il a libéré sans le savoir une force nouvelle dans le monde. Je me demande s'il a senti le frisson passant dans son dos comme je l'ai moi-même senti et continue à le sentir.

Telles étaient mes pensées, en ces premières heures du 3 janvier, lorsque j'ai regardé fixement les créations ensorcelantes de Giger, puis regardant par-dessus mon épaule vers toi, Giger et Megan, tentant de comprendre pourquoi et comment nous en étions tous arrivés là.

Ce n'est pas un hasard si nos chemins se sont croisés. Nous avons inexorablement avancé vers cette même lumière et l'un vers l'autre depuis la date de notre naissance. Aussi différents que nous soyons les uns des autres, nous sommes dans un certain sens très similaires. En tant que joueurs confiants et croyant en des entités invisibles, nous sommes réfractaires aux solutions faciles. Nous hésitons à accepter la possibilité que notre quête puisse s'achever avant de se poursuivre dans un autre être humain.

Nous avons été jetés dans ce monde dans des pays éloignés et des décennies distinctes et pourtant, nous avons toujours eu, codée dans nos psychismes, une conscience aiguë de la perte d'une clé, de l'existence d'un grand pouvoir, de la pièce manquante du puzzle, attendant quelque part sur cette planète pour enfin nous rencontrer. C'est là une explication possible à nos différents voyages, à ces forces qui nous ont attirés et poussés, à ces procès auxquels nous nous sommes soumis volontairement au cours des explorations en nous-mêmes et dans le monde en général.

Que la bête soit à l'intérieur ou de l'autre côté, Giger en reste le Gardien ou, pour reprendre une autre image, le brave petit garçon qui bouche la digue avec son doigt. Quant à nous, toute cette famille tellement humaine, avec tous ses amis et fans, nous sommes les armées de la nuit appelées à venir aider à ses côtés à retenir la vague de fond, alors qu'il esquisse notre cours allant de l'amertume à la compassion, des cendres aux étoiles.

Leslie Barany, NYC
7 janvier 2002

11

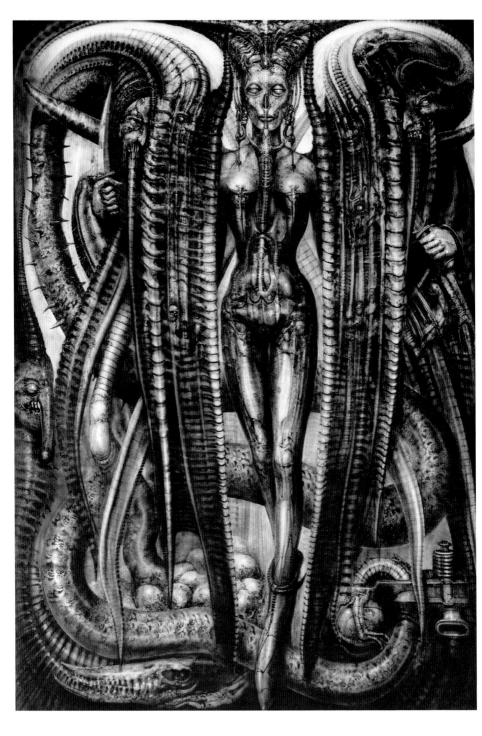

HR Giger and the Soul
of the Twentieth Century

Stanislav Grof

Several years ago, I had the privilege of spending some time with Oliver Stone, a Hollywood visionary genius who in his extraordinary films has portrayed the shadow side of modern humanity. At one point, we talked about the movie *Alien*, for which HR Giger received the Academy Award and about Giger's work in general. I expressed my great admiration for Giger's art and his uncanny ability to depict the deep dark recesses of the human psyche. Oliver Stone described his own very high opinion about Giger and his contribution to modern art. In this context, he shared with me an original insight about Giger's place in the world of art and in human culture. "I do not know anybody else," he said, "who has so accurately captured the soul of modern humanity. A few decades from now, when they talk about the twentieth century, they will think of Giger."

Although Oliver Stone's statement momen-

tarily surprised me, I immediately realized that it reflected a profound truth. Since then, I have often recalled this conversation when I was confronted with various disturbing developments in the Western industrial civilization. Giger's art has often been called "biomechanoid." It would be difficult to find a better word describing the Zeitgeist of the twentieth century, characterized by staggering technological progress that has enslaved modern humanity in an internecine symbiosis with the world of machines.

In the course of the twentieth century, modern technological inventions became extensions of our muscles, our nervous system, our eyes and ears, and even our reproductive organs, to such an extent that the boundaries between biology and mechanical contraptions have all but disappeared. The archetypal stories of Faust, the sorcerer's apprentice, Golem, and

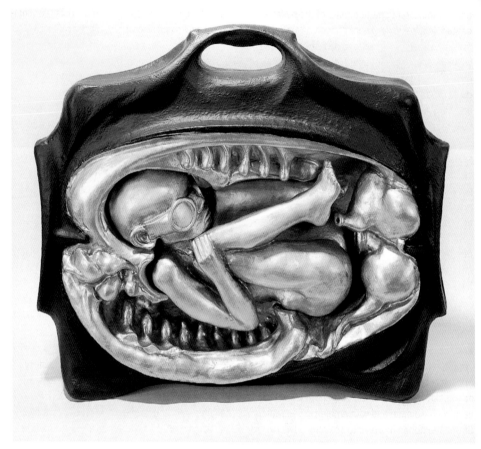

Suitcase Baby, Work No. 77b, 1967.
Edition of 5, gold-plated bronze, 75 x 30 x 20 cm

Frankenstein became the leading mythology of our times. Materialistic science, in its effort to gain knowledge of the world of matter and to control it, has engendered a monster that threatens the very survival of life on our planet. The human role has changed from that of creator to that of victim.

When we look for another characteristic feature of twentieth century, what immediately comes to mind is unbridled violence and destruction on an unprecedented scale. It was a period in which internecine wars, bloody revolutions, totalitarian regimes, genocide, brutality of secret police, and international terrorism ruled supreme.

The destructive abuses of modern science and the nature and scale of violence committed in the course of the twentieth century gave this period of history distinctly demonic features. Yet

another important characteristic of the twentieth century is the extraordinary change of attitude toward sexuality. The second half of the century witnessed an unprecedented lifting of sexual repression. On the one hand, it was the removal of cultural constraints leading to sexual freedom and early experimentation by the young generation, promiscuity, and gay liberation.

On the other hand, the shadow sides of sexuality surfaced to an unprecedented degree and became part of modern culture – teenage pregnancy, adult and child pornography, red light districts offering all imaginable forms of prostitution, sadomasochistic parlors, sexual "slave markets," etc. And the deepest shadow of them all – the rapidly escalating specter of the worldwide AIDS epidemic forged an inseparable link between sexuality and death, Eros and Thanatos.

All the essential elements of the twentieth century's Zeitgeist are present in Giger's biomechanoid art. In his inimitable style, he masterfully merges elements of dangerous mechanical contraptions of the technological world with various parts of human anatomy. Equally extraordinary is the way in which Giger blends deviant sexuality with violence and with emblems of death. Skulls and bones morph into sexual organs or parts of machines and vice versa to such a degree and so smoothly that the resulting images portray with equal symbolic power sexual rapture, violence, agony, and death. The satanic potential of these domains is depicted with such artistic skill that it gives them archetypal depth.

Giger portrays in his unique way the horrors of war. We need only think about his *Necronom II*, whose skeletal figure wearing a military helmet condenses in a terrifying way symbols of death, violence, and sexual aggression. Many of Giger's paintings depict the ugly world of the future, destroyed by excesses of technology or ravaged by nuclear winter – a world of utter alienation, without humans and animals, dominated by soulless skyscrapers, plastic materials, steel, and asphalt. And his *Atomic Children* envision the grotesque population of mutants who have survived nuclear war or the impact of the amassed fall-out of atomic energy industry.

However, there is one recurrent motif in Giger's art that seems to have very little to do with the soul of the twentieth century – the abundance of images depicting tortured and sick fetuses. And yet, this is where Giger's visionary genius offers the most profound insights into the hidden recesses of the human psyche. Adding the prenatal and perinatal elements to the symbolism of sex, death, and pain reveals a depth and clarity of psychological understanding that by far surpasses that of mainstream psychologists.

Giger's determined quest for creative self-expression is inseparable from his relentless self-exploration and self-healing. Like Francisco Goya, who was convinced that painting his terrifying visions could give him control and mastery over them, Giger tries to overcome in his paintings his terrifying claustrophobic nightmares. As he himself has pointed out, art is for him a vital activity that keeps him from falling into madness. Giger's artistic skills and his talent to portray the fantastic match those of his models – Hieronymous Bosch, Salvador Dalí, and Ernst Fuchs; but the depth of his psychological insight is unparalleled in the world of art.

By seeking the source of his own nightmares and disturbing fantasies, Giger discovered, independently from the pioneers of modern consciousness research, the paramount psychological importance of the trauma of biological birth. The existence of this fascinating domain of the unconscious, intuited by Giger and reflected in his art, has not yet been recognized and accepted by official academic circles. Intimate

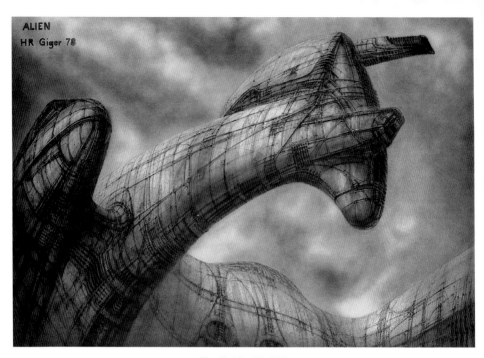

ALIEN
HR Giger 78

Alien, Work No. 396, 1978.
Wreck detail, acrylic on paper, 100 x 140 cm (stolen)

knowledge of this domain is also missing in the world of Giger's predecessors and peers from the world of surrealists and fantastic realists.

Mainstream psychology and psychiatry is dominated by the theories of Sigmund Freud, whose ground-breaking pioneering work laid the foundations for modern "depth-psychology." Freud's model of the psyche, however avant-garde and revolutionary for his time, was very superficial and narrow, being limited to postnatal biography and the individual unconscious.

Freud's work had a profound effect on art. His concepts of the Oedipus complex, mother fixation, the castrating father, and the vagina dentata became a gold mine of ideas for novelists and film-makers. Freud's discovery of sexual symbol-

ism and interpretation of dream symbolism was one of the main sources of inspiration for the surrealist movement. It became fashionable for the artistic avant-garde to imitate the dreamwork by juxtaposing in a most surprising fashion various objects in a manner that defied elementary logic. The selection of these objects then often showed a preference for those that, according to Freud, had hidden sexual meaning.

However, while the connections between the seemingly incongruent dream images have their own logic and meaning, which can be revealed by psychological analysis, this was not always true of surrealistic paintings. Here startling juxtaposition of images often reflected empty mannerism separated from the truth and logic of

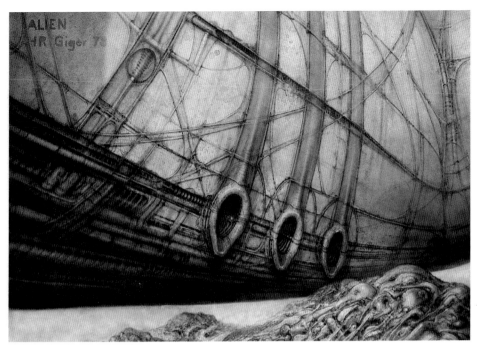

Alien, Work No. 375, 1978.
Wreck entrance, acrylic on paper, 100 x 70 cm

the unconscious dynamic. Giger's art is diametri-
cally different in this regard. The combinations of
images in his paintings might seem illogical and
incongruous only to those who are not familiar
with the findings of pioneering consciousness re-
search in the last several decades. These reveal
that Giger's understanding of the human psyche
is far ahead of mainstream professionals.

Critics have described Giger's work as be-
ing simultaneously a telescope and microscope
revealing dark secrets of the human psyche.
Looking into the deep abyss of the unconscious
that modern humanity prefers to deny and ig-
nore, Giger discovered how profoundly human
life is shaped by events and forces that precede
our emergence into the world. One could hardly

imagine more powerful representations of the
terrifying ordeal of human birth than Giger's *Birth
Machine I and II,* or his *Death Delivery Machine.*
Equally powerful birth motifs can be found in *Bio-
mechanoid I* featuring three fetuses as heavily
armed grotesque Indian warriors with steel
bands constricting their foreheads, in *Landscape
XIV* that portrays an entire tapestry of tortured
babies, and in Giger's self-portrait *Biomechanoid*
on the poster for the Sydow-Zirkwitz Gallery. The
symbolism of *Landscape X* is more subtle and
less obvious; here Giger combines the uterine in-
terior, symbolizing sex and birth, with black
crosses in the shape of targets for shooting
practice of the Swiss army that signify death, as
well as violence. Echoes of birth symbolism can

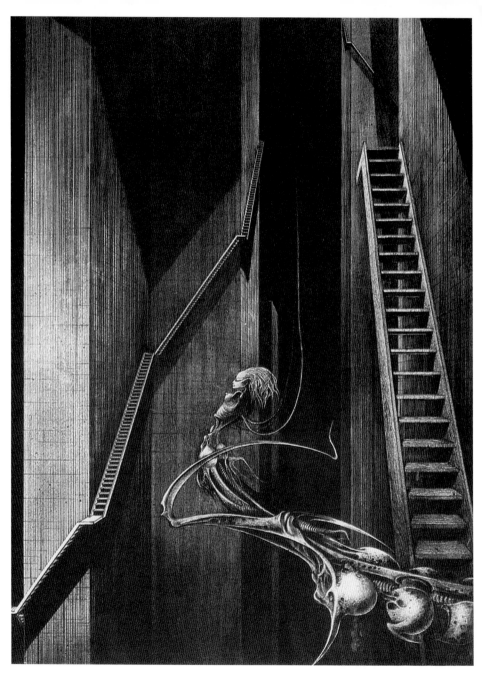

Shaft No. 7, Work No. 63.
Ink on tracing paper on paper on wood, 80 x 63 cm

be easily detected also in his *Suitcase Baby, Homage to Beckett I and II*, and throughout his work.

Giger's understanding of the psychological importance of the trauma of birth found its most salient expression in his *Passage Temple*. The entrance consisted of a sarcophagus-like opening padded with two down-filled leather bags. The visitors had to force their way into the temple, reenacting the sensation of their birth. The interior was decorated with perinatal images of extraordinary power. Giger's fascination with passages that led to this project was inspired by a nightmare in which he found himself in a large room without door and windows, from which the only escape route was a tiny, narrow chimney. It was a dream associated with anxiety and feelings of suffocation.

Individuals reliving the onset of biological birth typically feel that they are being sucked into a gigantic whirlpool or swallowed by some mythic beast. This can be accompanied by images of devouring or entangling archetypal monsters, such as leviathans, dragons, whales, giant snakes, tarantulas, or octopuses. The sense of overwhelming mortal threat can lead to intense anxiety and general mistrust bordering on paranoia. Another experiential variety of the beginning of birth is the theme of descending into the depths of the underworld, the realm of death, or hell. This immediately brings to mind Giger's fantasies of the monstrous labyrinth full of danger he envisioned behind the stairwell window in the house of his childhood and his fascination by the spiral stone staircase leading into the cellar. This also seems to have served as inspiration for a series of his works, from his early images of *Shafts to Underground* and *Under the Earth*.

In the fully developed first stage of biological birth, the uterine contractions periodically constrict the fetus, and the cervix is not yet open. Subjects reliving this part of birth feel caught in a monstrous claustrophobic nightmare; they experience agonizing emotional and physical pain, and have a sense of utter helplessness and hopelessness. Feelings of loneliness, guilt, the absurdity of life, and existential despair can reach metaphysical proportions. A person in this predicament often becomes convinced that this situation will never end and that there is absolutely no way out. An experiential triad characteristic for this state is a sense of dying, going crazy, and never coming back.

Reliving this stage of birth is typically accompanied by sequences that involve people, animals, and even mythological beings in a painful and hopeless predicament similar to that of the fetus caught in the clutches of the birth canal. This can be a medieval dungeon, a torture chamber of the Inquisition, a smothering and crushing mechanical contraption, a concentration camp, or an insane asylum. Archetypal versions of the same theme portray intolerable tortures of sinners in hell or the agony of Christ on the cross. In this state, people are unable to see anything positive in their life and in human existence in general. Through the prism of this experiential matrix, life seems to be meaningless. Theater of the Absurd, a farce staging cardboard characters and mindless robots, or a cruel circus sideshow. Giger's work conveys this predicament with unparalleled artistic power.

In the next stage of delivery, the uterine contractions continue to encroach on the fetus, but the dilated cervix allows gradual propulsion of the fetus through the birth canal. The reliving of this stage of birth does not involve an exclusive identification with the role of the suffering victim like the previous stage; it also provides access to enormous reservoirs of pent-up murderous aggression. This leads to images of vicious fights, torture. Sexual experiences are character-

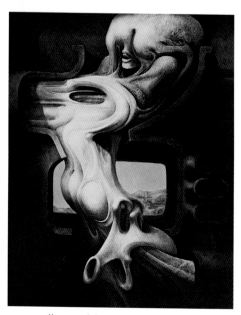

Homage to S. Beckett I, Work No. 93, 1968.
Oil on wood, 100 x 80 cm

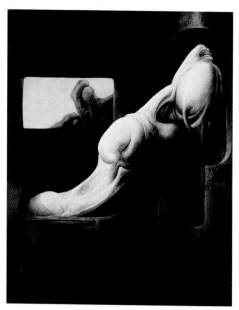

Homage to S. Beckett II, Work No. 94, 1969.
Oil on wood, 100 x 80 cm

ized by enormous intensity of the sexual drive. It is this stage of birth that represents the deep psychological source of sexual variations, deviations, and perversions from sadomasochism through coprophilia to necrophilia and criminal sexuality.

The fact that the fetus can often encounter in the final stages of birth various forms of biological material – vaginal secretions, mekonium, blood and even urine and feces – is responsible for the scatological dimension of the perinatal symbolism. In Giger's art this finds expression in his fascination with toilet bowls, garbage trucks, and refuse collection, and his sharp awareness of the erotic overtones of these objects and activities. It also seems to account for the inclusion of the motif of offal, decomposition of corpses, repulsive worms and insects, and vomit in his paintings. As the ultimate master of the nightmarish aspect of the perinatal unconscious, which is the source of individual and social psychopathology and of much of the suffering in the modern world, Giger has no match in the history of art.

However, the perinatal dynamics also has its light side and harbors great potential for healing and transcendence, for psychospiritual death and rebirth. In the history of religion, a profound encounter with the Shadow in the form of the Dark Night of the Soul or Temptation has often been a prerequisite to spiritual opening. The arduous ordeals of Saint Teresa of Avila, Saint John of the Cross, and Saint Anthony, as well as the stories of the Buddha, Jesus, and Mohammed testify to that effect.

It has been repeatedly noted that Giger's art, like Greek tragedy, can mediate powerful emotional catharsis to those who are open to it. And Giger himself experiences his

art as healing and as a means of maintaining his sanity. It seems that he also intuits the spiritual potential of a deep experiential immersion in the world of dark perinatal images. For example, in one of the paintings in the interior of the *Passage Temple*, he depicted a throne bathed in light standing at the top of seven steps and flanked by biomechanoid virgins. He has described it as "the way of the magician that has to be taken to become on a level with god." Similarly, his image of the staircase to the Harkonen Castle for the movie *Dune*, lined with dangerous phallic death symbols, seems to lead to heaven.

However, the transcendental potential of the perinatal process has so far received little of Giger's attention. It would be interesting to speculate about the possible reasons for it. The great American mythologist Joseph Campbell once commented that the images of hell in world mythology are by far more intriguing and interesting than those of heaven because, unlike happiness and bliss, suffering can take so many different forms. Maybe Giger feels that the transcendental dimension has been more than adequately exploited in Western art, while the deep abyss of the dark side has been avoided. It is also possible that Giger's own healing process has not yet proceeded far enough to embrace the transcendental dimension.

I personally hope that the last alternative is closest to the truth. I would love to see Giger's genius to use his incredible imagination and masterful freehand airbrush technique to portray the transcendental beauty of the imaginal world with the same mastery with which he has documented its "terrible beauty." I have heard this comment from many others from the circle of his admirers. But Giger has always pursued his own inner truth and disliked taking orders from his customers. It is unlikely that the wishes of his fans, however sincere and passionate, would be more successful in this regard. He will follow the inner logic of his Promethean quest wherever it takes him, as he has always done, and those of us who love his art will continue enjoying the extraordinary products of this process as they keep emerging into the world.

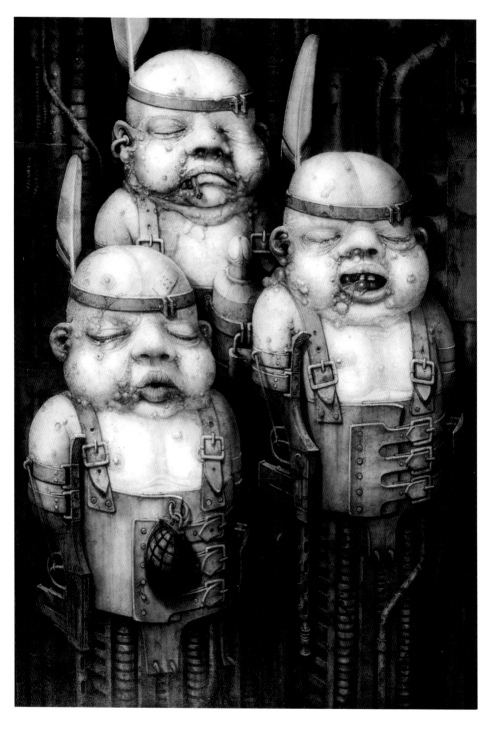

HR Giger und die Seele des zwanzigsten Jahrhunderts

Stanislav Grof

Vor mehreren Jahren hatte ich die Ehre, einige Zeit mit dem Regisseur Oliver Stone verbringen zu dürfen, einem genialen Visionär, der in seinen außergewöhnlichen Filmen die diversen Schattenseiten der modernen Zivilisation porträtiert. Im Verlauf dieses Treffens kamen wir auch auf den Film *Alien* zu sprechen, für den Giger mit einem Oscar ausgezeichnet wurde, und auf sein Werk im Allgemeinen. Ich äußerte meine Bewunderung für Gigers Kunst und sein unglaubliches Talent, die pechschwarzen Abgründe der menschlichen Psyche so akkurat wiederzugeben. Oliver Stone teilte nicht nur meine Wertschätzung für diesen Künstler, sondern meinte in Bezug auf dessen Bedeutung für die moderne Kunst und die menschliche Kultur generell:»Ich kenne niemanden, der die seelische Befindlichkeit der heutigen modernen Gesellschaft so treffend im Bild festhalten kann wie er. Wenn in ferner Zukunft die Rede sein wird vom zwanzigsten Jahrhundert, wird man an Giger denken.«

Obwohl Oliver Stones Bemerkung mich im ersten Moment überraschte, wurde mir bald bewusst, dass in seiner Einsicht viel Wahres lag. Seitdem kam mir dieses Gespräch oft wieder in den Sinn, nämlich bei jeder weiteren Konfrontation mit den unzähligen beunruhigenden Entwicklungen in der westlichen Industriekultur. Gigers Kunststil ist oft als »biomechanisch« bezeichnet worden. Man findet wohl kaum eine treffendere Bezeichnung, will man den Zeitgeist des zwanzigsten Jahrhunderts beschreiben, dessen charakteristischste Eigenschaft doch der überwältigende technische Fortschritt ist. Ein Fortschritt, der die Gesellschaft in einer zerstörerischen Symbiose von Mensch und Maschine zum Sklaven machte.

Die technologischen Errungenschaften des zwanzigsten Jahrhunderts dienten zunehmend

der »Erweiterung« unserer Gliedmaßen und Muskeln, unseres Nervensystems, unserer Augen und Ohren, selbst der Fortpflanzungsorgane. Dies ging so weit, dass die Grenzen zwischen Biologie und mechanischen Vorrichtungen kaum mehr erkennbar waren. Die archetypischen Figuren von Faust, dem Zauberlehrling, vom Golem oder von Frankenstein sind zu mythologischen Leitfiguren unserer Tage geworden. Die materialistische Wissenschaft hat in ihrem Bestreben, die stoffliche Welt zu erforschen und kontrollieren zu wollen, ein Monster geschaffen, das alles Leben auf dem Planeten gefährdet. Der Mensch hat die Rolle des Schöpfers mit der des Opfers eingetauscht.

Sucht man nach einem weiteren charakteristischen Merkmal dieses Jahrhunderts, so kommen einem schnell hemmungslose Gewalt und Zerstörung in bis dahin undenkbaren Ausmaßen in den Sinn. Diese Epoche war beherrscht von verheerenden Kriegen, blutigen Revolutionen, totalitären Regimes, von Völkermord und internationalem Terrorismus. Des weiteren haben der zerstörerische Missbrauch der modernen Naturwissenschaften und der Raubbau an der Natur dem Jahrhundert ein ausgesprochen dämonisches Gesicht verliehen.

Ein anderes wichtiges Kennzeichen ist der enorme Wandel im Bereich der Sexualität. Die zweite Hälfte dieses Jahrhunderts erlebte eine nie dagewesene Aufhebung der sexuellen Repression. Einerseits wurden kulturelle Zwänge gelockert, was zur sexuellen Befreiung und zu frühen Sexexperimenten der jungen Generation führte, zu Promiskuität und zur Schwulen- und Lesbenbewegung.

Andererseits wurden ebenso die Schattenseiten dieser Liberalisierung zu einem wesentlichen Merkmal unserer Gesellschaft: Pornographie und Kinderpornographie, Rotlichtviertel, in denen alle erdenklichen Formen der Prostitution

angeboten werden, sadomasochistische Salons, Märkte für Sexsklaven und Ähnliches. Die wachsende Gefahr einer weltweiten Aids-Epidemie als düsterste all dieser Schattenseiten hat Sexualität und Tod, Eros und Thanatos untrennbar miteinander verschmolzen.

Alle wesentlichen Elemente dieses Zeitgeistes sind in Gigers biomechanischem Kunststil wiederzufinden. Meisterhaft verbindet er Elemente gefährlicher, mechanischer Apparaturen mit Teilen der menschlichen Anatomie. Ebenso außergewöhnlich ist die Art und Weise, wie er Sexualität mit Gewalt und Symbolen des Todes verschmelzen lässt. Schädel und Knochen formen sich zu Sexualorganen oder Maschinenteilen und umgekehrt, so dass sexuelle Ekstase, Gewalt, Qual und Tod mit gleicher Symbolkraft präsent sind. Das satanische Potential dieser Bereiche wird künstlerisch so virtuos wiedergegeben, dass deren Tiefe schon archetypische Dimensionen besitzen.

In seinem einzigartigen Stil porträtiert er auch die Schrecken des Krieges. Denken wir nur an das *Necronom II*, dessen skelettartige Gestalt, bestückt mit einem Soldatenhelm, auf furchterregende Weise die Symbole von Tod, Gewalt und sexueller Aggression vereint. Viele Bilder zeigen eine durch technologische Exzesse oder den nuklearen Winter verwüstete Zukunft – tote Landschaften, verlassen von Mensch und Tier, beherrscht nur von seelenlosen Wolkenkratzern, Stahl und Beton. Seine *Atomkinder* sind eine groteske Population von Mutanten, die den Atomkrieg oder die Verwüstung der Natur durch radioaktive Abfälle der Atomenergiewirtschaft überlebt haben.

Doch es gibt ein wiederkehrendes Thema in Gigers Werk, das nur entfernt diesen Geist des zwanzigsten Jahrhunderts zum Motiv hat – in einer Vielzahl seiner Bilder sind gefolterte und kranke Föten zu sehen. Vor allem hier zeigt sich

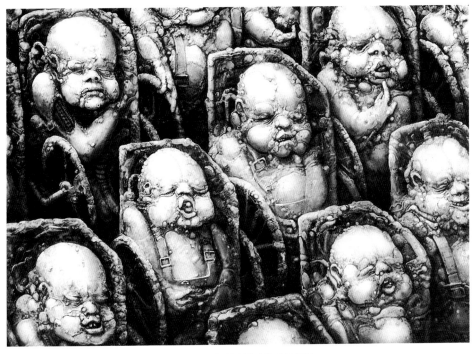

Landscape XXIX (Babies), Work No. 249, 1974.
Acrylic on paper on wood, 70 x 100 cm

sein visionäres Genie und eine tiefe Einsicht in die dunklen Bereiche der menschlichen Psyche: Dass er den Symbolen für Sex, Tod und Schmerz noch die Elemente des Prä- und Perinatalen hinzufügt, spricht für ein psychologisches Verständnis von einer Tiefe und Klarheit, das dem heutiger Mainstream-Psychologen weit überlegen ist.

Gigers Drang nach kreativer Betätigung ist untrennbar mit der Erforschung seiner selbst verbunden. Wie Francisco Goya, der überzeugt war, dass das Niedermalen seiner Schreckensvisionen ihm dabei helfen könne, diese zu kontrollieren und zu meistern, so sucht auch Giger durch seine Bilder seinen quälenden klaustrophobischen Albträumen zu entkommen. Wie er selbst

sagt, ist Kunst für ihn eine lebensnotwendige Beschäftigung, die ihn davor bewahrt, wahnsinnig zu werden. Sein künstlerisches Talent für Phantastische Malerei ist dem seiner Vorbilder – Hieronymus Bosch, Salvador Dali und Ernst Fuchs – sicher ebenbürtig. Die Tiefe seiner psychologischen Erkenntnis jedoch ist in der Welt der Kunst unerreicht.

Auf der Suche nach dem Ursprung seiner Albträume entdeckte Giger unabhängig von der modernen Bewusstseinsforschung die psychologische Bedeutung des Geburtstraumas. Dieser faszinierende Bereich des Unbewussten, den er intuitiv erahnt hat und der in seiner Kunst reflektiert wird, ist bis heute in offiziellen akademi-

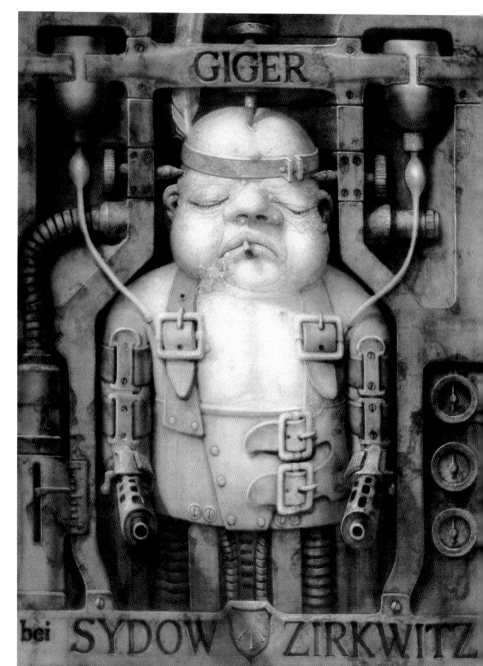

schen Kreisen weder wirklich erkannt noch akzeptiert worden. Eine profunde Kenntnis dieses Themas fehlt auch bei Gigers Vorläufern und Gleichgesinnten aus der Welt des Surrealismus und des Phantastischen Realismus.

In der heutigen Psychologie und Psychiatrie dominieren noch immer die Theorien Sigmund Freuds, dessen bahnbrechende Pionierarbeit die Grundlagen der modernen »Tiefenpsychologie« schuf. Doch Freuds Modell der Psyche, so zukunftsweisend und revolutionär es auch war, bleibt in Anbetracht der neuesten Erkenntnisse doch oberflächlich. Beschränkt auf die postnatale Biographie und das individuelle Unbewusste ist es zu eng gefasst.

Freuds Arbeit hatte seinerzeit auch einen profunden Einfluss auf die Kunst. Seine Konzepte vom Ödipus-Komplex, der Mutterfixierung, des kastrierenden Vaters und der Vagina dentata waren eine wahre Goldgrube für Schriftsteller und Filmschaffende und eine der wichtigsten Inspirationsquellen für die Surrealisten. In der künstlerischen Avantgarde gehörte es zum guten Ton, die Traumarbeit zu adaptieren, indem man auf originelle und verblüffende Weise Objekte einander gegenüberstellte, die keinerlei logischen Zusammenhang zu haben schienen. Diese Objekte waren bevorzugt solche, die für Freud eine versteckte sexuelle Bedeutung hatten.

Doch während die Verbindungen scheinbar unzusammenhängender Bilder im Traum ihre eigene Logik und Bedeutung haben, die anhand der Psychoanalyse ans Licht gebracht werden können, trifft dies in der surrealistischen Malerei nur selten zu. Hier reflektieren die Kombinationen von Bildern oft einen sinnentleerten Manierismus, der mit den tiefen Wahrheiten und der inneren Logik der Mechanismen des Unbewussten nur noch wenig zu tun hat. Nicht so beim künstlerischen Werk Gigers: Die Kompositionen erscheinen nur denjenigen unlogisch und zusammenhanglos, die

mit der modernen Bewusstseinsforschung nicht vertraut sind. Sie zeigen, dass er sich in der menschlichen Psyche weit besser auskennt als ein Großteil der Fachwelt.

Kunstkritiker verglichen Gigers Werk mit einem Teleskop oder auch Mikroskop, welches die dunklen Bereiche der menschlichen Psyche ans Licht bringt. Durch seine Beschäftigung mit den tiefen Abgründen des Unbewussten – und dem, was der moderne Mensch geflissentlich verdrängen und ignorieren möchte – wurde er sich auch des bedeutenden Einflusses bewusst, den Erlebnisse aus vorgeburtlicher Zeit auf uns ausüben. Eindringlichere Darstellungen zur entsetzlichen Tortur während der Geburt wie zum Beispiel seine *Gebärmaschinen I und II* und seine *Todgebärmaschine* können wir uns wohl kaum vorstellen. Ebenso beeindruckend sind die Geburtsmotive in *Biomechanoid I*, das drei Föten als schwerbewaffnete, groteske Indianerkrieger mit stählernen Bändern zeigt; das Bild *Landschaft XIV*, in welchem ein ganzer Wandteppich gefolterter Babies dargestellt ist, oder auch Gigers Selbstporträt *Biomechanoid*, ein für die Galerie Sydow-Zirkwitz kreiertes Plakat. Die Symbolik in *Landschaft X* ist subtiler und weniger offensichtlich. Hier verbindet Giger Sex und Geburt, symbolisiert durch die Gebärmutter, mit Tod und Gewalt, verkörpert durch schwarze Kreuze, die die Form von Schießzielscheiben haben, wie sie in der schweizerischen Armee eingesetzt werden. Ein Nachhall des Geburtstraumas lässt sich auch beim *Kofferbaby* und den beiden *Hommagen an Samuel Beckett* entdecken. Dieses Thema ist in seinem gesamten Werk vorhanden.

Sein Wissen um die psychologischen Auswirkungen des Geburtstraumas fand seinen herausragendsten Ausdruck im *Passagentempel*. Der Eingang besteht aus einer sarkophagartigen Öffnung. Die (zwar bislang noch nicht ausgeführte) Idee war, diesen mit daunengefüllten Leder-

◄ *Biomechanoid*, 1976.
Sydow Zirkwitz Gallery, Frankfurt. Exhibition poster, 80 x 63 cm

27

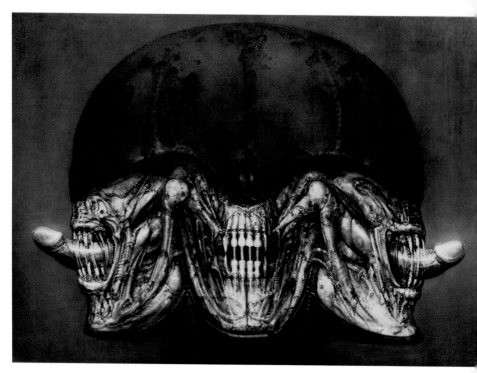

Necronom II, Work No. 301, 1974.
Acrylic on paper on wood, 70 x 100 cm

säcken zu polstern, damit die Besucher, die sich ins Innere des Tempels begeben wollen, sich hindurchzwängen müssen und so eine geburtsähnliche Erfahrung wiedererleben. Das Tempelinnere enthält Bilder von einer unglaublichen Intensität. Der Grund, warum Passagen auf Giger eine solche Faszination ausübten und ihn zu diesem Projekt führten, beruht nach seinen eigenen Angaben auf einem wiederkehrenden Albtraum: Er befindet sich in einem großen, weiten Raum ohne Türen und Fenster. Nur ein kleiner, enger Kaminschacht führt hinaus. Der Traum war von tiefen Ängsten und dem Gefühl zu ersticken begleitet.

Menschen, die das Einsetzen der Geburt nacherleben, haben gewöhnlich das Gefühl, in einen gigantischen Whirlpool eingesaugt oder von einem mythischen Ungeheuer verschlungen zu werden. Das kann von Bildern alles verschlingender archetypischer Monstren begleitet sein, wie etwa Leviathane, Drachen, Wale, Riesenschlangen, Taranteln oder Kraken. Die Empfindung einer bedrohlichen, überwältigenden Gefahr für das eigene Leben kann zu extremen Angstgefühlen oder einem allumfassenden, an Paranoia grenzenden Misstrauen führen. Der einsetzende Geburtsvorgang kann auch Bilder hervorrufen, in denen der Betroffene in die Tiefen der Unterwelt, das Totenreich, die Hölle hinabgezogen wird.

Hier kommen einem Gigers Phantasien von monströsen, gefahrvollen Labyrinthen in den Sinn, die er als Kind hinter dem Treppenhausfenster wähnte, und die Faszination, welche die steinerne, in den Keller führende Wendeltreppe auf ihn ausübte. Diese beiden Motive inspirierten ihn auch zu einer ganzen Serie von Arbeiten: Dabei entstanden Bilder wie die *Schächte* oder *Unter der Erde.*

Wenn die erste Stufe der Geburt in vollem Gange ist, pressen die Kontraktionen den Fötus periodisch zusammen, der Muttermund ist jedoch noch nicht geöffnet. Wer diesen Teil der Geburt erneut durchlebt, fühlt sich in einem monströsen, klaustrophobischen Albtraum gefangen; man erlebt emotionale und physische Todesqualen, hat das Gefühl von absoluter Hilflosigkeit und Verlassenheit. Empfindungen von tiefer Schuld, von existenzieller Verzweiflung und der Absurdität des Lebens können metaphysische Ausmaße annehmen. In dieser Situation ist man oft davon überzeugt, dass sie niemals enden wird und absolut ausweglos ist. Dreierlei Gefühlszustände sind für diesen Zustand charakteristisch: das Gefühl zu sterben, verrückt zu werden und nie mehr zurückkehren zu können.

Das Durchleben dieses Geburtsstadiums ist typischerweise begleitet von Episoden, in denen sich Menschen, Tiere und selbst mythologische Wesen in einer qualvollen und hoffnungslosen Zwangslage befinden, ähnlich derjenigen des Fötus in der Umklammerung des Geburtskanals. Hier entstehen Bilder von mittelalterlichen Verliesen, von Folterkammern der Inquisition, von erstickenden, zermalmenden Maschinen, von Konzentrationslagern und Irrenhäusern. Archetypische Versionen desselben Themas zeigen die unerträglichen Qualen von Sündern in der Hölle oder das Leiden Christi am Kreuz. In diesem Zustand sind die Menschen unfähig, irgendetwas Positives in ihrem Leben oder der menschlichen

Existenz schlechthin zu sehen. Im Zerrspiegel dieser Erfahrungsmatrix erscheint das Leben als ein sinnloses Theater des Absurden, als eine Farce, in der hölzerne Figuren und hirnlose Roboter auftreten: die Welt als billige Jahrmarktbude. In Gigers Arbeiten finden sich all diese qualvollen Zustände wieder, dargestellt mit einer einzigartigen künstlerischen Kraft.

Im nächsten Stadium der Niederkunft öffnet sich der Muttermund, die Kontraktionen erlauben jetzt dem Fötus ein Vorwärtskommen im Geburtskanal. Er erlebt sich nun nicht mehr als leidendes Opfer, sondern kommt in Kontakt mit enormen Reservoirs angestauter, mörderischer Aggression. Hier finden sich Szenen von brutalen Kämpfen, von Folterungen oder auch Bilder von sehr hoher sexueller Intensität. Typisch sind Episoden pornographischer Natur, von Vergewaltigung oder Perversionen wie Koprophilie, Nekrophilie und krimineller Sexualität.

Im letzten Stadium des Geburtsvorgangs kann der Fötus mit den verschiedensten biologischen Materialien in Kontakt kommen – mit Vaginalsekreten, Kindspech, Blut oder auch Urin und Fäkalien. Hier gründet die skatologische Dimension der perinatalen Symbolik. Bei Giger findet sie ihren Ausdruck in seiner Faszination für Kloschüsseln, Müllwagen und Müllabfuhr und in seinem geschärften Bewusstsein für den sexuellen Beiklang dieser Objekte und der damit verbundenen Aktivitäten. Hierzu gehören auch die in seinen Bildern wiederholt auftretenden Elemente wie Aas, verwesende Leichen, widerliche Würmer, Insekten, Erbrochenes und Ähnliches. Kunstgeschichtlich gesehen ist Giger unangefochtener Meister in der Darstellung albtraumhafter Aspekte des perinatalen Unbewussten – aus welchen sich die individuelle und soziale Psychopathologie und ein Großteil des Leidens in der modernen Welt ableiten lassen.

Dennoch haben diese tiefsitzenden Trau-

Passage XXIV, Work No. 184, 1972.
Acrylic on paper on wood, 100 x 70 cm

Passage XXI, Work No. 181, 1971.
Acrylic on paper on wood, 100 x 70 cm

mata auch ihre lichten Seiten und bergen ein großes Potenzial an Heilung und Transzendenz. Sieht man sich in der Religionsgeschichte um, so erkennt man, dass die Erfahrung von Tod und Wiedergeburt, die Begegnung mit dem Schatten in Form der »dunklen Nacht der Seele« oder der »Versuchung« oft unerlässlich war für ein spirituelles Erwachen. Die Heimsuchungen und Feuerproben einer heiligen Theresa von Avila, des heiligen Johannes vom Kreuz oder des heiligen Antonius von Padua ebenso wie die Geschichten von Buddha, Jesus und Mohammed geben Zeugnis davon.

Es wurde wiederholt darauf hingewiesen, dass Gigers Kunst – ähnlich der griechischen Tragödie – denen, die dafür offen sind, eine mächtige emotionale Katharsis vermitteln kann. Und Giger selbst hat das spirituelle und heilende Potential von Erfahrungen der perinatalen Welten erkannt. So zeigt eines seiner Bilder im *Passagentempel* einen von Licht umgebenen Thron. Zu diesem führen sieben Treppenstufen, die vor biomechanischen Jungfrauen flankiert werden. Er nannte dies den »Weg des Magiers, den man beschreiten muss, um auf eine Ebene mit Gott zu gelangen«. Ebenso scheint das für den Film *Dune* geschaffene Bild des Treppenaufgangs zur Burg der Harkonen, der mit phallischen Todessymbolen gesäumt ist, in den Himmel zu führen.

Und trotzdem hat Giger dem transzendentalen Potential perinataler Erfahrungen noch wenig Aufmerksamkeit geschenkt. Über die Gründe dafür kann man nur spekulieren. Der große amerikanische Mythenforscher Joseph Campbell sagte dazu einmal, die Bilder der Hölle seien wesentlich reizvoller und interessanter als die des Himmels, da das Leiden im Gegensatz zur himmlischen Glückseligkeit so viele verschiedene Formen annehmen kann. Vielleicht hat Giger das Gefühl, die lichten Dimensionen seien in der

estlichen Kunst schon zur Genüge dargestellt, ie abgründigen Nachtseiten jedoch gerne mgangen worden. Es ist auch möglich, dass igers eigener Prozess ihn noch nicht zur vollständigen Erkenntnis der transzendentalen imension geführt hat.

Ich persönlich hoffe, dass die letztere Alternative der Wahrheit am nächsten kommt. Ich ürde es zu gerne sehen, wenn Gigers Genie ich seiner unglaublichen Vorstellungskraft und einer unerreichten Freihand-Airbrush-Technik bedienen würde, um die transzendentale Schönheit er Phantasiewelten ebenso meisterhaft abzubilen wie er ihre »schreckliche Schönheit« dokuentiert hat. Ich habe diesen Kommentar schon

von vielen anderen seiner Verehrer gehört. Aber Giger ist immer seiner eigenen persönlichen Wahrheit gefolgt und hat sich ungern von seinen Auftraggebern Vorschriften machen lassen. Es ist unwahrscheinlich, dass die Wünsche seiner Fans, so aufrichtig und leidenschaftlich sie auch sein mögen, in dieser Hinsicht mehr Erfolg haben werden. Er wird der inneren Logik seiner prometheischen Mission folgen, wohin sie ihn auch führen wird, so wie er es immer getan hat. Und diejenigen unter uns, die seine Kunst lieben, werden sich weiterhin an all seinen außergewöhnlichen Schöpfungen erfreuen, die ihren Weg in die Welt finden werden.

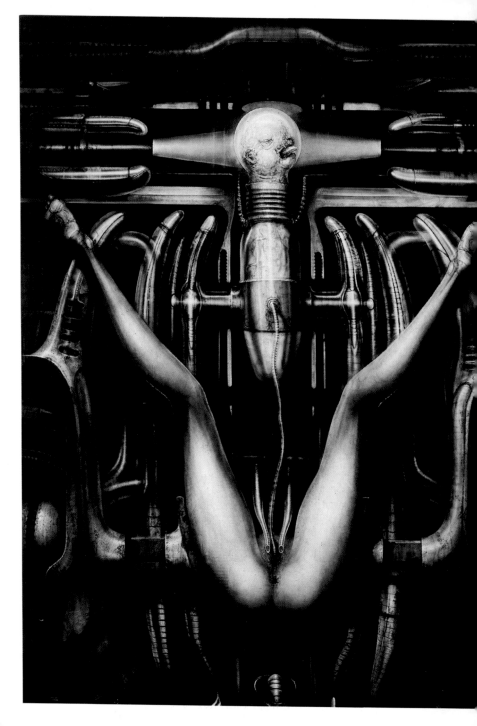

HR Giger et l'âme du XXe siècle

Stanislav Grof

Il y a quelques années, j'ai eu le privilège de rencontrer Oliver Stone, le grand réalisateur et génie visionnaire qui a souvent dévoilé dans ses films la face obscure de la civilisation contemporaine. A un certain moment, nous avons évoqué le film *Alien*, pour lequel HR Giger avait obtenu un Oscar, et parlé de son travail en général. Je lui ai fait part de ma grande admiration pour l'art de Giger et son extraordinaire talent pour dépeindre les abîmes de la psyché humaine. Oliver Stone m'a confié la grande estime qu'il éprouvait lui aussi à l'égard de Giger et de sa contribution à l'art moderne. Oliver Stone était d'accord avec moi pour placer très haut Giger au sein des arts visuels et plus généralement de la culture de notre temps. « Je ne connais personne d'autre, me disait-il, qui a su rendre avec autant de précision l'âme de l'homme moderne. Dans quelques décennies, en évoquant l'art du XXe siècle, on reparlera de Giger. »

Le jugement d'Oliver Stone m'a d'abord surpris, mais j'ai aussitôt compris qu'il touchait le fin fond de la vérité. Depuis lors, je me suis souvent rappelé cette conversation quand j'essayais de mieux comprendre certaines évolutions inquiétantes de la civilisation industrielle occidentale. On a souvent qualifié l'art de Giger de « biomécanique ». Difficile de choisir meilleure expression pour désigner l'esprit et l'air du temps de ce XXe siècle caractérisé par les énormes progrès technologiques qui ont asservi l'humanité moderne au monde des machines, engendrant une symbiose réciproquement destructrice.

Au cours du XXe siècle, les innovations technologiques sont pour ainsi dire venues prolonger nos muscles, notre système nerveux, nos yeux et nos oreilles, voire nos organes reproduc-

◄ Stillbirth Machine III, Work No. 355, homage to David Lynch, 1977.
Acrylic on paper on wood, 200 x 140 cm

teurs, et ce à un tel point que les frontières entre biologie et appareils mécaniques ont peu à peu disparu. Les histoires de Faust, de l'apprenti sorcier, du Golem et de Frankenstein sont devenues des mythes incontournables de notre époque. La science matérialiste, dans son effort pour connaître et contrôler le monde de la matière, a engendré un monstre qui menace la survie même de notre planète. Et l'être humain a échangé son rôle de créateur contre celui de victime.

Un autre fait marquant du XXe siècle est incontestablement l'apparition de formes de violence et de destructions monstrueuses à une échelle jusque-là inconnue. Guerres dévastatrices, révolutions sanglantes, régimes totalitaires, génocides, brutalités des polices secrètes et terrorisme international occupent le devant de la scène.

Les ravages causés dans certains domaines des sciences naturelles ainsi que la nature et la dimension des violences commises au cours du XXe siècle ont donné à cette période de l'histoire des traits particulièrement démoniaques.

Autre caractéristique importante du XXe siècle, l'extraordinaire changement d'attitude envers la sexualité. On a assisté au cours de la seconde moitié du siècle à un recul sans précédent de la répression sexuelle. D'un côté, cet allègement des contraintes culturelles a engendré une liberté sexuelle et une précocité accrue de l'initiation des jeunes générations, de la promiscuité sexuelle et de la libération gay.

D'un autre côté, les aspects obscurs de la sexualité se sont exposés comme jamais auparavant et font partie de la culture moderne – grossesse adolescente, pornographie adulte et enfantine, quartiers « chauds » offrant toutes les formes possibles de prostitution, lieux de rencontres pour sadomasochistes, « marchés aux esclaves sexuels ». Le spectre le plus sinistre

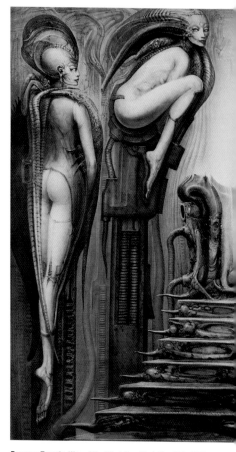

Passage Temple, **Way of the Magician, Work No. 264, 1975. Acrylic on paper on wood, 240 x 280 cm**

reste, aujourd'hui encore, la pandémie du SIDA qui s'étend inexorablement dans le monde, forgeant un lien indissoluble entre sexualité et mort, entre Eros et Thanatos.

L'art biomécanique de Giger rassemble tous ces éléments qui ont marqué l'histoire du XXe siècle. Dans son style inimitable, il mêle avec brio certains éléments de dispositifs mécaniques dangereux du monde technologique avec diffé-

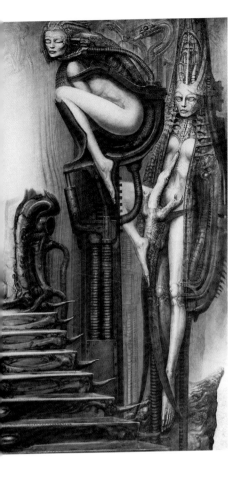

satanique de ces domaines est rendu avec une telle virtuosité artistique qu'il y trouve une profondeur archétypale.

Giger montre avec une acuité qui n'appartient qu'à lui les horreurs de la guerre. Prenons *Necronomicon II* dont la figure squelettique triple, coiffée d'un casque militaire, condense d'une manière terrifiante les symboles de mort, violence et agression sexuelle. Nombre des peintures de Giger représentent un monde du futur détruit par les excès de la technologie et ravagé par l'hiver nucléaire – un univers d'extrême aliénation, sans humains ni animaux, dominé par des gratte-ciels sans âme, un monde fait de matières plastiques, d'acier et de goudron. Ses Enfants Atomiques forment une population grotesque de mutants ayant survécu à la guerre nucléaire où à l'empoisonnement dû aux déchets nucléaires accumulés.

Il y a cependant un motif récurrent dans l'art de Giger qui semble moins être dans l'air du temps de ce XXe siècle : les nombreuses images montrant des fœtus torturés et malades. Et pourtant, c'est avec ce thème que le génie visionnaire de l'artiste ouvre les plus profondes perspectives sur les recoins secrets de l'âme humaine. Grâce aux éléments prénatals et périnatals qu'il ajoute au symbolisme de la sexualité, de la mort et de la douleur, Giger atteint une perspicacité psychologique qui dépasse souvent de loin celle des psychologues classiques.

Chez lui, la quête résolue d'expression créatrice est inséparable d'une auto-exploration et d'une thérapie intime poursuivies sans relâche. Comme Francisco Goya, qui devait peindre ses terrifiantes visions pour parvenir à les contrôler, Giger s'efforce de surmonter dans ses peintures ses terrifiants cauchemars claustrophobes. Comme il l'a lui-même souligné, l'art est pour lui une activité vitale qui l'empêche de sombrer dans la folie. La virtuosité technique de

rentes parties de l'anatomie humaine. Tout aussi extraordinaire est la façon dont Giger entremêle sexualité déviante, violence et emblèmes de la mort. Crânes et ossements se muent en organes sexuels ou pièces de machines, et vice versa, avec un degré d'intégration et une fluidité telle que les images qui en résultent reflètent avec une puissance symbolique égale extase sexuelle, violence, souffrance atroce et mort. Le potentiel

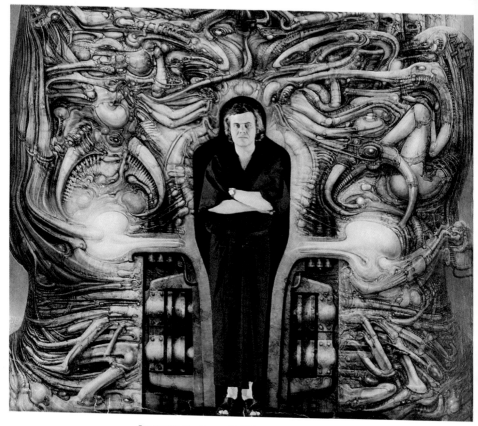

Passage Temple entrance with HR Giger, Work No. 262, 1975.
Acrylic on paper on wood, 240 x 280 cm

Giger et son talent dans le domaine du fantastique en font l'égal de ses maîtres, Jérôme Bosch, Salvador Dalí et Ernst Fuchs, mais la profondeur de son intuition psychologique est inégalée dans le monde de l'art.

En recherchant la source de ses propres cauchemars qui le tourmentent, Giger a découvert, indépendamment des pionniers de la recherche moderne sur la conscience, l'importance psychologique majeure du trauma de la naissance. L'existence du fascinant domaine de l'inconscient tel que Giger l'a appréhendé intuitivement et traduit dans son art, n'a pas encore été reconnue et acceptée par les milieux artistiques officiels. Une connaissance intime de ce domaine est également absente des œuvres des prédécesseurs ou des pairs de Giger, que ce soit dans le monde des surréalistes ou celui des réalistes fantastiques.

La psychologie et la psychiatrie officielles sont dominées par les théories de Sigmund Freud, dont l'œuvre novatrice a posé les fonde-

ments de la « psychologie des profondeurs » moderne. Le modèle freudien de la psyché, si avant-gardiste et révolutionnaire soit-il pour son époque, reste très superficiel et se limite à la biographie post-natale et à l'inconscient individuel.

L'œuvre de Freud a eu des répercussions considérables sur l'art. Ses concepts du complexe d'Œdipe, de la fixation sur la mère, du père castrateur et de la « vagina dentata » ont été une vraie mine d'or pour les romanciers et les cinéastes. La découverte par Freud du symbolisme sexuel et l'interprétation de la symbolique des rêves fut l'une des principales sources d'inspiration du mouvement surréaliste. L'avant-garde artistique s'est d'ailleurs mise à imiter le travail du rêve en superposant d'une façon surprenante divers objets d'une manière qui défiait la logique élémentaire. La sélection de ces objets montrait souvent une préférence pour ceux qui, selon Freud, avaient une signification sexuelle cachée.

Mais si les liens entre les images apparemment incohérentes du rêve possèdent leur propre logique – leur signification intime, que l'analyse psychologique a pour tâche de débusquer – il n'en va pas toujours de même pour les peintures surréalistes. Dans ce cas, les juxtapositions d'images reflètent souvent un maniérisme vide sans relation avec la vérité et la logique d'une dynamique inconsciente. L'art de Giger se situe aux antipodes de cette démarche. La combinaison d'images propre à son art ne semblera illogique et incohérente qu'à ceux qui ne sont pas familiers des découvertes des chercheurs obtenues ces dernières décennies dans le domaine de la conscience. Cela confirmerait une fois encore que la compréhension de la psyché humaine, chez Giger, est très en avance sur la plupart des psychologues.

Les critiques ont souvent décrit cet art comme effectuant simultanément le travail d'un microscope et d'un télescope pour révéler les secrets les plus profonds de la psyché humaine. Scrutant les abîmes insondables de l'inconscient, que la société contemporaine préfère nier et ignorer, Giger a découvert que la vie humaine était intimement façonnée par toutes sortes d'événements et de forces qui précèdent notre apparition en ce monde. On peut difficilement imaginer plus puissantes représentations de cette expérience terrifiante de la naissance humaine que les œuvres *Birth Machine I et II* ou *Death Delivery Machine*. Le thème de la naissance revient aussi dans *Biomechanoid I* qui représente trois fœtus sous les traits de grotesques guerriers indiens au front cerclé de rubans d'acier et armés jusqu'aux dents, et dans *Paysage XIV*, à la surface entièrement recouverte de bébés torturés, ou encore dans l'autoportrait *Biomechanoid* réalisé pour l'affiche de la galerie Sydow-Zirkwitz. Le symbolisme de *Landscape X* est plus subtil et moins évident. Giger mêle ici un espace utérin symbolisant sexe et naissance avec des croix noires en forme de cibles pour l'entraînement au tir de l'armée suisse qui représentent la mort et la violence. On détecte aisément des échos de ce symbolisme de la naissance dans *Suitcase Baby*, *Hommage à Beckett I et II* – et dans le reste de son œuvre.

L'expression la plus frappante de l'importance psychologique du trauma de la naissance se trouve dans *Passage Temple*. Les visiteurs sont invités à pénétrer dans ce temple à travers une ouverture en forme de sarcophage et doivent se frayer leur chemin en écartant des sacs en cuir duvetés, afin de revivre les sensations de leur propre naissance, l'intérieur étant décoré d'images périnatales d'une intensité extraordinaire. La fascination de Giger pour ce projet s'inspirait d'un cauchemar où il se trouvait enfermé dans une grande pièce sans porte ni fenêtres, la seule issue étant constituée d'un minuscule

conduit de cheminée, un rêve particulièrement angoissant et étouffant.

Des individus revivant le début de la naissance biologique éprouvent le sentiment typique d'être aspiré dans un gigantesque tourbillon ou avalé par quelque bête mythique. Ils verront souvent des archétypes de monstres omnivores : léviathans, dragons, requins, serpents géants, tarentules ou pieuvres… Le sentiment d'une menace de mort imminente peut générer une anxiété intense et une méfiance généralisée proche de la paranoïa. Autre variante de la même expérience, le thème de la descente dans les entrailles de la terre, dans le royaume de la mort, dans l'enfer. Ce qui nous conduit aussitôt aux fantasmagories de Giger sur les monstrueux labyrinthes grouillants de dangers qu'il imaginait derrière la fenêtre de la cage d'escalier de la maison de son enfance et sa fascination pour l'escalier en colimaçon menant à la cave. Cette expérience et ce thème a aussi inspiré toute une série d'autres œuvres, comme *Shafts to Underground* ou *Under the Earth*.

Dans la première phase de la naissance biologique, les contractions de l'utérus compriment le fœtus à intervalles réguliers alors que le col n'est pas encore ouvert. Les sujets qui revivent ce moment de la naissance se sentent prisonniers d'un monstrueux cauchemar claustrophobe. Ils éprouvent une souffrance émotionnelle et physique intense mêlée à un profond sentiment d'impuissance et de désespoir. Solitude, culpabilité, absurdité de la vie et désespoir existentiel peuvent atteindre des proportions métaphysiques. Un être confronté à une telle épreuve est souvent convaincu que cette situation ne finira jamais et qu'il n'existe absolument pas d'issue. D'où le triple sentiment caractéristique de cet état : on se sent mourir, devenir fou, et on a l'impression de ne plus pouvoir revenir en arrière.

La réitération de cette étape de la naissance entraîne des séquences typiques dont les acteurs sont des êtres humains, des animaux et même des monstres mythologiques traversant une épreuve douloureuse et désespérée semblable à celle d'un fœtus pris dans les convulsions du canal de la vie. On est prisonnier d'un donjon médiéval, une chambre de tortures de l'Inquisition, un appareil mécanique qui étouffe et écrase, un camp de concentration ou un asile de fous. Des versions archétypales du même thème montrent les tortures intolérables de pécheurs en enfer ou l'agonie du Christ sur la Croix. Dans cet état, les sujets deviennent incapables de voir le moindre aspect positif dans leur vie et l'existence humaine en général. A travers le prisme de cette matrice existentielle, la vie semble un Théâtre de l'Absurde privé de sens, une farce mettant en scène des personnages de carton-pâte et des robots sans âme, ou une sinistre exhibition de fête foraine. L'œuvre de Giger restitue cette épreuve avec une puissance artistique inégalée.

Dans l'étape suivante de l'accouchement, les contractions utérines continuent d'enserrer étroitement le fœtus, mais le col, à présent dilaté, permet la propulsion graduelle de ce dernier dans le canal de la naissance. L'expérience consistant à revivre ce stade dépasse l'identification exclusive au rôle de la victime souffrante, comme lors de l'étape précédente. Elle fournit aussi un accès à d'énormes réservoirs d'agressions meurtrières refoulées. Ce qui conduit à des images de lutte violente et de tortures. Les expériences sexuelles se caractérisent par l'extrême intensité des pulsions sexuelles. Ce stade de la naissance constitue la source psychologique profonde des variations, déviations et perversions sexuelles, qu'il s'agisse de sadomasochisme, de coprophilie, de nécrophilie ou de sexualité criminelle.

Le fait que le fœtus rencontre souvent aux

stades ultimes de la naissance différentes formes de matières biologiques – secrétions vaginales, méconium, sang et même urine et fèces – explique la dimension scatologique du symbolisme périnatal. Dans l'art de Giger il s'exprime par la fascination pour les cuvettes de WC, les bennes à ordures et le ramassage de celles-ci, ainsi que par sa conscience aiguë des connotations érotiques de ces objets et activités. Il est aussi en cause dans la présence des thèmes d'abats, de décomposition corporelle, d'insectes répugnants, d'excréments et de vomissures dans ses peintures. Maître suprême de l'aspect cauchemardesque de l'inconscient périnatal, qui est la source de la psychopathologie individuelle et sociale et de bon nombre des souffrances de l'humanité moderne, Giger n'a pas d'équivalent dans l'histoire de l'art.

Pourtant, la dynamique périnatale possède aussi ses côtés lumineux et recèle un énorme potentiel de guérison et de transcendance en vue d'une mort et d'une renaissance psychospirituelle. Dans l'histoire de la religion, une rencontre profonde avec l'Ombre, qu'elle prenne la forme de la Nuit Noire de l'Âme ou de la Tentation a souvent constitué un préalable à l'ouverture spirituelle. Les épreuves rigoureuses de sainte Thérèse d'Avila, saint Jean de la Croix et saint Antoine, tout comme l'histoire du Bouddha, de Jésus et de Mahomet, le démontrent.

On a souvent noté que l'art de Giger, comme la tragédie grecque, peut déclencher une intense catharsis émotionnelle chez ceux qui s'ouvrent à elle. Et Giger lui-même éprouve son art comme une thérapie et un moyen de conserver son équilibre. Il semble qu'il ait aussi compris le potentiel spirituel d'une profonde immersion dans le monde obscur des images périnatales. Par exemple, dans l'une des peintures du *Passage Temple*, il représente un trône baigné de lumière dressé au sommet d'un escalier

Passage V, Work No. 117, 1969.
Oil on wood, 100 x 80 cm

Passage VI, Work No. 118, 1970.
Oil on wood, 100 x 80 cm

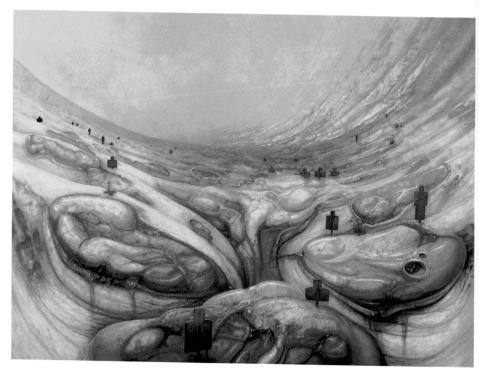

Landscape X (Tell '73), Work No. 203, 1972.
Acrylic on paper on wood, 140 x 200 cm

de sept marches et flanqué de vierges biomécaniques. Il le décrit comme « le chemin que le magicien doit emprunter pour parvenir au niveau de Dieu. » De la même manière, son image de l'escalier menant au Château Harkonen pour le film *Dune*, entouré de dangereux symboles phalliques et mortels à la fois, semble conduire au paradis.

Cependant, le potentiel transcendantal du processus périnatal n'a pas beaucoup retenu l'attention de Giger. Il serait intéressant de spéculer sur les raisons possibles de ce désintérêt. Le grand mythologue américain Jospeh Campbell soulignait que les images de l'enfer, dans toutes les mythologies, sont de loin plus intrigantes et

intéressantes que celles du paradis parce que, à la différence du bonheur et de la béatitude, la souffrance peut prendre une infinité de formes différentes. Peut-être Giger considère-t-il que la dimension transcendantale a été plus qu'adéquatement exploitée dans l'art occidental, alors que les abîmes du côté obscur ont été évités. Il est aussi possible que le propre processus thérapeutique de Giger ne soit pas encore assez avancé pour le pousser vers la dimension transcendantale.

J'espère personnellement que cette deuxième alternative est plus proche de la vérité. J'aimerais beaucoup que le génie de Giger utilise

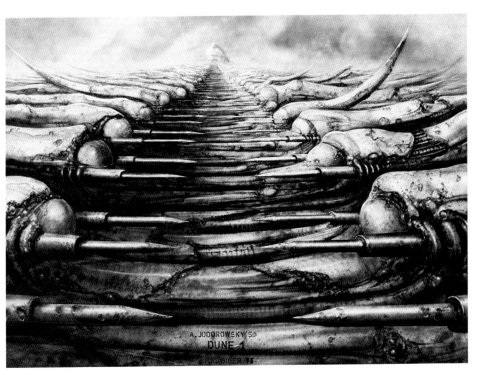

Dune I, Work No. 289, 1975.
Acrylic on paper on wood, 70 x 100 cm

son incroyable imagination et sa maîtrise dans le maniement libre de l'aérographe pour représenter la beauté transcendantale du monde imaginaire avec la même maîtrise que dans ses images de la « terrible beauté ». J'ai souvent entendu le même avis dans la bouche des admirateurs du peintre. Mais Giger a toujours poursuivi sa propre vérité intérieure et n'aime pas les contraintes d'éventuels commanditaires. Il est donc peu probable que les vœux de ses fans et admirateurs, si sincères et passionnés soient-ils, aient plus de succès. Il suivra la logique intérieure de sa quête prométhéenne où elle l'entraînera, comme il l'a toujours fait – et ceux d'entre nous qui aiment son art continueront d'apprécier les extraordinaires produits de ce processus à mesure de leur apparition en ce monde.

▸▸ Pages 42–47: Alu-eloxale prints, 2001.
Edition of 23, with frame by Luigi Colani. All dimensions with frames

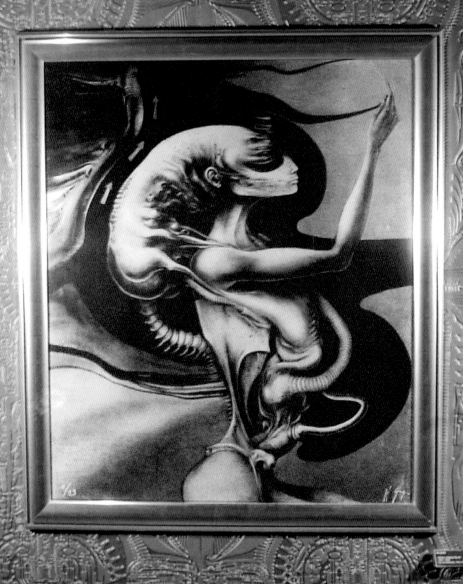

Alpha, Work No. 79b, 1967.
116 x 102 cm

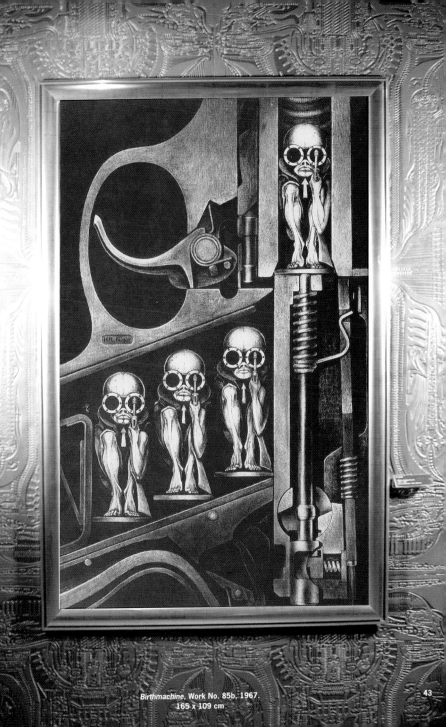

Birthmachine, Work No. 85b, 1967.
165 x 109 cm.

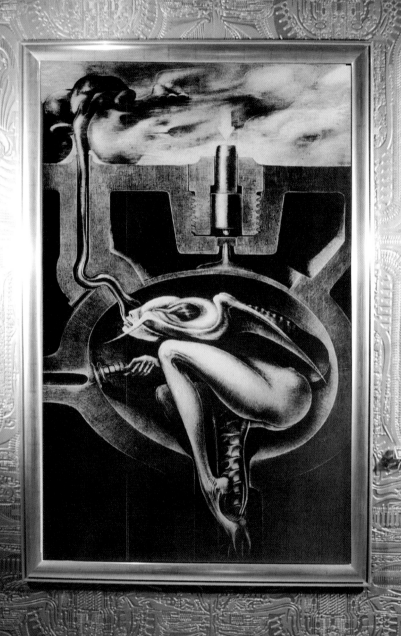

Under the Earth, Work No. 87b, 1968.
165 x 109 cm

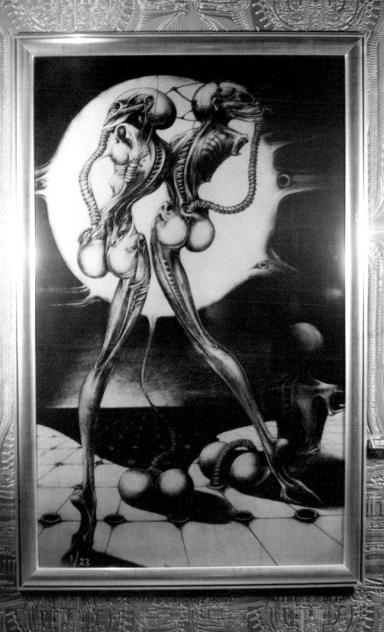

Atomic Children, Work No. 69b, 1968.
165 x 109 cm

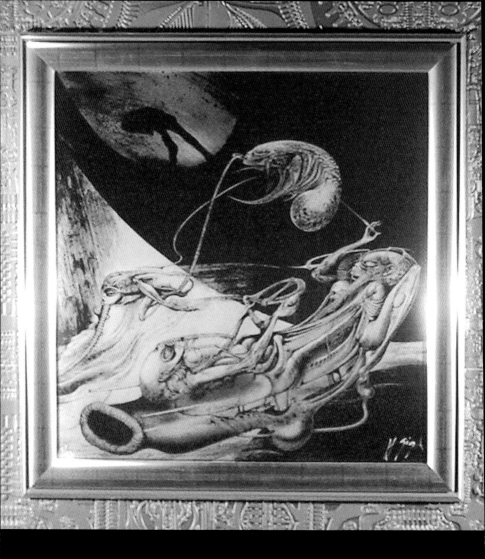

46 *Astreunuchen, Work No. 71b,*
82 x 82 cm

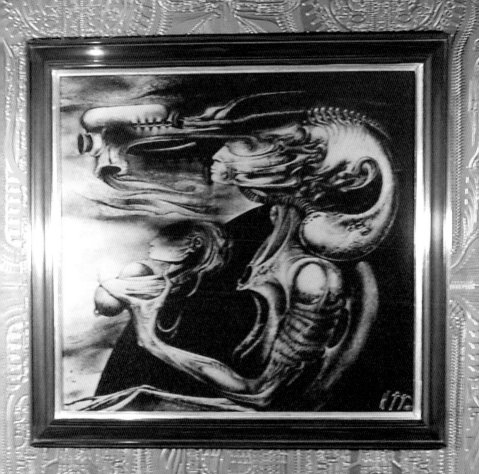

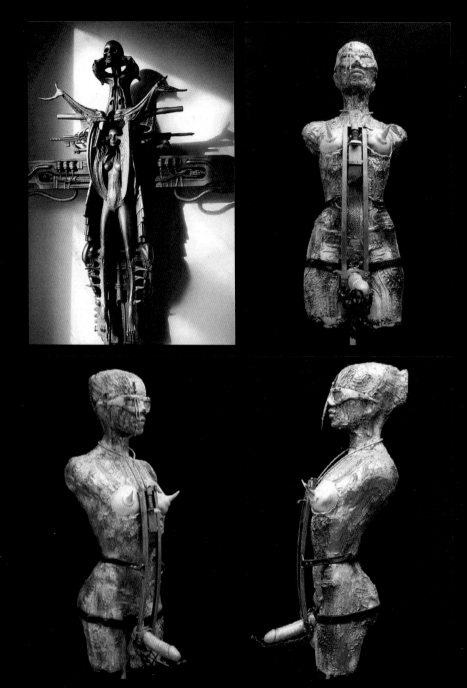

Top left: *Spell I*. Top right: *Hoopla I*.
Bottom left: 3/4 view *Hoopla I*. Bottom right: Side view *Hoopla I*

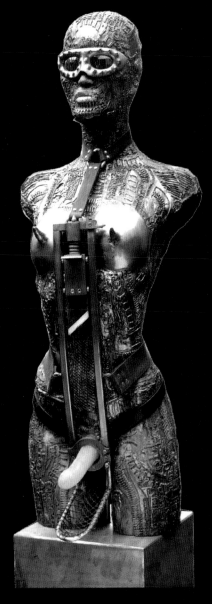

Hoppla II (St. Gallen Necktie), 1996. Fiberglass and steel, 100 x 40 x 35 cm

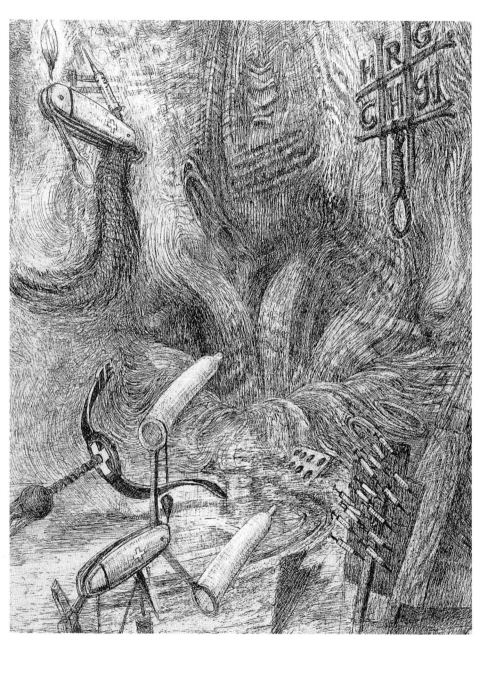

700 Years of Waiting for CH-1991.
Portfolio, edition of 300 (cover). Zinc lithograph on cardboard, 44 x 35 cm

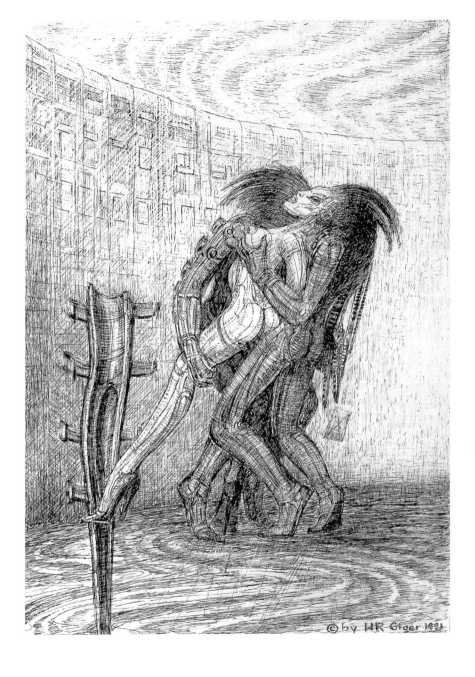

Interpersonal Relationship II, 1991, reproduced in *700 Years of Waiting* portfolio.
Ink on Transcop, 30 x 21 cm

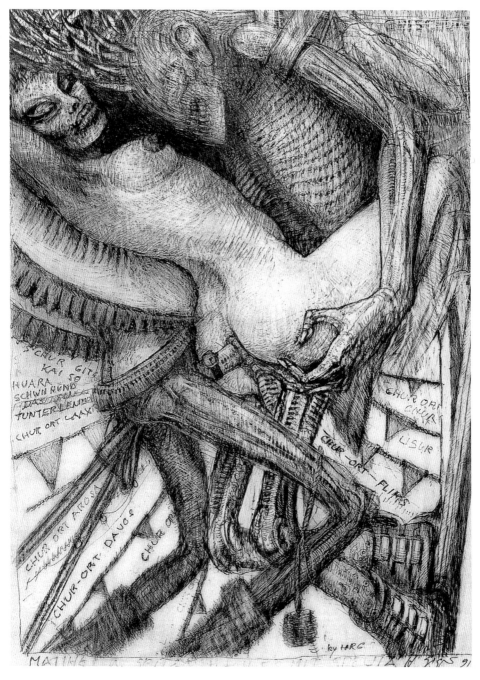

52 *Chur-Ort-Chur*, 1991, inside cover of *700 Years of Waiting* portfolio.
Ink on Transcop, 30 x 21 cm

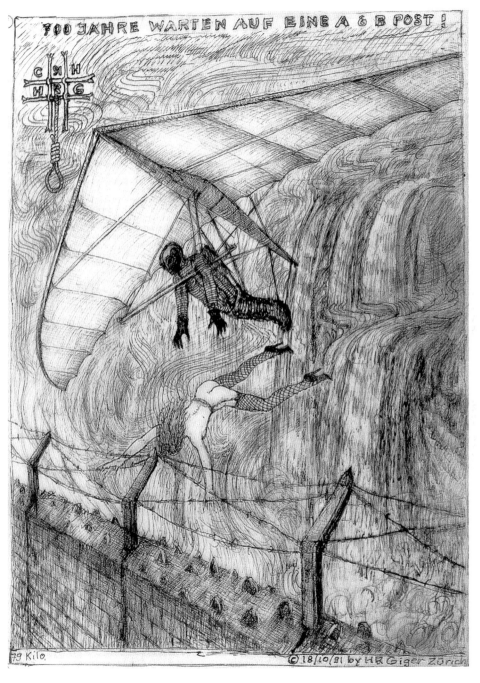

700 Years of Waiting for A + B Post, 1991.
Ink on Transcop, 30 x 21 cm

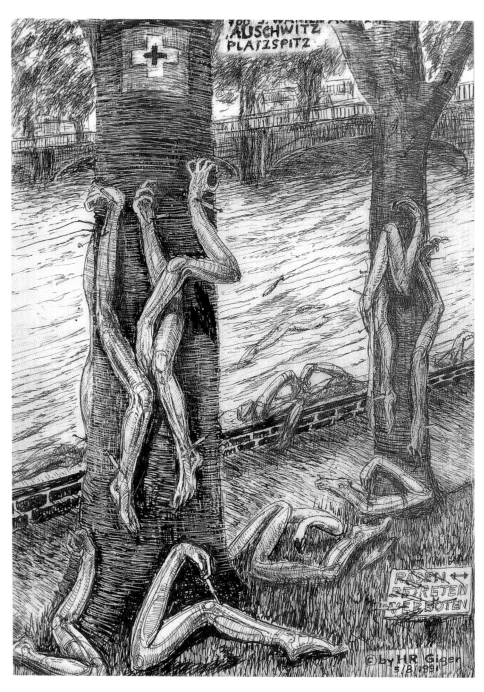

54

700 Years of Waiting for Auschwitz-Platzspitz, 1991.
Ink on Transcop, 30 x 21 cm

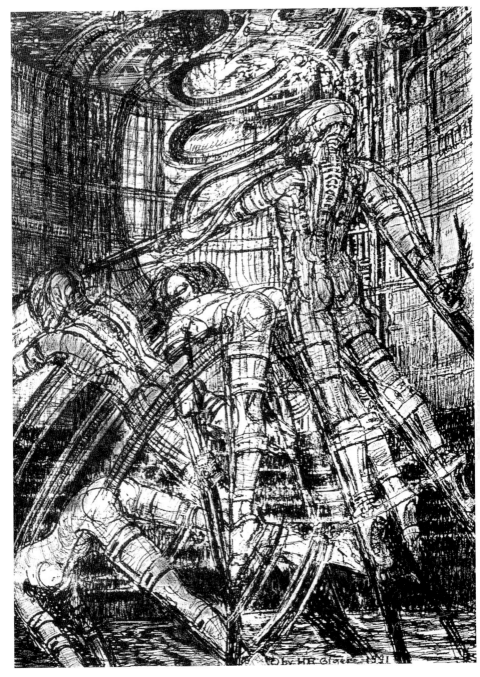

Illustration for *Marquis de Sade VIII*, 1991, reproduced in *700 Years of Waiting* portfolio.
Ink on Transcop, 30 x 21 cm

The objects are usually animated, and if they are not in a good mood, they challenge the magician. The world as a ghost train, in which coffin lids snap open like crocodile jaws, or the dry branches of death trees reach for the passengers. Where animated objects are not of his own making, the magician must focus all energies so as to keep the self-asserting forces in check and affirm his position as master of the universe. Stars are born, mountains call, the streets rise up to meet you, inflation gallops, *The Wind Cries Mary* and stones are mute. The language with which an understanding of the world is organized is interspersed with the metaphors of a living Nature. Magical and mythical pictures of the world retain their substrata even in the most commonplace expressions and develop into the forbidden shadow which brings out the light of the One God as well as the beacon of Enlightenment and the Natural Sciences. Neither mythical nor magical thinking have ever forfeited their status as alternatives in the search for sense and the inhabitability of the world.

Die Dinge sind meistens belebt, und wenn sie nicht wohlgesonnen sind, fordern sie den Magier heraus. Die Welt als eine Geisterbahn, in der Sargdeckel wie Krokodilskiefer aufklappen oder die verdorrten Äste von Todesbäumen nach den Passagieren greifen. Wo die belebten Dinge nicht seine eigenen Emanationen sind, muß der Magier alle Energien bündeln, um die sich verselbständigenden Kräfte in Schach zu halten und seine Position als Herr des Universums zu behaupten. Sterne werden geboren, Berge rufen, Straßen kommen entgegen, die Inflation galoppiert, *The Wind cries Mary* und Steine sind stumm. Die Sprache, mit der sich Weltverständnis organisiert, ist durchsetzt von Metaphern einer beseelten Natur. Magische und mythische Weltbilder haben ihr Substrat noch in den alltäglichsten Ausdrucksweisen und entwickeln sich in den verbotenen Schatten, die das Licht des Mono-Gottes genauso wie das Licht der Aufklärung und der Naturwissenschaften herausschneidet. Mythisches und magisches Denken haben ihren Status als Alternative bei der Suche nach Sinn und Bewohnbarkeit der Welt niemals eingebüßt.

Les choses sont le plus souvent animées, et lorsqu'elles ne sont pas bien intentionnées, elles lancent un défi au magicien. Le monde est présenté sous forme d'un train fantôme où les couvercles de cercueil s'ouvrent comme des mâchoires de crocodile et où les branches sèches des arbres de la mort cherchent à saisir les passagers. Là où les choses animées n'émanent pas de lui, le magicien est obligé de concentrer toutes les énergies pour tenter de contrecarrer les forces tendant à l'indépendance et pour s'imposer en tant que Seigneur de l'Univers. Des étoiles naissent, des montagnes appellent, des rues viennent à notre rencontre, l'inflation est galopante, *The Wind Cries Mary* et les pierres restent muets. Le langage qui structure la compréhension du monde est parsemé de métaphores se référant à une nature inspirée. Des visions du monde magiques et mythiques gardent leur substrat dans les formes d'expression les plus banales et se développent dans les ombres interdites que découpe aussi bien la Lumière du Dieu monothéiste que celle de l'Aufklärung et des sciences naturelles. La pensée mythique et magique n'a à aucun moment perdu son statut d'alternative dans la recherche de sens et d'habitabilité du monde.

Herbert M. Hurka: *Aliens Darkness – die andere Finsternis*

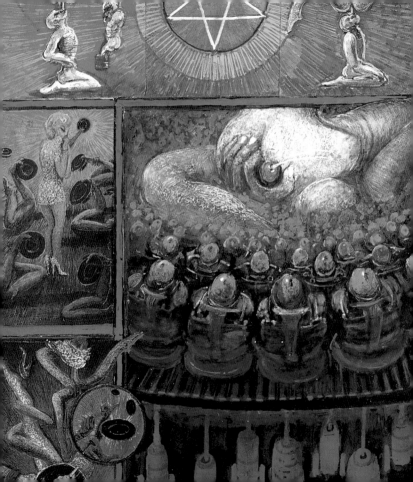

E L P

THE ENVIRONMENT

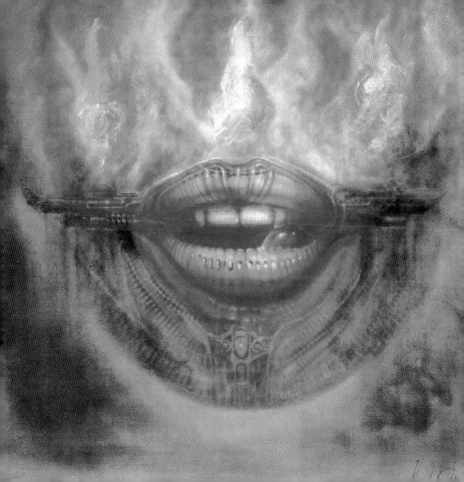

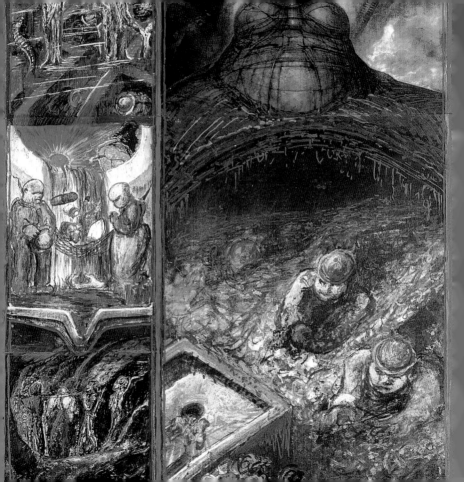

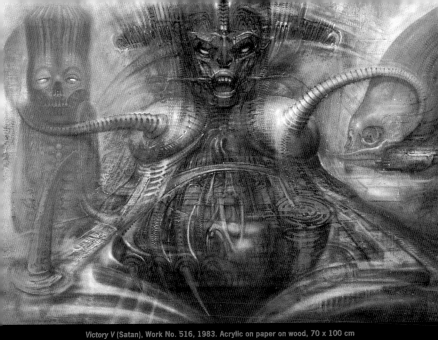

Victory V (Satan), Work No. 516, 1983. Acrylic on paper on wood, 70 x 100 cm

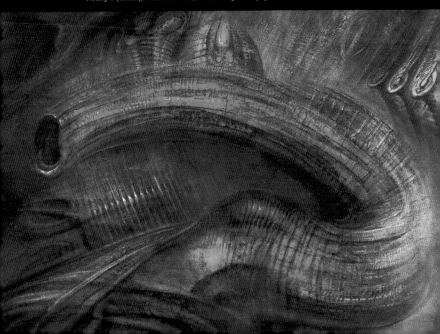

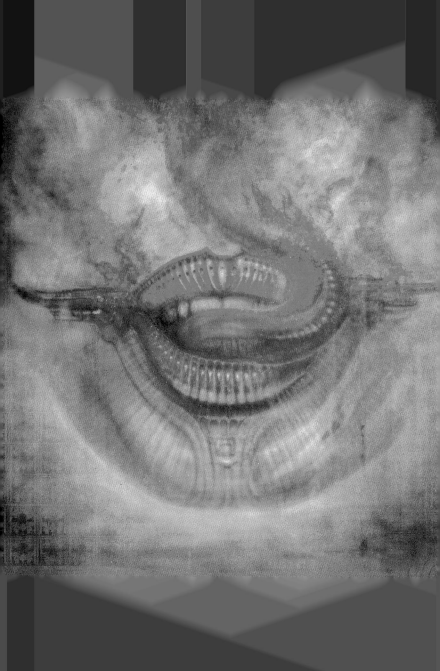

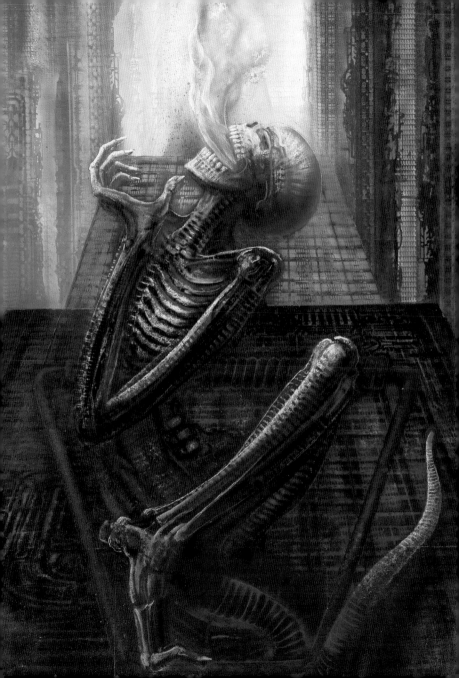

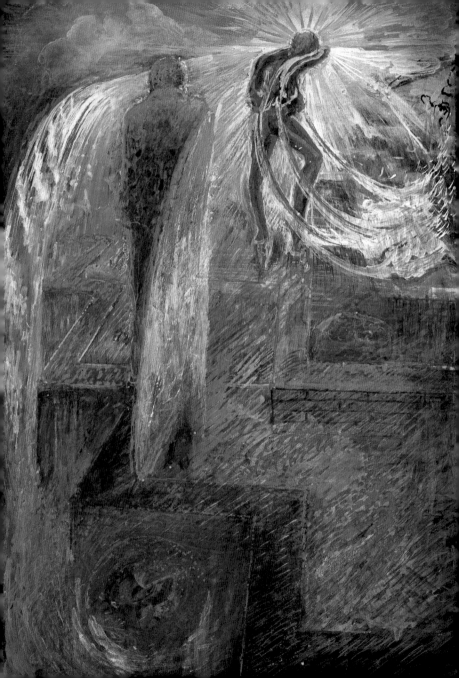

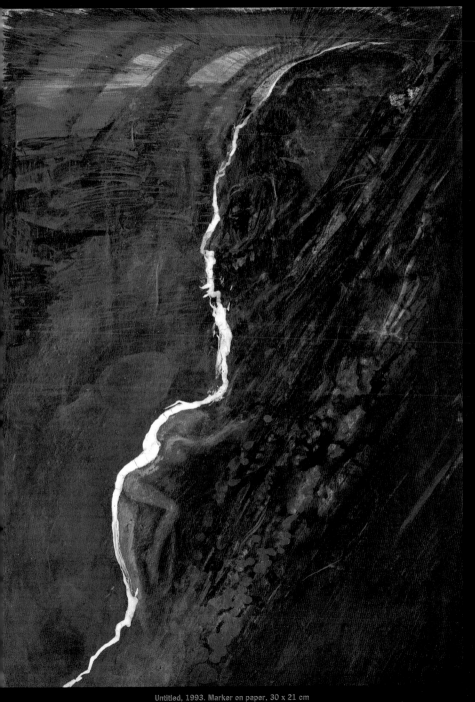

Untitled, 1993. Marker on paper, 30 x 21 cm

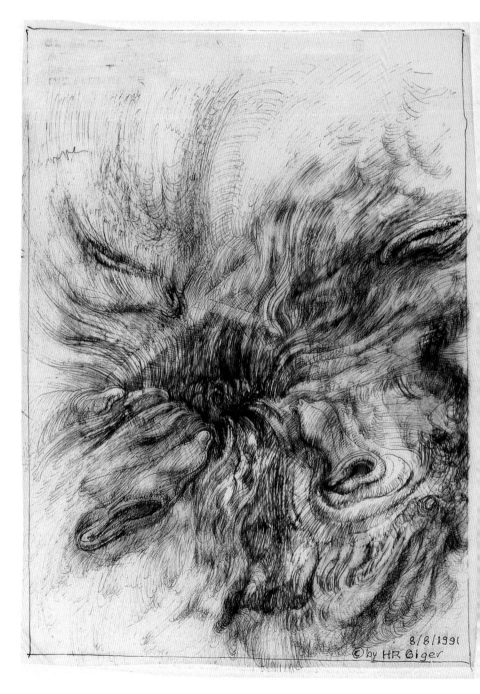

700 Years of Waiting for CH-1991, reproduced in portfolio.
Ink on paper, 30 x 21 cm

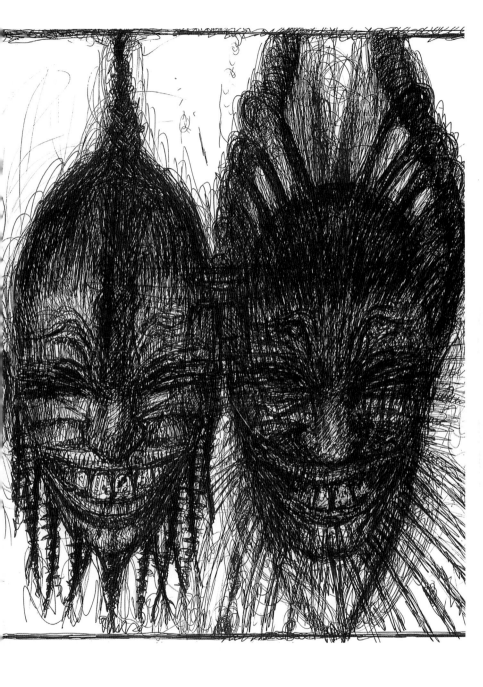

Window Lickers I, 1999.
Ball point on paper, 30 x 21 cm

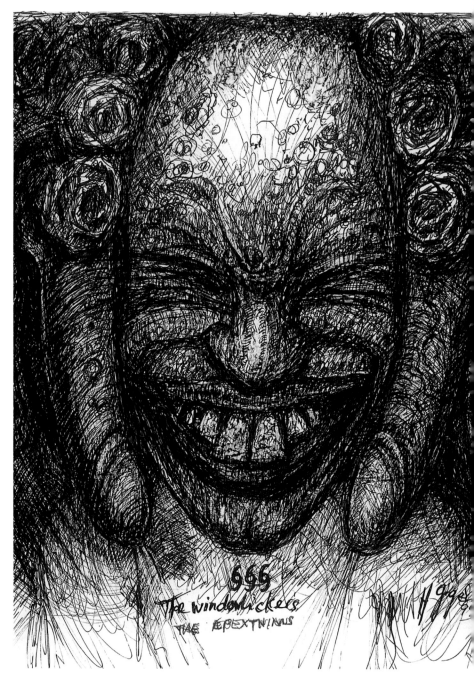

Window Lickers II, 1999.
Ball point on paper, 30 x 21 cm

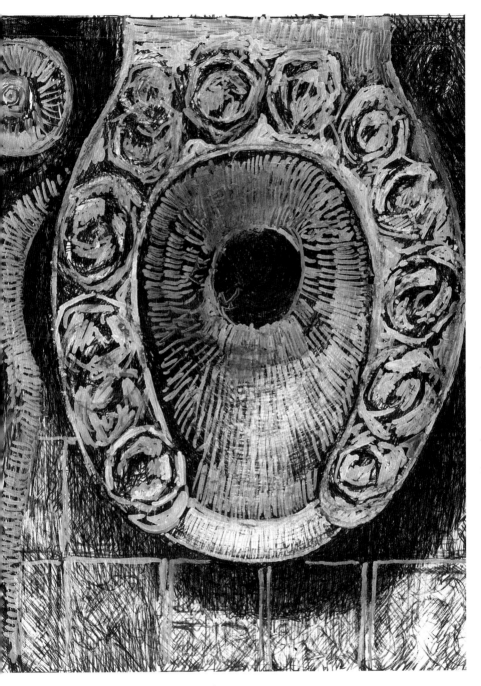

Window Lickers III, 1999.
Ball point and Tipp-Ex on paper, 30 x 21 cm

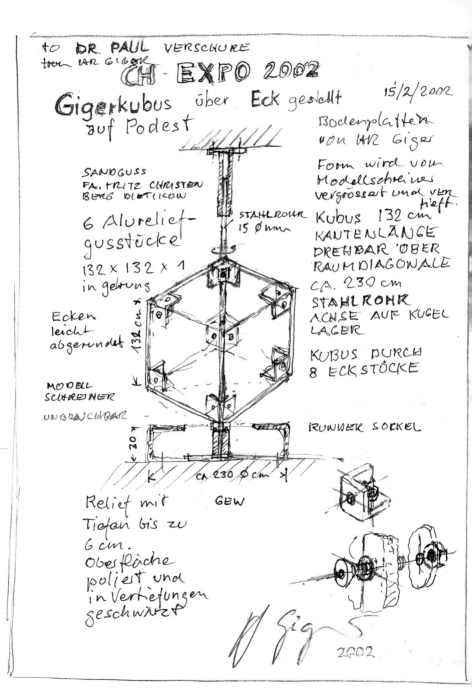

to DR. PAUL VERSCHURE
from IHR GIGER CH-EXPO 2002

Gigerkubus über Eck gestellt 15/2/2002

auf Podest

Bodenplatten von IHR Giger

SANDGUSS
FA. FRITZ CHRISTEN
BERG DIETIKON

Form wird vom Modellschreiner vergrössert und vertieft.

6 Alurelief-gussstücke

STAHLROHR 15 Ø mm

Kubus 132 cm KANTENLÄNGE DREHBAR ÜBER RAUMDIAGONALE CA. 230 cm

132 × 132 × 1 in gebrus

Ecken leicht abgerundet

132 cm

STAHLROHR ACHSE AUF KUGEL LAGER

KUBUS DURCH 8 ECKSTÜCKE

MODELL SCHREINER

UNBRAUCHBAR

20

RUNDER SOCKEL

CA 230 Ø cm

GEW

Relief mit Tiefen bis zu 6 cm. Oberfläche poliert und in Vertiefungen geschwärzt

Giger 2002

Homage to German heavy metal band *Rammstein*, 1999. Pencil on paper, 30 x 21 cm

►► Pages 72/73: *Erotomechanics VI*, Work No. 421b, from a limited edition portfolio of 300. Silkscreen, 70 x 100 cm

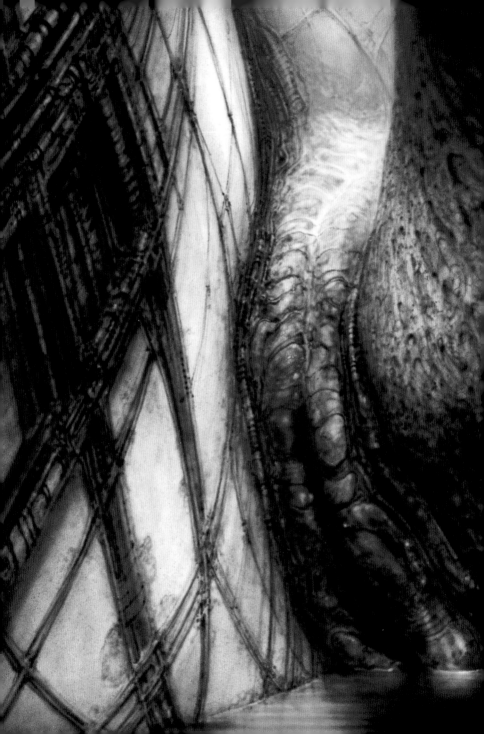

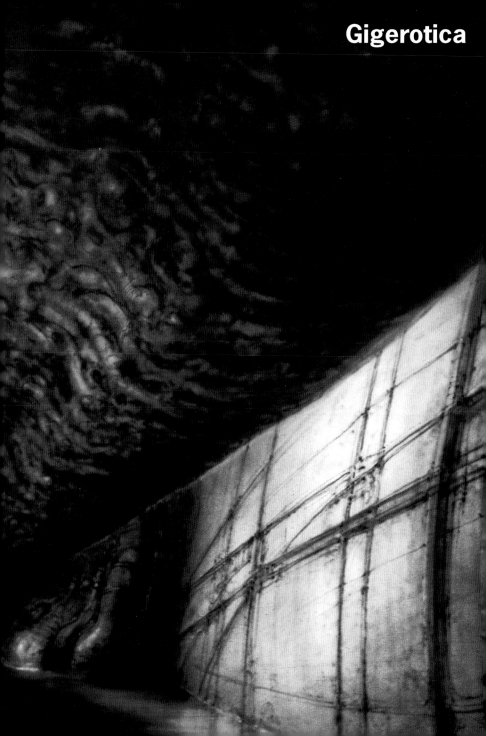

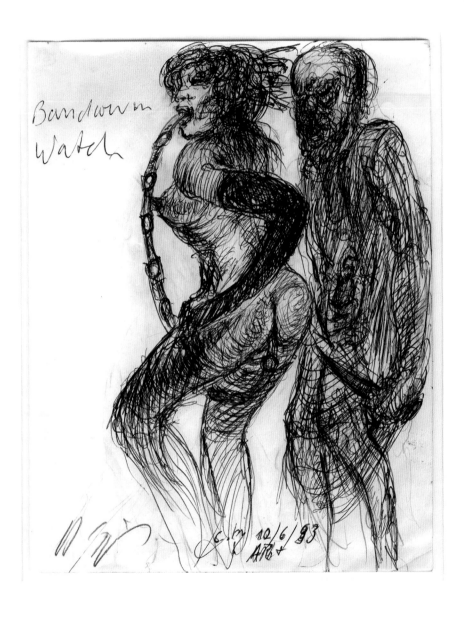

Bandwurm
Watch

74 *Bandwurmwatch*, 1993.
Ink on paper, 30 x 21 cm

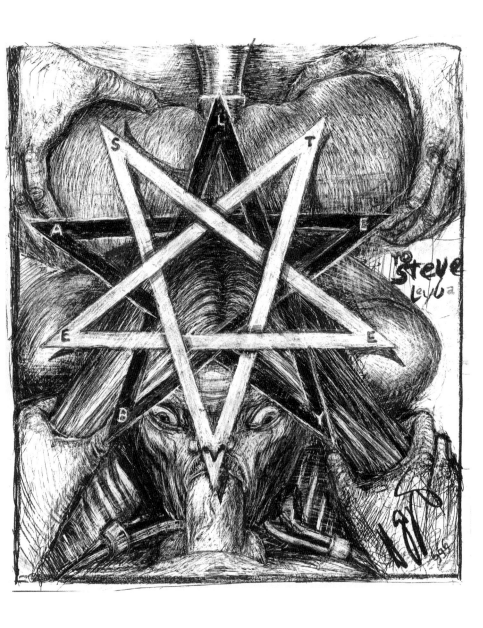

To Steve Johnson Leyba. Pencil on paper, 30 x 30 cm.
Introduction drawing for his book *Coyote Satan Amerika*, Last Gasp, 2001

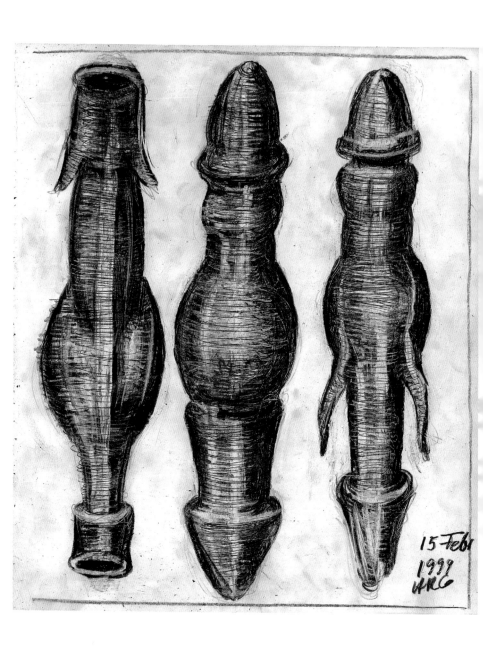

Untitled, 1999.
Pencil on paper, 30 x 30 cm

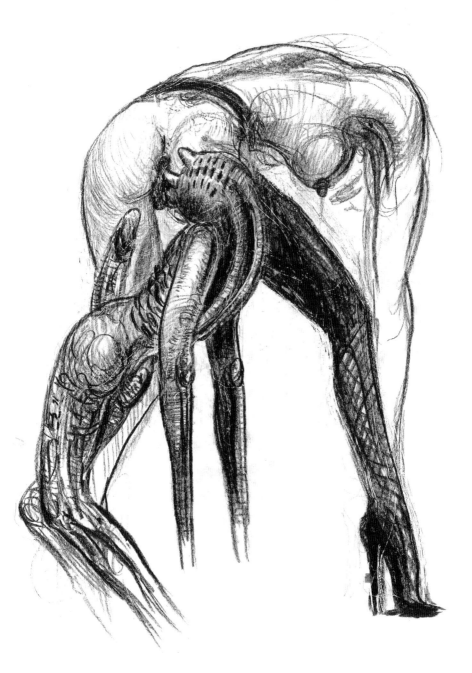

Untitled, 1998.
Pencil on paper, 30 x 30 cm

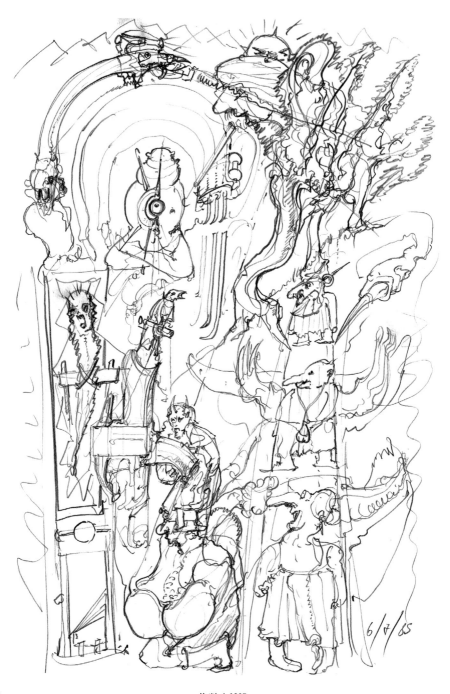

Untitled, 1985.
Pencil on paper, 42 x 30 cm

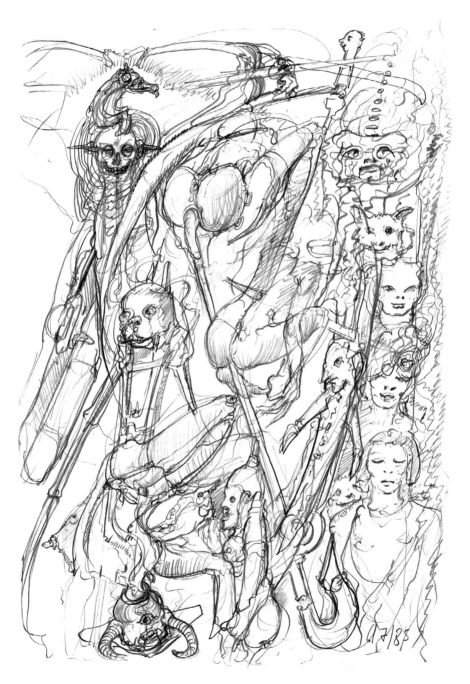

Untitled, 1985.
Pencil on paper, 42 x 30 cm

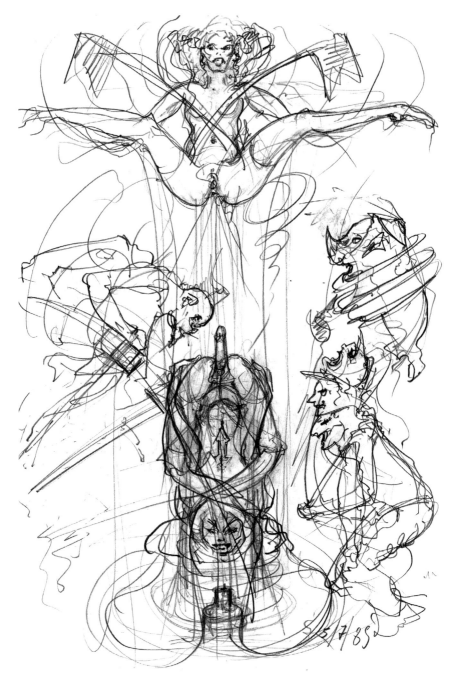

Untitled, 1985.
Pencil on paper, 30 x 21 cm

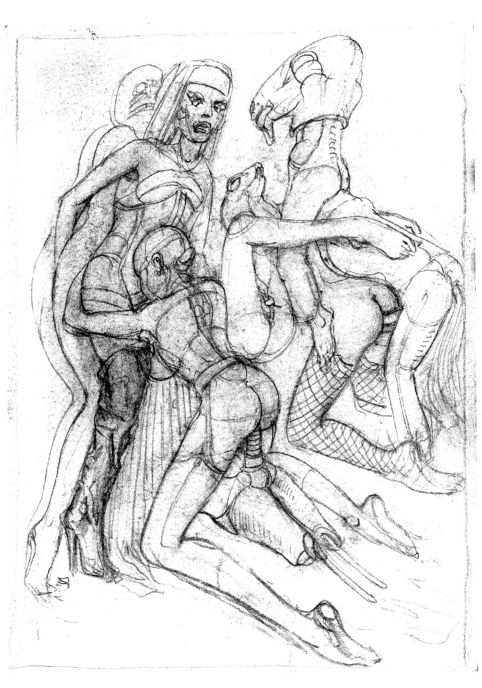

Untitled, 2000.
Pencil on paper, 30 x 21 cm

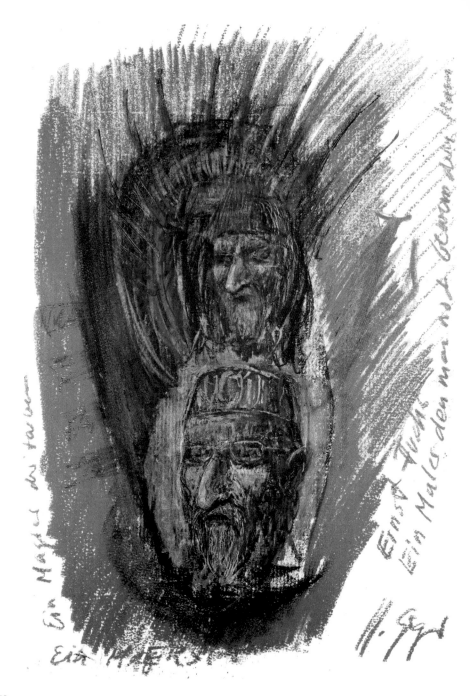

Ernst Fuchs, 1989.
Neocolor on paper, 30 x 21 cm

Wine label for *Noir et Blanc* exhibition, 1990.
Mixed media, 30 x 21 cm

84

Untitled.
Pencil on paper, 30 x 21 cm

Untitled, 1996.
Ball-point on paper, 30 x 21 cm

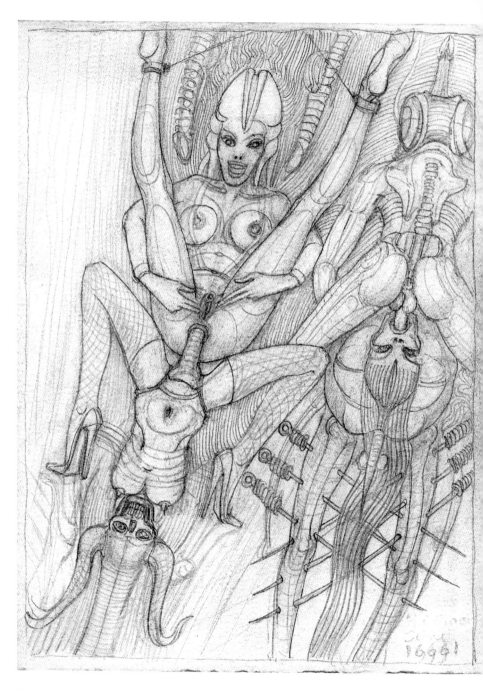

Untitled.
Pencil on paper, 30 x 21 cm

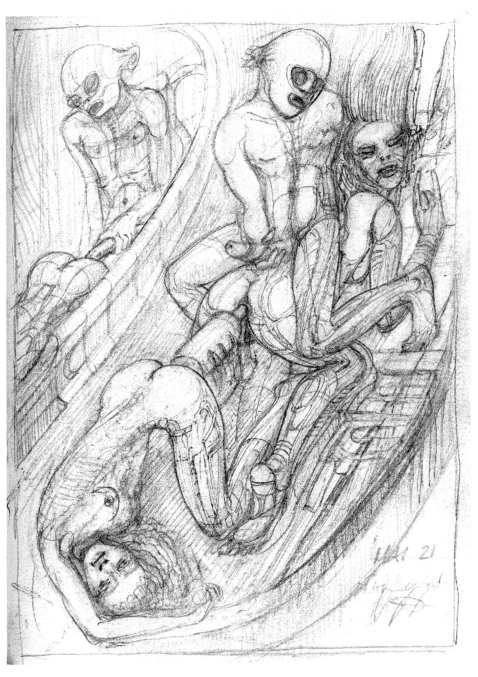

Untitled, 1999.
Litho-crayon on paper, 28 x 21 cm

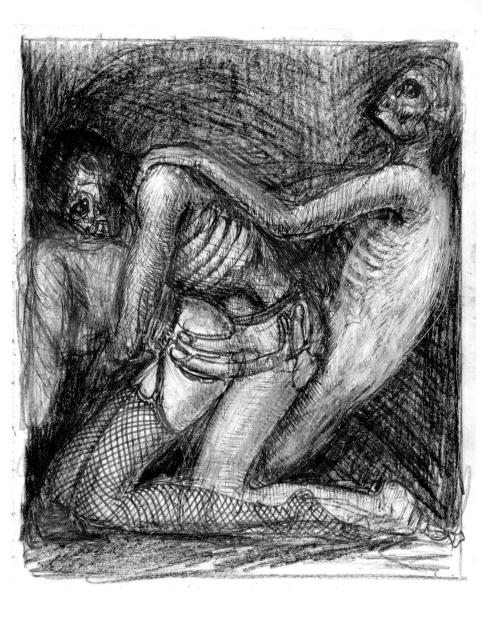

Untitled, 1999.
Litho-crayon on paper, 28 x 21 cm

Untitled.
Ink on paper, 30 x 21 cm

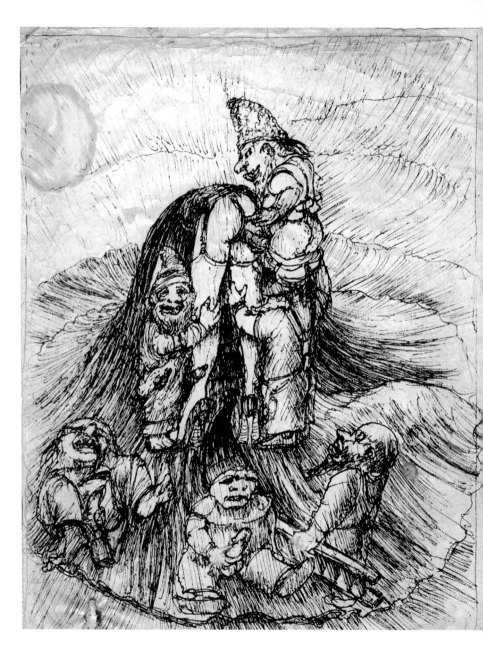

90

Untitled.
Ink on paper, 30 x 21 cm

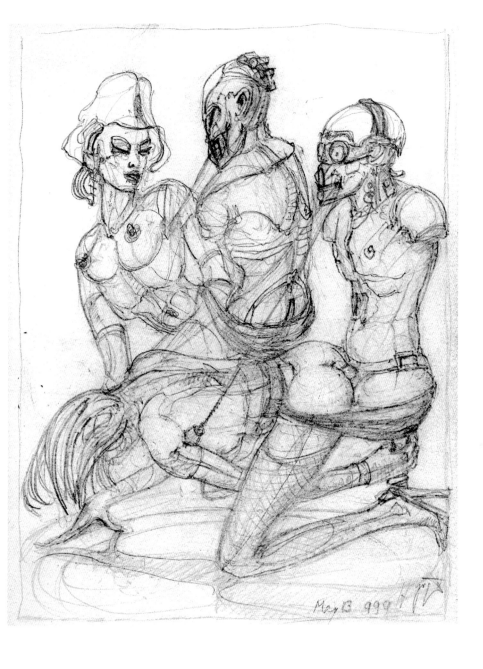

Untitled.
Pencil on paper, 28 x 21 cm

La Gruyère (sex and cheese), 2001.
Pencil on paper, 30 x 21 cm

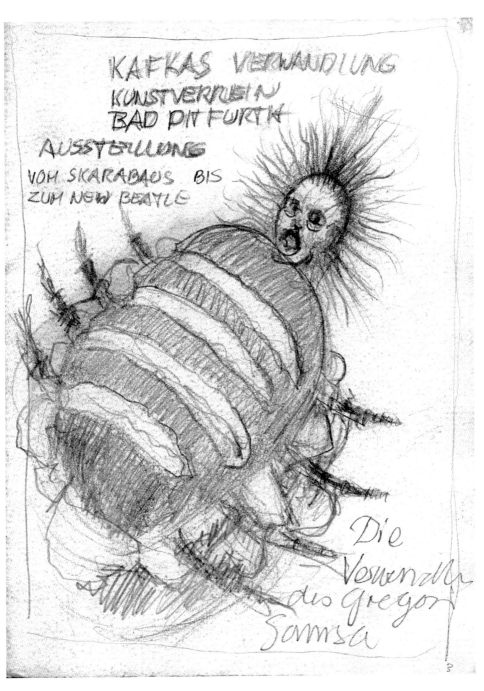

Metamorphosis by Kafka, 2000.
Zinc lithograph, 30 x 21 cm

Sketch of *Virus*, 2000.
Pencil and felt pen on paper, 30 x 21 cm

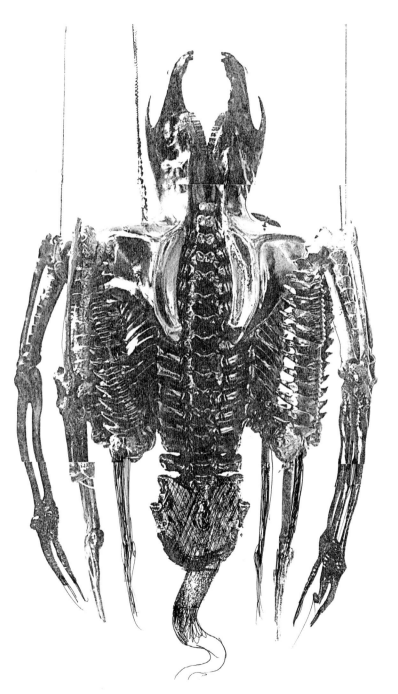

Virus, 2000.
Felt pen on photocopy, 30 x 20 cm

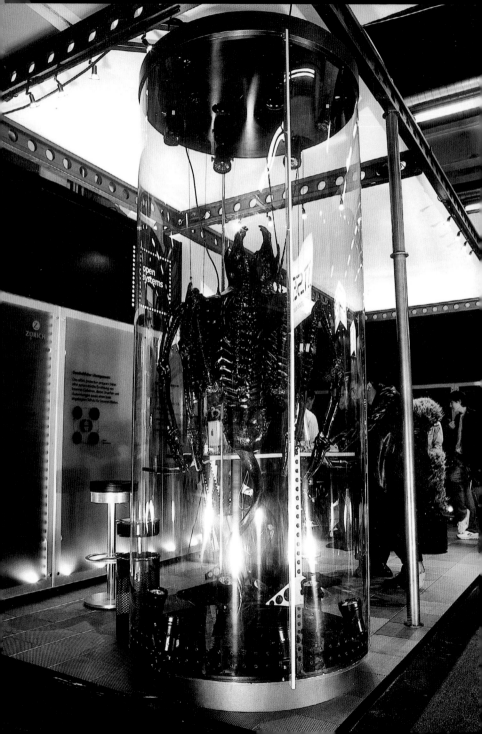

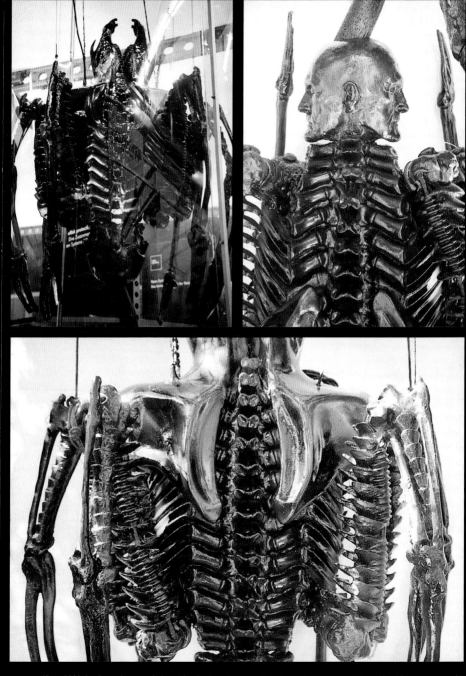

Virus, 2000. In glass tube commissioned for the Orbit Computer Fair, Basle, in fiberglass, 250 x 120 x 120 cm.
Photos: © 2000 Wolfgang Holz and HR Giger

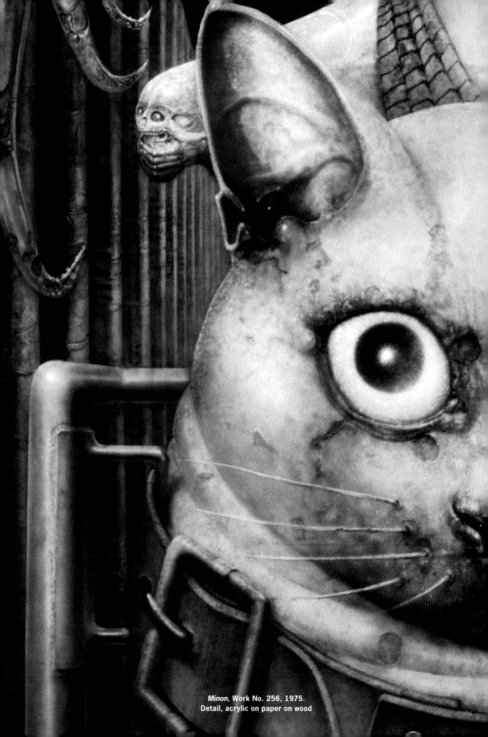

Minon, Work No. 256, 1975.
Detail, acrylic on paper on wood

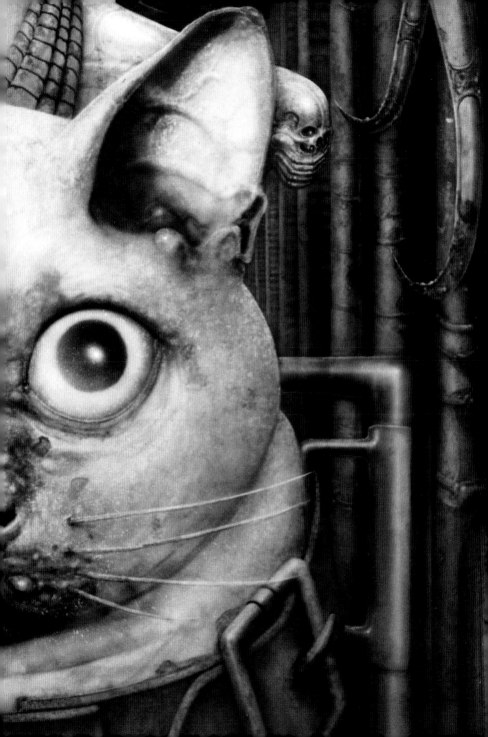

Visit to Dado's home, France.
Photos: © 1998 HR Giger

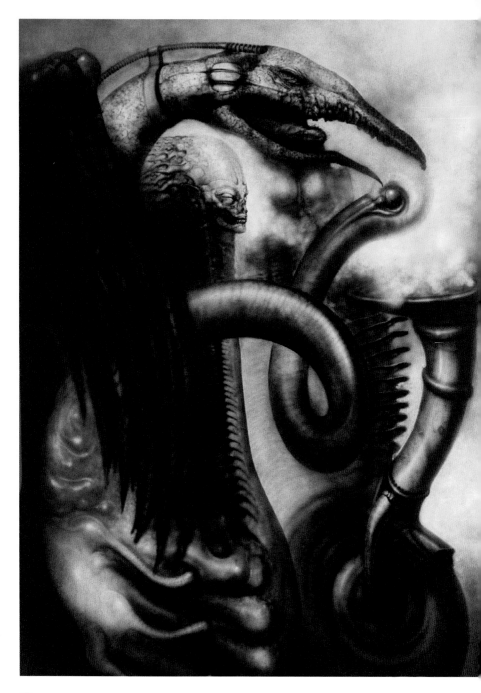

Mordor XII, Work No. 296, 1976.
Acrylic on paper on wood, 100 x 70 cm

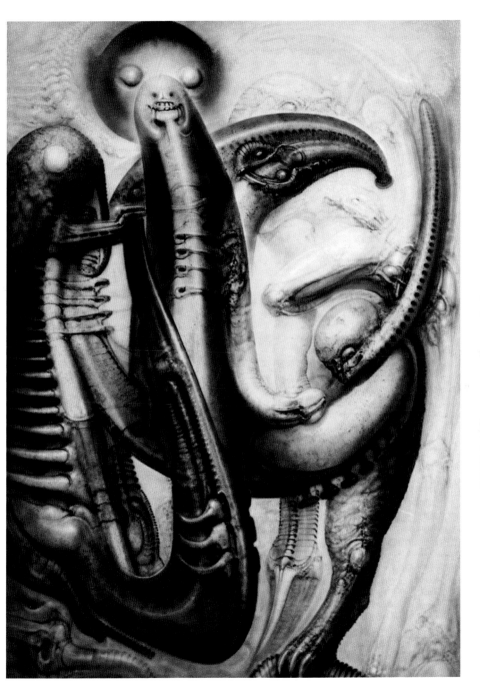

Mordor V, Work No. 281, 1975.
Acrylic on paper on wood, 100 x 70 cm

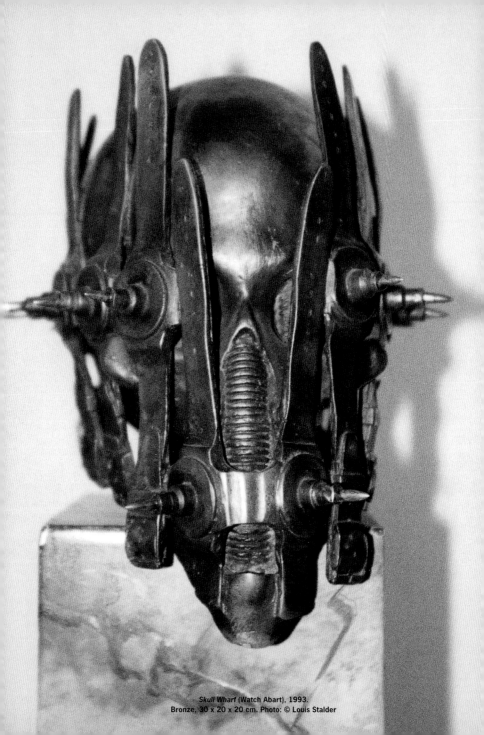

Skull Wharf (Watch Abart), 1993.
Bronze, 30 x 20 x 20 cm. Photo: © Louis Stalder

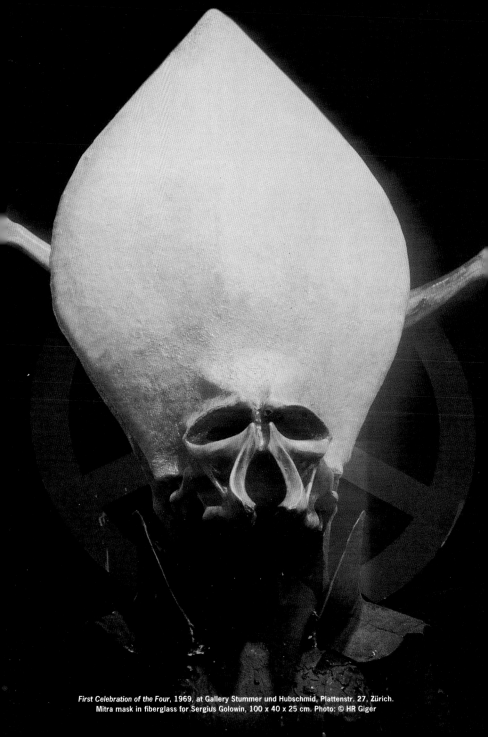

First Celebration of the Four, 1969, at Gallery Stummer und Hubschmid, Plattenstr. 27, Zürich.
Mitra mask in fiberglass for Sergius Golowin, 100 x 40 x 25 cm. Photo: © HR Giger

Sketches for *Hells Angels of Switzerland*, 1989.
Felt pen on paper, each: 42 x 30 cm

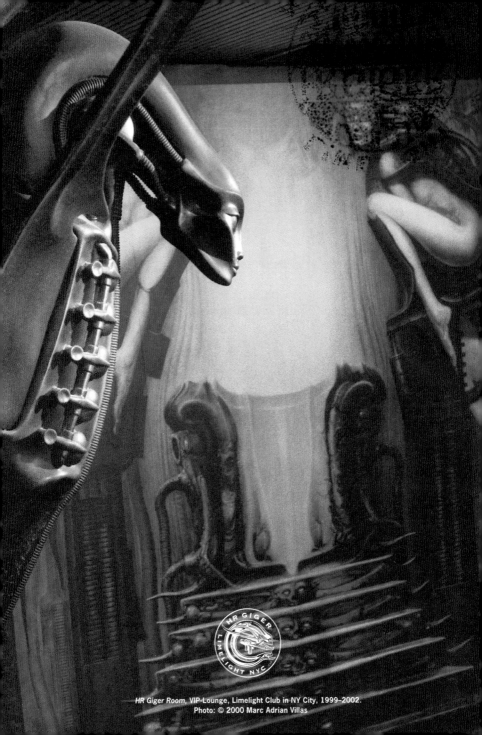

HR Giger Room, VIP-Lounge, Limelight Club in NY City, 1999–2002.
Photo: © 2000 Marc Adrian Villas

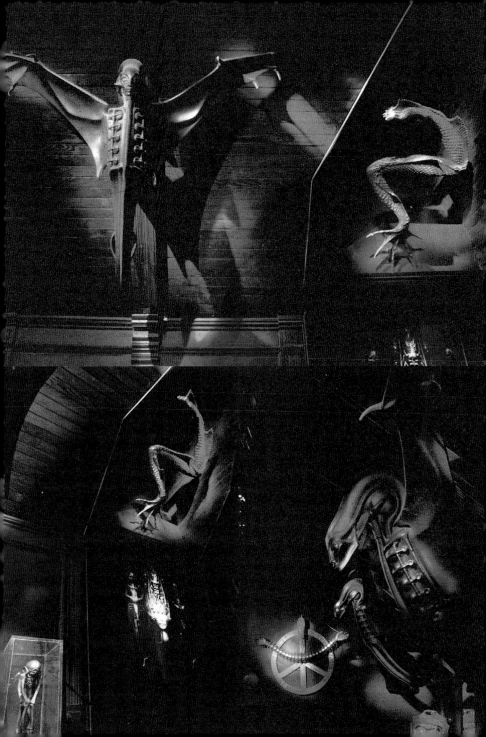

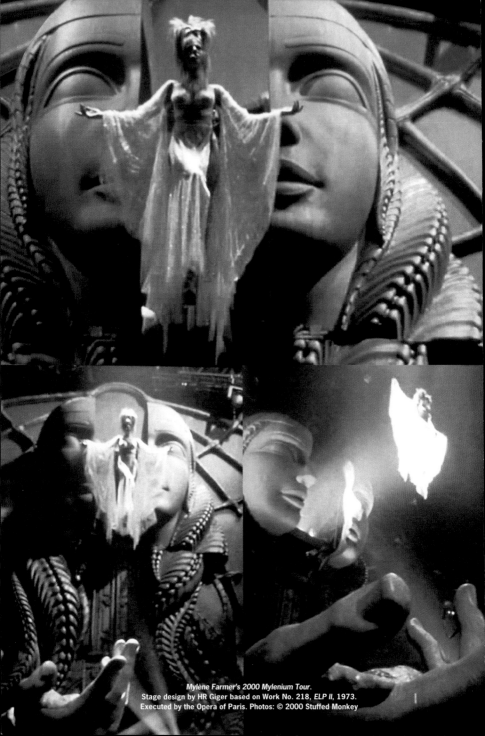

Mylène Farmer's 2000 Mylenium Tour.
Stage design by HR Giger based on Work No. 218, *ELP II*, 1973.
Executed by the Opera of Paris. Photos: © 2000 Stuffed Monkey

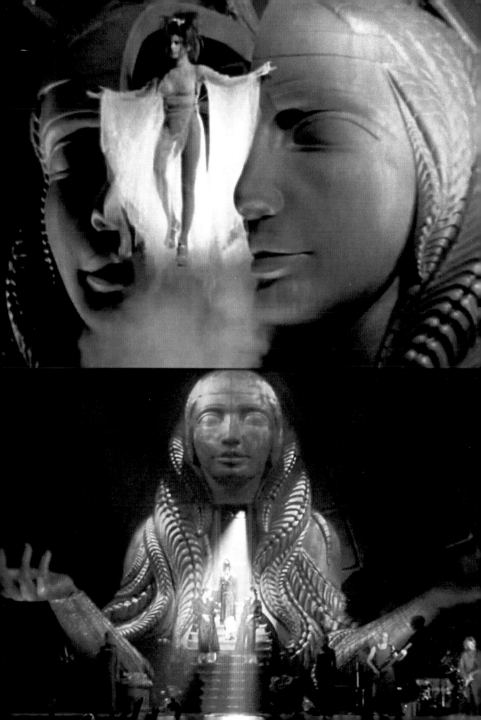

P

Q

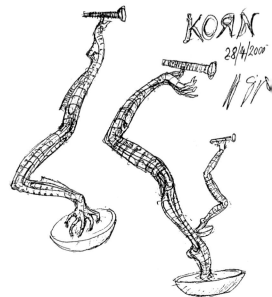

KOᴙN
28/4/2000

18/2/2000

KOᴙN
ИCTO

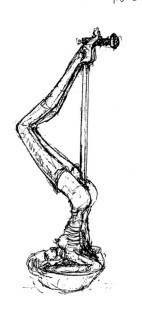

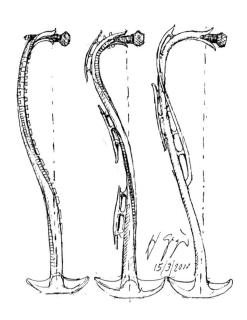

15/3/2000

Sketches for *KORN Microphone Stand*, 2000.
Pencil on paper, 30 x 21 cm

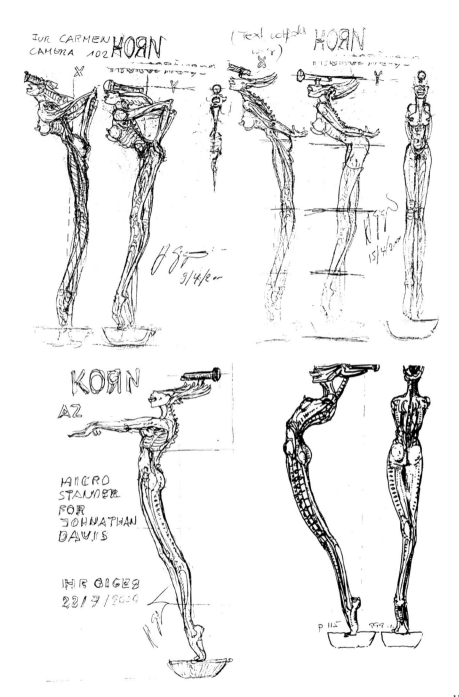

113

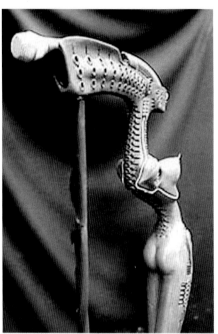

The KORN Mic-Stand

Since I listen mostly to Jazz these days, I first heard of KORN when I was contacted by Les, my agent, with the proposal to create a microphone stand for the band's lead singer, Jonathan Davis. After listening to their music, however, I quickly became a fan. The same day I accepted the project, I started sketching plantlike snakes and vertebrae mixed with technical elements. Meanwhile, Les taped KORN concerts for me in New York and Philadelphia, so I could get a feeling of how Jonathan performed. Telephoning from his dressing room, Jonathan gave me complete design freedom, asking only that the mic-stand be very erotic, Biomechanical and, most importantly, as movable as possible.

In July 2000, during KORN's European tour, Jonathan and his group visited the Giger Museum and then came to my home. I presented 3 design models, in miniature, that I made in resin. After the visit, I continued with more sketches and faxing them to Les. Before becoming an agent, he was an art director for many years, so he is very good at seeing what will work best for everyone. With his constructive critique, the mic-stand got thinner and better. I started a 1:1 clay model with Roni, my assistant, and Carmen, my girlfriend, and e-mailed photos of our progress to the USA. We also started a second, even slimmer model, keeping the first one for comparison.

When I was, finally, happy with the figure, we integrated it with Biomechanical elements, bullets, wires, and tubing. When the clay was finished, we gave it to the foundry and had a wax model made. I liked it so much that I ordered the aluminium to be cast and sent to Jonathan.

After testing the prototype, Jonathan decided that the original idea of a pop-up stand, weighed to spring back when it was pushed over, would not be practical in live performances. Otherwise, he was very happy with it, asking only for some minor adjustments. I hope Jonathan can work with my mic-stand with the same intensity as before, without being limited by it.

▲ Clay model for KORN Microphone Stand.
Photo: Wolfgang Holz
◄ Sketch for KORN mic-stand.
Photocopy and pencil on paper, 30 x 21 cm

Der Mikrophonständer für KORN

Da ich heute fast ausschließlich Jazz höre, lernte ich KORN erst durch meinen Agenten Les kennen. Er unterbreitete mir den Vorschlag, einen Mikrophonständer für Jonathan Davis, den Leadsänger der Band, zu entwerfen. Nachdem ich mir ihre Musik angehört hatte, wurde ich schnell Fan der Band. Ich stimmte dem Projekt zu und begann noch am selben Tag, eine Mischung aus pflanzenähnlichen Schlangen, Wirbelsäulen und technischen Elementen zu skizzieren. Derweil nahm Les für mich Konzerte der Band in New York und Philadelphia auf Video auf, damit ich ein Gespür dafür bekam, wie sich Jonathan auf der Bühne bewegte. Jonathan rief mich aus seiner Garderobe an und gab mir völlig freie Hand beim Design. Er bat lediglich darum, daß der Mikrophonständer sehr erotisch, biomechanisch und vor allem so beweglich wie möglich sein solle.

Während der Europatournee von KORN im Juli 2000 besichtigten Jonathan und die anderen Bandmitglieder das Giger Museum und besuchten mich anschließend zu Hause. Ich zeigte ihnen drei Miniaturmodelle, die ich aus Kunstharz angefertigt hatte. Nach dem Besuch zeichnete ich noch weitere Entwürfe und faxte sie an Les. Bevor er Agent wurde, war er lange Jahre Art Director gewesen, und hat daher ein gutes Auge für Proportionen. Dank seiner konstruktiven Kritik wurde der Mikroständer schlanker und besser. Mit meinem Assistenten Roni und meiner Freundin Carmen begann ich ein Modell in Originalgröße aus Ton zu formen. Per E-Mail schickte ich Fotos, die unsere Fortschritte zeigten, in die USA. Dann bauten wir ein zweites, noch schlankeres Modell und behielten das erste zum Vergleich.

Als ich schließlich mit der Grundform zufrieden war, integrierten wir biomechanische Elemente, Kugeln, Kabel und Röhren. Nachdem der Ton fest geworden war, gaben wir das Modell in die Gießerei und ließen ein Modell aus Wachs anfertigen. Es gefiel mir so gut, dass ich veranlasste, einen Aluminiumabguss zu machen und an Jonathan zu schicken.

Nachdem er den Prototyp getestet hatte, kam Jonathan zu dem Schluss, dass die ursprüngliche Idee eines Ständers, der so ausbalanciert war, dass er sich automatisch wieder aufrichtete, wenn er umgestoßen wurde, für die Live-Performance nicht geeignet war. Ansonsten war er sehr zufrieden und bat nur um geringfügige Änderungen. Ich hoffe, dass Jonathan mit meinem Mikroständer in der gewohnten Intensität arbeiten kann und sich durch ihn nicht eingeschränkt fühlt.

◄ HR Giger with Jonathan Davis and Müggi.
Photo: © 2000 Carmen Scheifele
► Fuse Gallery *HR Giger/NY City 2002* exhibition poster with KORN Microphone Stand. Edition of 5 in aluminum.
Photo: Louis Stalder, digital magic: Viktor Koen, concept: Les Barany

Le support microphone pour KORN

Comme je n'écoute plus que du jazz depuis quelque temps, j'ai
entendu parler pour la première fois de KORN par mon agent
Les qui m'a proposé de créer un support de microphone pour
le chanteur du groupe, Jonathan Davies. Après avoir écouté
leur musique, j'en suis aussitôt devenu un fan inconditionnel.
Le même jour où j'ai accepté le projet j'ai commencé à dessi-
ner des serpents et vertébrés en forme de plantes et en com-
binaison avec des éléments techniques. Entre-temps, Les avait
enregistré pour moi des concerts de KORN à New York et à
Philadelphie pour que je puisse me faire une idée du jeu de
scène de Jonathan. Ce dernier m'a un jour téléphoné de sa lo-
ge pour me donner une liberté totale pour la forme, deman-
dant simplement à ce que le support micro soit très érotique,
biomécanique et surtout aussi le plus mobile possible.

Lors de la tournée européenne de KORN, en juillet 2000,
Jonathan et les autres membres du groupe ont visité le Musée
Giger avant de venir chez moi. Je leur ai présenté trois modèles
miniatures que j'avais réalisés en résine. Après cette visite, j'ai
exécuté d'autres dessins que j'ai faxés à Les. Avant de devenir
mon agent, il a été pendant de nombreuses années directeur
artistique si bien qu'il est capable de voir très vite ce qui arran-
gera tout le monde. Grâce à sa critique constructive, le support
de micro est devenu plus mince et meilleur. J'ai donc commen-
cé à créer un modèle en argile à l'échelle 1:1 avec mon assis-
tant Roni et ma compagne Carmen et j'ai envoyé au fur et à me-
sure par e-mail aux Etats-Unis des photos de notre progression.
Nous avons commencé un deuxième modèle, plus fin encore,
en gardant le premier à titre de comparaison.

Lorsque j'ai enfin été satisfait de la forme, nous y avons
intégré des éléments biomécaniques, des balles, rouages et
tuyaux. Une fois le modèle en argile achevé, nous l'avons
transmis à la fonderie et obtenu un modèle en cire. Je l'ai telle-
ment aimé que j'ai commandé l'aluminium afin de pouvoir en-
voyer le support monté à Jonathan.

Après avoir testé le prototype, Jonathan a décidé que
l'idée initiale de faire en sorte que le micro rebondisse et re-
vienne en arrière lorsqu'on le pousse en avant n'était en fait
pas très pratique pendant un concert. Mais il était quand
même très satisfait et n'a demandé que quelques ajustements
minimes. J'espère que mon support de microphone permet à
Jonathan de s'exprimer avec autant d'intensité qu'avant et
sans être limité par lui.

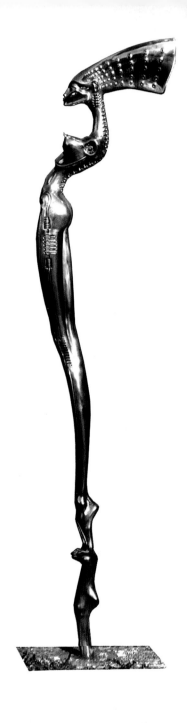

▸ *Nubian Queen*, 2002.
Edition of 6, cast aluminum, 183 cm, 12kg.
Photo: Wolfgang Holz

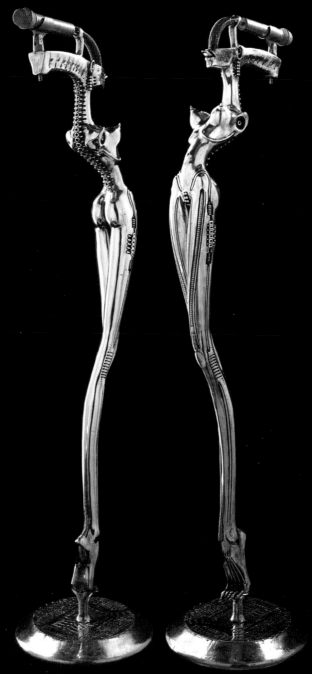

KORN Microphone Stand, 2000.
Edition of 5, cast aluminum, 150 cm. Photo: © 2000 Louis Stalder

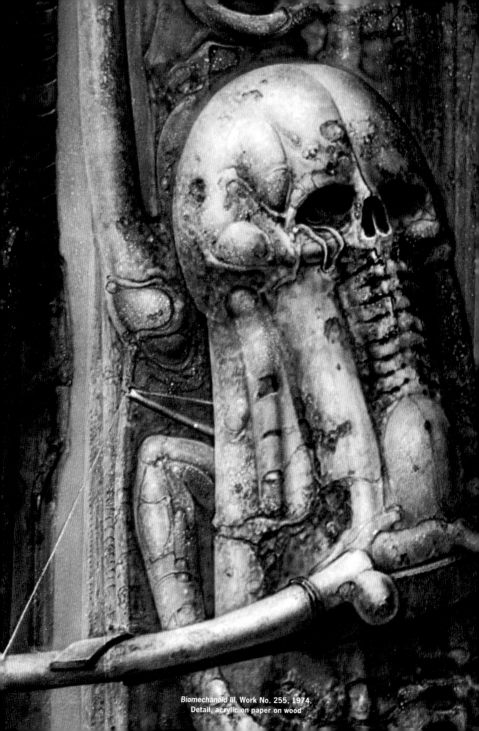

Biomechanoid III, Work No. 255, 1974.
Detail, acrylic on paper on wood

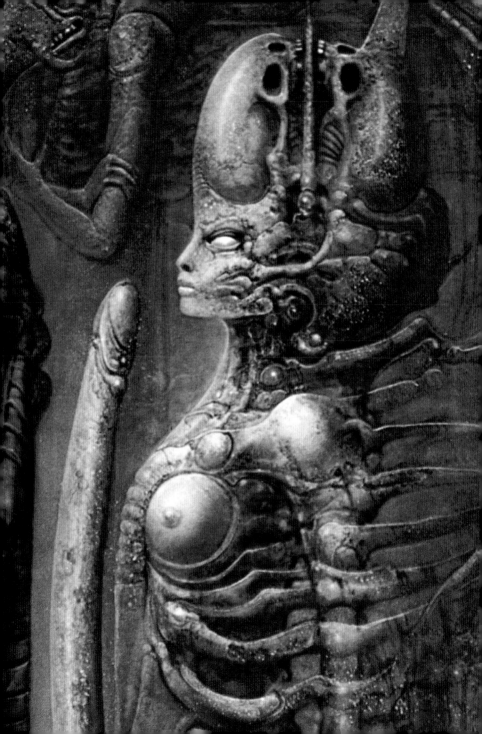

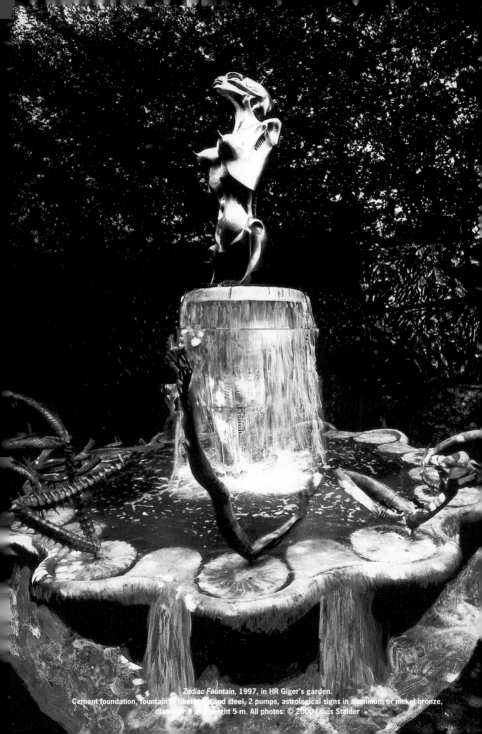

Zodiac Fountain, 1997, in HR Giger's garden.
Cement foundation, fountain in fiberglass and steel, 2 pumps, astrological signs in aluminum or nickel bronze,
diameter 6 m. Height 5 m. All photos: © 2000 Louis Stalder

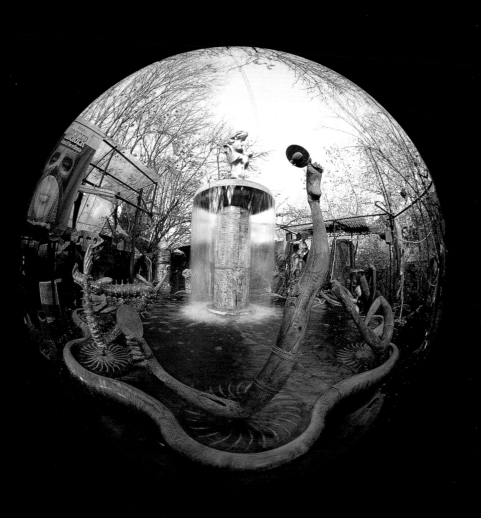

Fish-Eye lens view of Zodiac Fountain

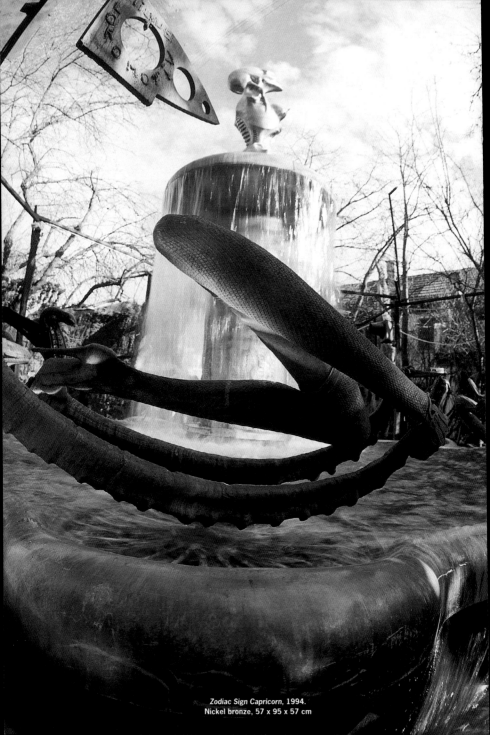

Zodiac Sign Capricorn, 1994.
Nickel bronze, 57 x 95 x 57 cm

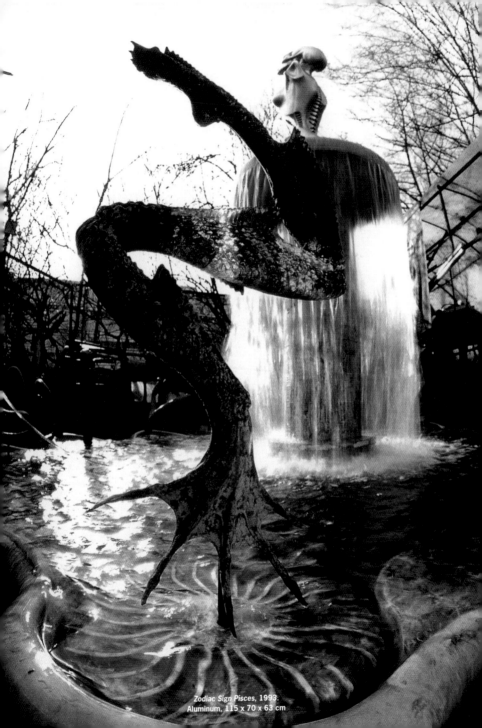

Zodiac Sign Pisces, 1993.
Aluminum, 115 x 70 x 63 cm

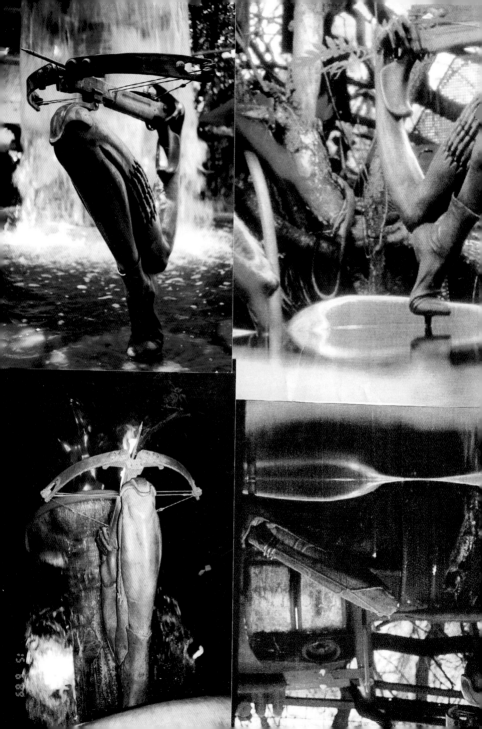

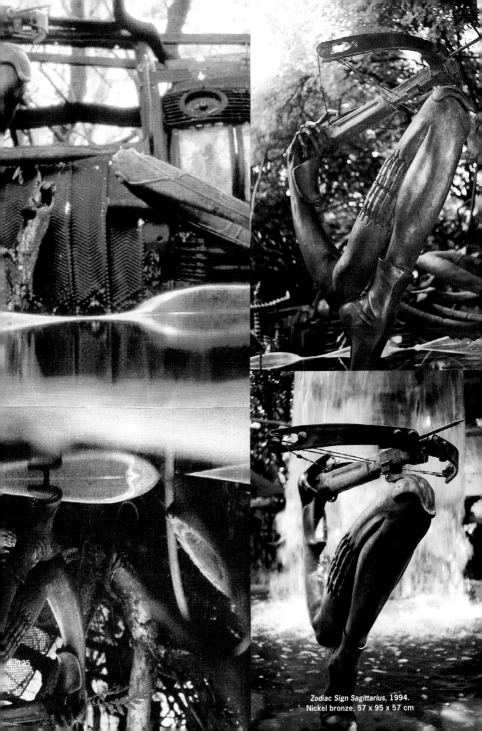

Zodiac Sign Sagittarius, 1994.
Nickel bronze, 57 x 95 x 57 cm

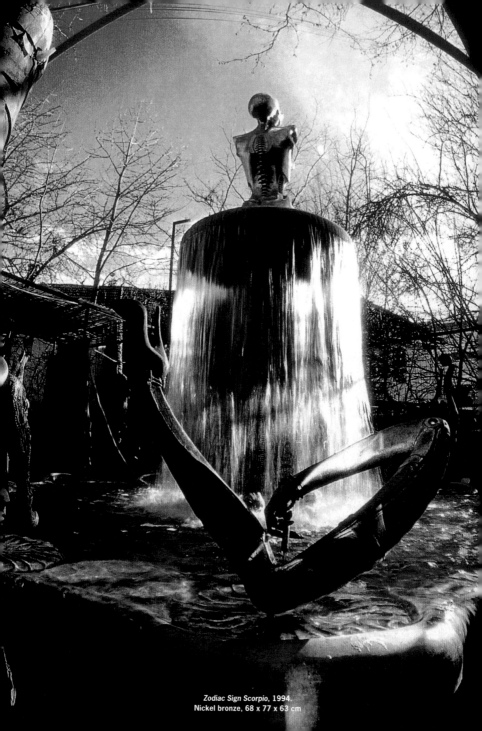

Zodiac Sign Scorpio, 1994.
Nickel bronze, 68 x 77 x 63 cm

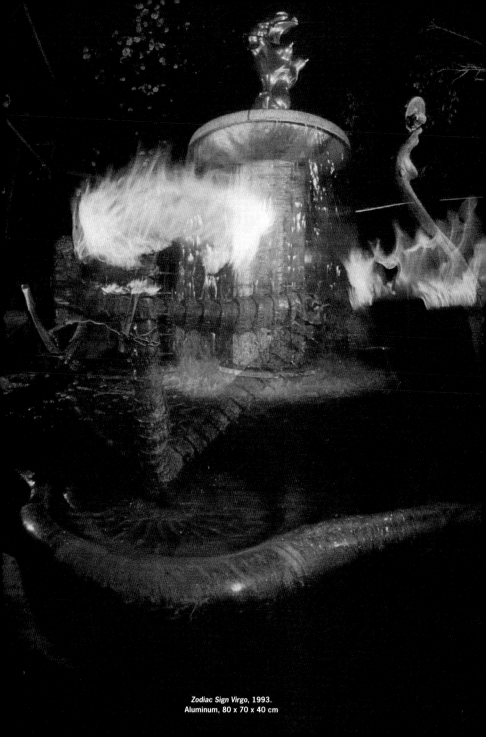

Zodiac Sign Virgo, 1993.
Aluminum, 80 x 70 x 40 cm

Claustrophobia is the center around which the stars of Giger's artistic universe revolve.
Die Klaustrophobie ist der Pol, um den sich die Gestirne des Gigerschen Kunstuniversums drehen.
La claustrophobie est le pôle autour duquel tournent les astres de l'univers artistique de Giger.

Giger's conceptions of space are based on the experience of being locked up in imaginings of the abyss. Both have darkness in common.
Gigers Raumkonzeptionen beruhen auf der Erfahrung des Eingeschlossenseins in Imaginationen des Abgrunds. Beiden ist die Finsternis gemeinsam.
Les conceptions spatiales de Giger sont basées sur l'expérience d'un enfermement dans les visions de l'abîme. Les deux ont les ténèbres en commun.

Although the scenarios are composed of the most rarified ingredients of horror and violence, the figures themselves are enveloped in an aura of somnambular peacefulness and a secret agreement on their desires.
Obgleich sich die Szenarien aus den seltensten Ingredenzien des Grauens und der Gewalt zusammensetzen, sind die Figuren in eine Aura somnambuler Friedlichkeit und ein geheimes Einverständnis über ihre Lüste gehüllt.
Bien que les scénarios soient composés à partir des ingrédients les plus rares de l'horreur et de la violence, les figures sont plongées dans une aura de paix somnambule et d'accord tacite par rapport à leurs désirs.

The repetitive patterns recall mon associations with skyscrapers. In keeping with their nature and origin, the stencils bring the industrial factor into the picture, the machine-automaton and the electronic factor. Parts of some pictures resemble automatic weapons, others saxophone figures. Machine, violence, jazz. The lyrical condensation of the abysses and the magic of the urban hyper-structure that is New York.
Die repetitiven Muster wecken indessen nicht nur Assoziationen an Scyscrapers. Gemäß ihrer Natur und Herkunft setzen die Schablonen den industriellen Faktor ins Bild, das Maschinen-, Automatenhafte, Elektronische. Manche Bildpartien haben Ähnlichkeit mit automatischen Waffen, andere mit Saxophontastaturen. Maschine, Gewalt, Jazz. Die lyrische Verdichtung der Abgründe und des Zaubers der urbanen Hyper-Struktur New York.
La répétition des motifs ne renvoie cependant pas seulement à l'image de gratte-ciel. Selon leur nature et provenance, les modèles mettent en avant le facteur industriel, la machine, l'automate, l'appareil électronique. De nombreuses parties de l'image ressemblent à des armes automatiques, d'autres aux touches d'un saxophone. Machine, violence, jazz – une densification lre thayrique de l'abîme et de la magie de l'hyperstructure urbaine qu'est New York.

Herbert M. Hurka: *Aliens Darkness – die andere Finsterni*

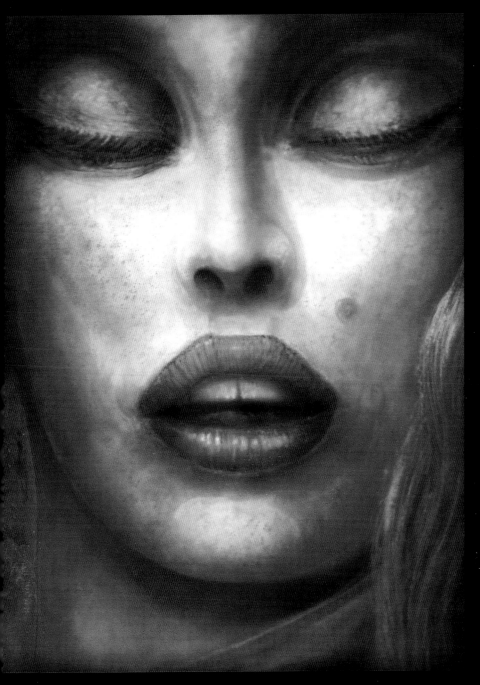

Irena, 1985.
Acrylic on paper, 100 x 70 cm

My biomechanoids, the main characters of my *Mystery of San Gottardo*, are organisms with no heads, each reduced simply to an arm and a leg. The twins' brains – or rather, their replacement (computers run via electricity and a nutrient solution) – which control everything are located at the juncture where the left upper arm seamlessly connects to the right upper thigh. Biomechanoids have gills and small circulatory systems which are cleansed through sweating. These organisms have sensors and communicate with each other telepathically. With humans they sign like deaf-mutes.

Every biomechanoid was once a normal human being until divided into three beings when the extremities were removed. The main part, the torso and head, is the most unhappy of the three, because it has to spend the rest of its life as an amputee in a rolling cart and usually serves only as a biomechanoid trainer. It does so, hoping one day to be reunited with its extremities. The two arm-leg constructs, on the other hand, are ecstatic to not have to heed the brain anymore, since they were sick of their existence as slaves.

from: *The Mystery of San Gottardo* by HR Giger

Meine Biomechanoiden, die Hauptdarsteller meines *Mystery of San Gottardo*, sind Organismen ohne Kopf, schlicht auf Arm und Bein reduziert. An den Stellen, wo bei diesen Zwillingen der linke Oberarm nahtlos in den rechten Oberschenkel mündet, beziehungsweise der rechte Oberarm in den linken Oberschenkel, befinden sich deren Gehirne, besser gesagt deren Ersatz (mittels Strom und Nährlösung betriebene Computer), die alles kontrollieren. Diese Biomechanoiden besitzen Kiemen und einen kleinen Blutkreislauf, der durch Schwitzen gereinigt wird. Mit Sensoren ausgestattet, verständigen sich diese Organismen untereinander durch Gedankenströme. Mit den Menschen hingegen durch Zeichen, wie sie auch die Taubstummen verwenden.

Jeder Biomechanoid war zuerst einmal ein normaler Mensch, der durch das Abtrennen der Gliedmassen in drei Lebewesen gegliedert wurde. Da ist natürlich das Kernstück, der Rumpf samt Kopf, welches das unglücklichste der drei Wesen darstellt, weil es amputiert seine Zukunft im Rollwagen verbringen muß und meist nur als Biomechanoiden-Ausbilder figuriert. Dies, um so seinen Extremitäten vielleicht wieder einmal zu begegnen. Die beiden Arm-/Beinkonstruktionen hingegen sind froh, nicht mehr dem Hirn folgen zu müssen, da sie das Sklavendasein satt hatten.

aus: *The Mystery of San Gottardo* von HR Giger

Les hommes biomécaniques, les biomécanoïdes, acteurs principaux de mon *Mystery of San Gottardo*, sont des êtres hybrides démunis de têtes et dont le corps est réduit simplement à un bras et une jambe. Le cerveau de ces jumeaux, ou plutôt ce qui leur sert de cerveau et qui contrôle tout (des ordinateurs alimentés par courant électrique et une nourriture liquide), est situé au point d'intersection entre le bras gauche, relié directement à la jambe droite, et le bras droit, relié à la jambe gauche. Ces biomécanoïdes sont munis de branches et d'une circulation sanguine réduite qui s'autonettoie grâce à la transpiration. Equipés de capteurs sensoriels, ces êtres animés communiquent entre eux par des flux de pensées et avec les hommes au moyen de signes, un peu comme le langage des sourds-muets.

Chacun de ces biomécanoïdes était autrefois un homme normal qui a généré trois êtres distincts par l'ablation et la division de ses membres. L'être issu de la partie centrale du corps, le torse et la tête, est naturellement la plus malheureuse des trois créatures générées puisque, amputée de la sorte, son avenir se réduit à l'horizon d'un fauteuil roulant et il ne sert guère que comme instructeur aux autres biomécanoïdes. De cette façon, peut-être aura-t-il un jour la chance de retrouver à nouveau ses propres extrémités. Quant aux deux autres mutants, les bras et les jambes, ils sont ravis d'être libérés des ordres du cerveau et de quitter ainsi leur existence d'esclaves.

extrait de : *The Mystery of San Gottardo* de HR Giger

▸ **The Mystery of San Gottardo (Searching for Brothers and Sisters), 1994.**
Ink on paper.

The Mystery of San Gottardo

R L

L R

L R

R L

© by HRGiger
5.2.94. ARh+
ARMANDO

R L
ARM BEINDO BEINARMDO

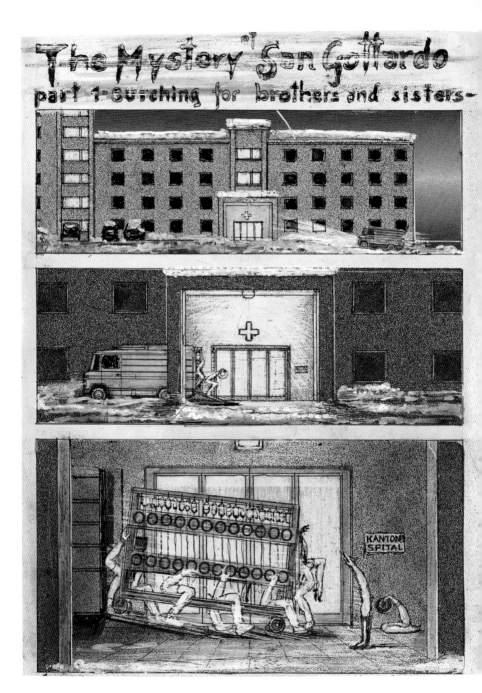

The Mystery of San Gottardo (Searching for Brothers and Sisters), 1994.
Ink on paper.

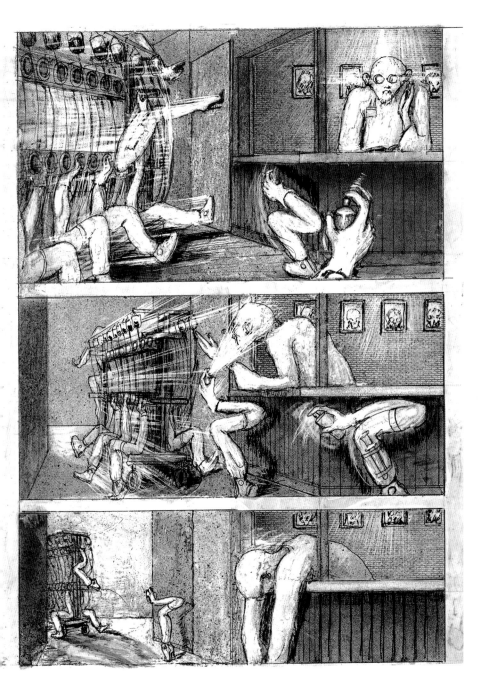

The Mystery of San Gottardo (Searching for Brothers and Sisters), 1994.
Ink on paper.

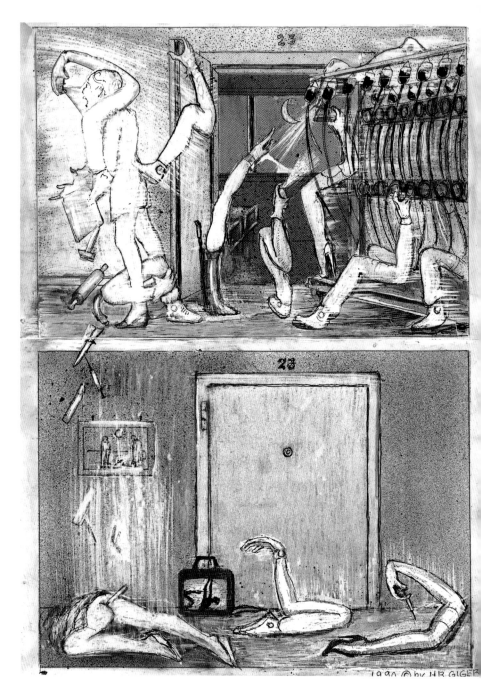

The Mystery of San Gottardo (Searching for Brothers and Sisters), 1994.
Ink on paper.

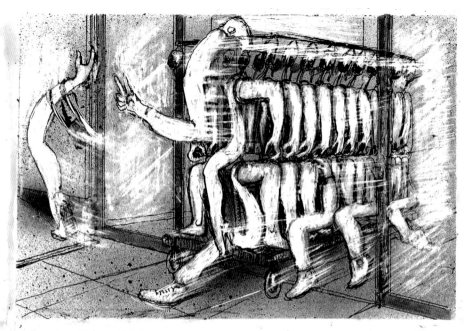

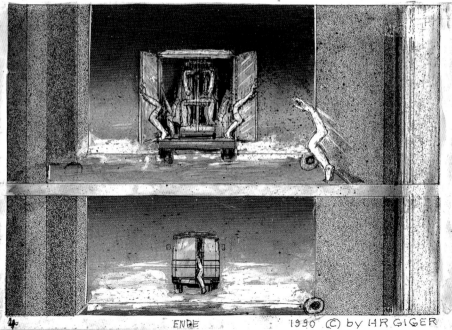

The Mystery of San Gottardo (Searching for Brothers and Sisters), 1994.
Ink on paper.

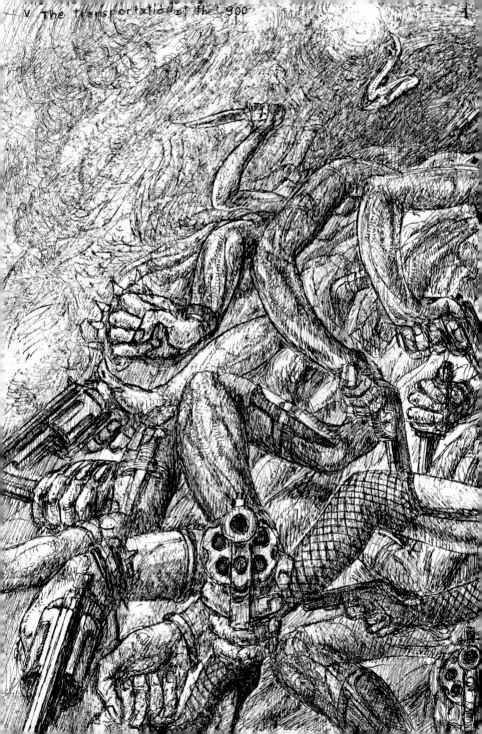

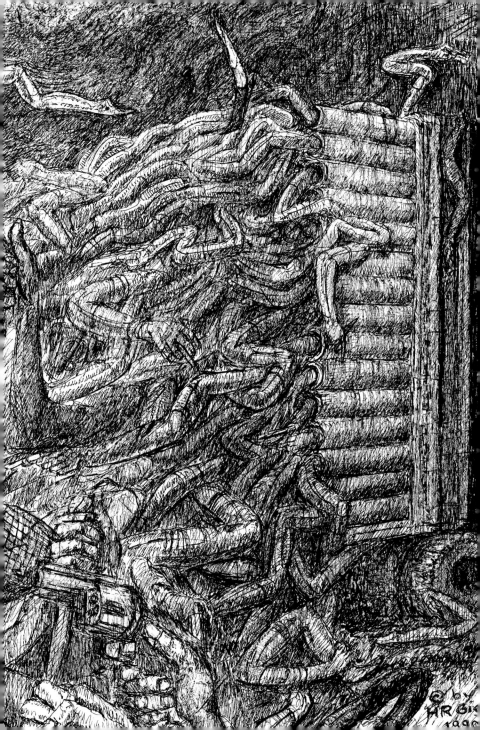

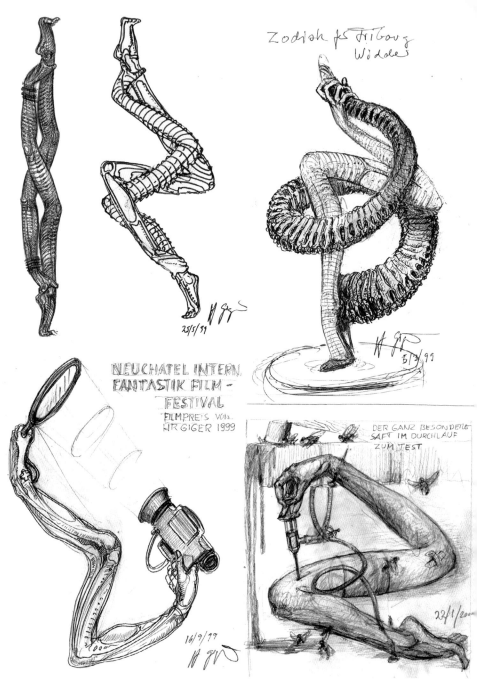

Within the image, the following handwritten text appears:

Zodiah fc Fribourg
Widder

25/5/99

5/3/99

NEUCHATEL INTERN.
FANTASTIK FILM -
FESTIVAL
FILMPRE'S VON
HR GIGER 1999

16/9/99

DER GANZ BESONDERE
SAFT IM DURCHLAUF
ZUM TEST

22/1/2000

Top left: *Biomechanoid Twins*, 1999. Felt pen on paper, 15 x 10.5 cm. Top right: *Aries sketch*, 1999. Pencil on paper, 30 x 21 cm.
Bottom left: Film festival award sketch, *Biomechanoid Narcissus*, 1999. Pencil on paper, 30 x 21 cm.
Bottom right: *Bloodplayer*, 2000. Pencil on paper, 30 x 30 cm

The Professionals

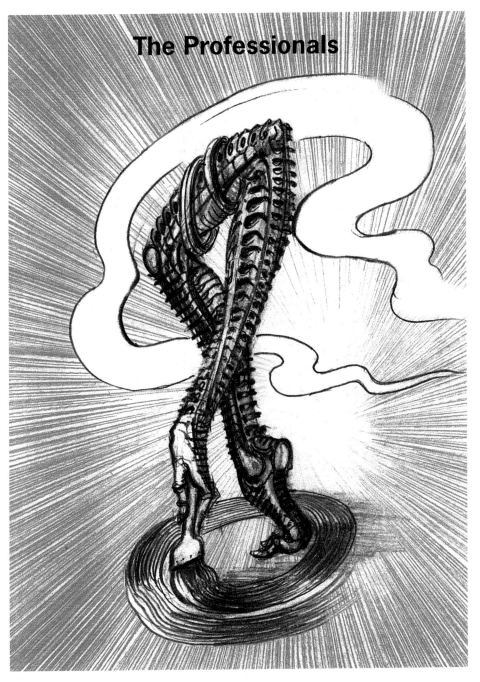

Biomechanoid Painter, 2001.
Limited edition print of 99, 30 x 21 cm

▲ Sketch for the *Biomech-Car-Mechanic*, 2001, felt pen on paper, 30 x 21 cm

▸ Top left: *Biomech Bricklayer*, 2001. Top right: *Biomech Phone Repairman*, 2001. Both in pencil on paper, 30 x 21 cm
Bottom left: *Biomech Bricklayer*, 2001. Bottom right: *Biomech Loading-dock Worker*. Both pencil on paper, 30 x 21 cm

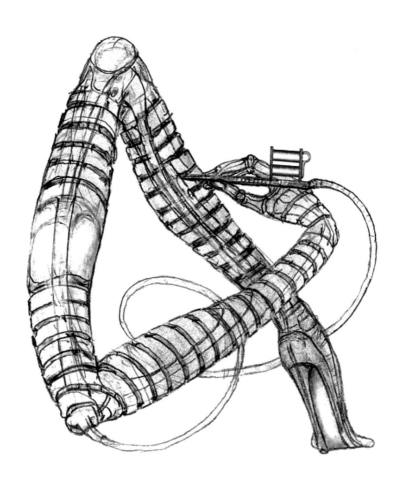

LAUSANNE · 2001

Biomech Tattoo Artist, 2001, for Tattoo Festival at Lausanne, Switzerland.
Pencil on paper, 30 x 21 cm

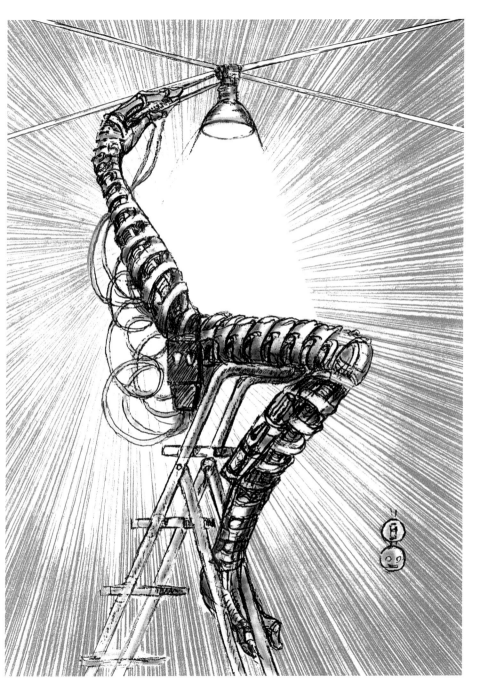

Biomech Electrician, 2001.
From the *Professionals* portfolio, edition of 99, 8 giclee prints, 42 x 30 cm

▲ *Biomech Stock-Boy*, 2001. Pencil on paper, 30 x 21 cm

▸ Top left and right: *Biomech Plumber*. Pencil on paper, 30 x 21 cm
Bottom left: *Biomech Construction Worker*, 2001. Bottom right: *Biomech Architect*. Both pencil on paper, 30 x 21 cm

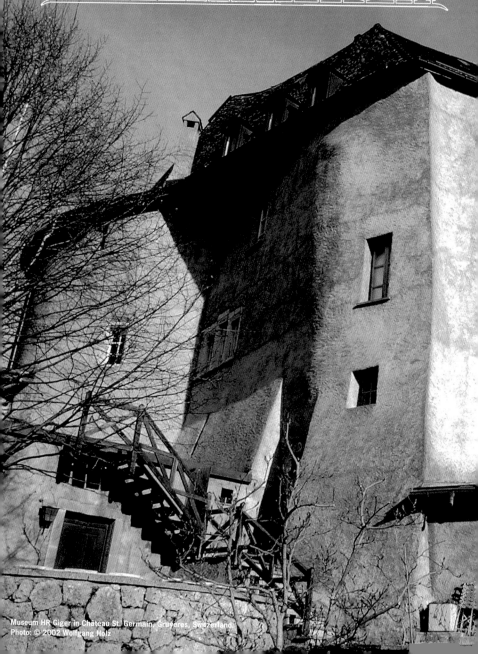

MUSEUM HR GIGER

Museum HR Giger in Château St. Germain, Gruyères, Switzerland.
Photo: © 2002 Wolfgang Holz

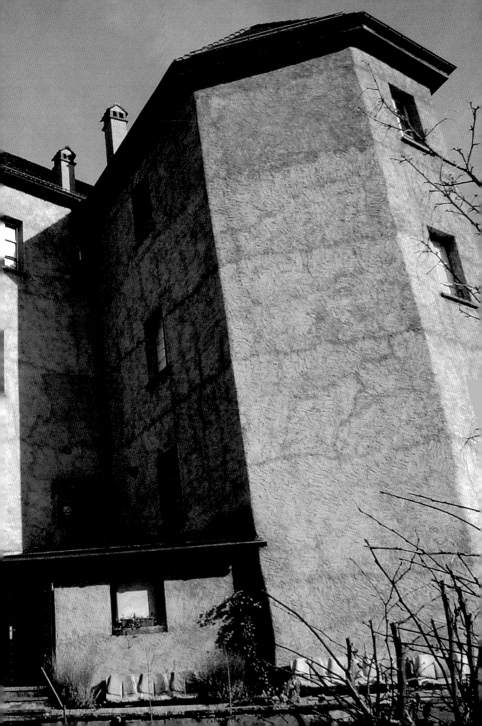

Museum HR Giger – Entstehung und Werdegang

In 1990, on the occasion of his 50th birthday, HR Giger was invited to mount a major retrospective of his work at Château de Gruyères. The exhibition, *Alien dans ses meubles*, was a huge success and was attended by 110,000 visitors. After many visits to the medieval village of Gruyères, HRG fell in love with this wondrous region. And when he heard from Etienne Chatton and Barbara Gawrysiak that the fortress structure further below, the Château St. Germain, was up for sale, the idea to establish his own museum and a Center for Fantastic Art was born: on September 11, 1997, he acquired the Château. With the help of architect Roger Cottier and Museum Director Barbara Gawrysiak and the invaluable support of many co-workers, the museum opened (most of) its doors on June 21, 1998.

Certain long-term tenants posed unexpected problems. By order of the court, they managed to halt construction twice. A lady of extraordinarily full proportions blocked what was to be the main entrance – for two years! So an expensive temporary side entrance had to be built into the tower. The frustration caused by these circumstances, once again, fired Giger's imagination. Within a very short time, thirty drawings dedicated to the *Ghost of Château St. Germain* were created. Among other amusements, they feature the delights of the most wear-and-tear-resistant oversize underwear.

When the globular ghost finally gave up its space in 2000, the much-longed-for main entrance was finally built and the upper portion of the wall in the forecourt was torn down and replaced by a ramp.

In 2001, after doing a commendable job, Barbara Grawysiak resigned from her position as Director. Her enthusiasm and passion during the inception of the museum will forever make her one of its cornerstones. Giger's girlfriend Carmen together with Ingrid Lehner and Liliane Perroud assumed the new management.

On permanent display at the Museum is the most extensive collection of artworks from Giger's different creative periods. In addition to such seminal works as *The Spell* and *Passages* series, the museum houses, intact, most of Giger's film designs, including the artwork for *Alien* and *Alien 3*, *Dune*, *Species*, *Poltergeist II*, and *The Mystery of San Gottardo*.

Museum HR Giger – Entstehung und Werdegang

Im Jahr 1990 wurde HR Giger anlässlich seines 50. Geburtstages zu einer großen Ausstellung im Schloß Gruyères eingeladen. Die Retrospektive *Alien dans ses meubles* wurde zu einem vollen Erfolg und konnte an die 110 000 Besucher verzeichnen.

Nach vielen Aufenthalten im mittelalterlichen Städtchen Gruyères verliebte sich HR Giger in die wunderbare Gegend. Und als er durch Etienne Chatton und Barbara Gawrysiak vernahm, dass die weiter unten befindliche Festungsbaute, Schloß St. Germain, zum Verkauf stand, wurde die Idee geboren, dort ein eigenes Museum und ein Zentrum für Phantastische Kunst einzurichten: Am 11. September 1997 ersteigerte er das Château. Mit Hilfe des Architekten Roger Cottier, der tatkräftigen Unterstützung der Directrice Barbara Gawrysiak und dem unschätzbaren Einsatz der vielen Mitarbeiter gelangte das Museum am 21. Juni 1998 zu seiner ersten (Teil-)Eröffnung.

Unerwartete Probleme stellten die langjährigen Mieter dar. Unter Einberufung des Gerichts brachten sie es fertig, zwei Baustopps zu erwirken. Eine Dame von ungemein fülliger Statur blockierte nun weiterhin den ursprünglich vorgesehenen Haupteingang – für zwei volle Jahre. Deshalb musste im Turm ein aufwendiger provisorischer Eingang gebaut werden. Die durch diese Umstände angestaute Wut aber beflügelte einmal mehr HR Gigers Phantasie: In kurzer Zeit entstanden an die dreißig Zeichnungen, gewidmet dem *Schlossgespenst von St Germain*. Unter vielen anderen Köstlichkeiten finden sich hier auch die Wonnen strapazierfähigster Megaunterwäsche.

Als im Jahr 2000 das Kugelgespenst endlich seinen Platz freigab, konnte der lang ersehnte Haupteingang realisiert werden. Der obere Teil der Vorplatzmauer wurde bis zur Treppe abgerissen und durch eine Rampe ersetzt.

Barbara Gawrysiak trat Ende 2001 nach großartigem Einsatz als Directrice zurück. Ihre Begeisterung und Passion während der ganzen Entstehungszeit des Museums ließen sie zur tragenden Seele des Museums werden. Die Leitung übernahmen nach ihrem Rücktritt HR Gigers Freundin Carmen sowie Ingrid Lehner und Liliane Perroud.

Im weitläufigen Museum ist eine Vielzahl von HR Gigers Werken aus den verschiedensten Schaffensperioden ausgestellt. Neben Schlüsselwerken wie *The Spell* und *Passagen* finden sich auch viele Werke aus dem Film-Design: unter anderem aus *Alien* und *Alien 3*, *Dune*, *Species*, *Poltergeist II* oder *The Mystery of San Gottardo*.

Museum HR Giger –
Naissance et évolution

En 1990, à l'occasion de son 50ᵉ anniversaire, HR Giger invite le public à une grande exposition au château de Gruyères. La rétrospective intitulée *Alien dans ses meubles* est un immense succès et attire environ 110 000 visiteurs.

Après de nombreux séjours dans la petite ville médiévale de Gruyères, HR Giger tombe littéralement amoureux de cette région. Lorsque Etienne Chatton et Barbara Gawrysiak lui apprennent que la fortification inférieure, le château St-Germain, est à vendre, l'idée naît d'y installer un musée et un centre d'art fantastique. Il acquiert finalement le château lors d'une vente publique le 11 septembre 1997. Grâce au savoir-faire de l'architecte Roger Cottier, le soutien énergique de la directrice Barbara Gawrysiak et l'engagement inestimable de tous les collaborateurs, le musée ouvre ses portes le 21 juin 1998.

Les anciens locataires du château ont toutefois posé des problèmes inattendus. Par deux fois, ils ont saisi la justice pour faire arrêter les travaux. Une dame aussi volumineuse qu'encombrante a ainsi empêché pendant deux longues années l'aménagement de l'entrée principale. Il a fallu construire à grands frais une entrée provisoire à l'intérieur de la tour. Mais la colère provoquée par ces contrariétés inspirera une fois de plus la fantaisie de HR Giger : en peu de temps, il réalise en effet une trentaine de dessins consacrés au *Fantôme du château de St-Germain*.

Lorsqu'en 2000 le fantôme sphérique a enfin libéré les lieux, la voie était ouverte pour réaliser l'entrée principale. La partie supérieure du mur a été démolie jusqu'à l'escalier et remplacée par une passerelle.

Après s'être engagée corps et âme dans le projet, la directrice, Barbara Gawrysiak, a donné son congé fin 2001. Grâce à son enthousiasme et sa passion, elle aura été, pendant toute la période de naissance du musée, sa véritable âme porteuse. La direction est dorénavant conjointement assurée par Carmen, la compagne de Giger, Ingrid Lehner et Liliane Perroud.

Le musée spacieux héberge de nombreuses œuvres de HR Giger de différentes périodes de création. Hormis des œuvres-clés, comme *The Spell* et *Passages*, le spectateur rencontre également de nombreux travaux liés au cinéma, parmi eux *Alien* et *Alien 3*, *Dune*, *Species*, *Poltergeist II* ou encore *The Mystery of San Gottardo*.

Mystery Passage on the 2nd floor of the museum.

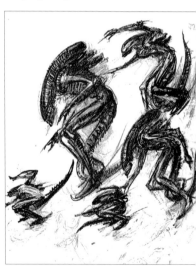

Alien Studies, 1998.
Neo-color on paper, 21 x 21cm

► *Bulwark Gate* to Château St. Germain, 1998.
Pencil on paper, 30 x 21 cm

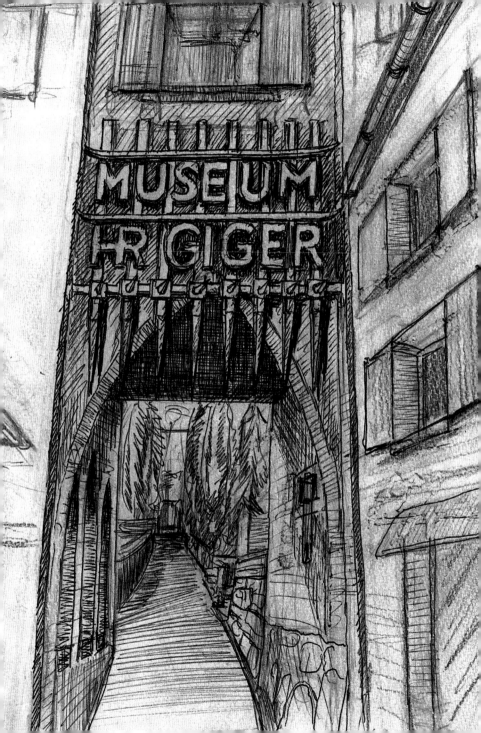

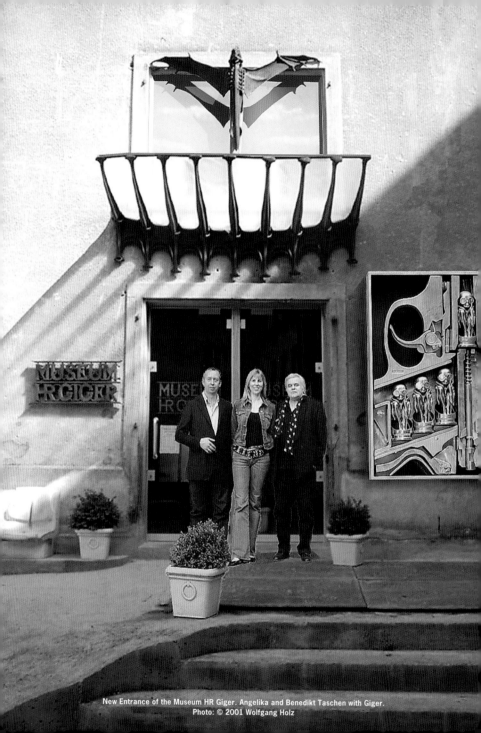

New Entrance of the Museum HR Giger. Angelika and Benedikt Taschen with Giger.
Photo: © 2001 Wolfgang Holz

Thank you for buying
TASCHEN – we hope you
enjoyed this book

If you would like to stay updated about upcoming TASCHEN titles, please request
our magazine at *www.taschen.com* or return this card. We will be happy to send you
a free copy of our magazine which is filled with information about all of our books.

Last name

First name

Street

Country/State

ZIP code

City

E-mail address

I am especially interested in

☐ Architecture ☐ Classics ☐ Fashion ☐ Photography
☐ Art ☐ Design ☐ Film ☐ Pop Culture
☐ Artists' Editions ☐ Digital ☐ Interiors ☐ Sex
☐ Travel

My age range is

☐ 18-30 ☐ 46-60
☐ 31-45 ☐ over 60

Reply card

"The TASCHEN empire,
or the art of making beautiful books
available to everyone." *Numéro, Paris*

Germany
TASCHEN Deutschland
Hohenzollernring 53
D–50672 Köln

France
TASCHEN France Sarl
82, rue Mazarine
F–75006 Paris

Spain
TASCHEN España S.A.U.
c/Victor Hugo, 1-2° Dcha.
E–28004 Madrid

UK
TASCHEN UK Ltd.
13, Old Burlington Street
GB–London W1S 3AJ

US
TASCHEN America LLC
Crossroads of the World
6671 Sunset Blvd.
Suite 1508
Los Angeles CA 90028

Japan
TASCHEN Japan Inc.
Atelier Ark Building
5-11-23, Minami
Aoyama Minato-ku
J–Tokyo, 107-0062

contact@taschen.com

www.taschen.com

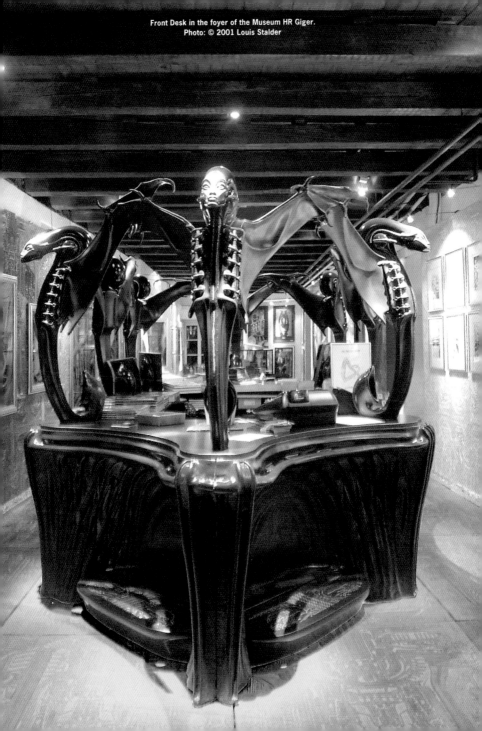

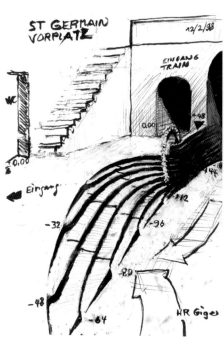

Top: 4 sketches from the New Entrance. Bottom: 4 sketches of the Old Entrance.
Pencil, ball point and/or felt-tip pen on paper, 30 x 21 cm

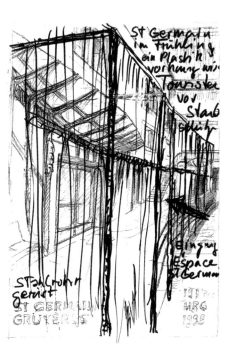

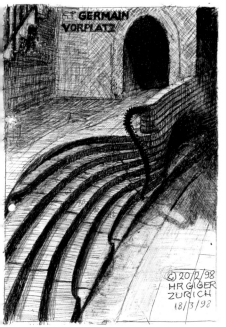

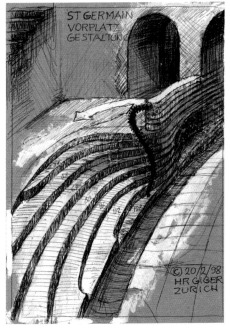

The Alpine Principality of Myths

Sergius Golowin

Château Gruyères and its environs were the favorite locale of tales about mountain monsters – it is said that the Irishman Beatus instituted order here and locked them up in subterranean cells. Here, also are "the gates to the cave kingdom of love", populated by Fairies, whose Queen is none other than Lady Venus herself.

In the 19th century, it seems, a doctor suspected that the fantasies of the mountain folk and their guests were the result of "the blazing heat which the cheese fondue ignites in body and soul." (This dish, by the way, achieved its crowning glory here, precisely because of the Gruyères cheese!)

Between the Count's castle and the impregnable bastions which later became the independent Château St. Germain, the famous "Fools' Days" celebrations were held around carnival time and other days of rejoicing. Their heart and soul was the Count's counselor, steward and court jester – "the memory of a pastoral race of people". He understood how the "mountain spirit" caused the hunters who chased the chamois, beyond all restraint, to plummet from the rocks. He spoke of the enchanted beauty of the mountain Fairies, from whom the maidens of the Gruyères region inherited their looks, and how they lured young shepherds into their caves: "They made love with them for centuries".

The great poet Chalamala and his descendants knew well about the goblins and gnomes that "guard the golden veins and crystal grottos" in the tunnels under the bedrock of the castle walls. Apparently, these traditions were the reason why, for a long time after, "mysterious Venetians and alchemists" made their way to the Gruyères region "to win the friendship of the subterranean ones."

It was even thought that there was a connection between the legends and the Romantic poetry written by Byron and the Shellys in Western Switzerland. Thus, the story of the Swiss alchemist and magician, "the Swiss aristocrat Frankenstein" owes its origin, not lastly, to the legends of Gruyères.

Looking at these old walls in a storm or by moonlight, this modern interpretation of the Alpine myths seems entirely comprehensible to us.

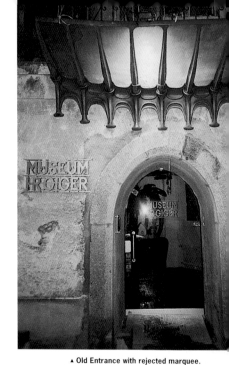

▲ Old Entrance with rejected marquee.
▼ Seating area with concrete furniture in entrance foyer
Photos: © 2001 HR Giger

Das Alpenfürstentum der Mythen

Sergius Golowin

Schloss Greyerz und Umgebung galt als die Lieblingsheimat der Geschichten um Gebirgsungetüme – der Ire Beatus soll auch hier Ordnung geschaffen und diese in unterirdische Räume eingeschlossen haben. Hier sind auch »die Tore zum Höhlenreich der Liebe«, bewohnt von den Feen, über die als Königin Frau Venus selber herrscht.

Ein Arzt soll im 19. Jahrhundert vermutet haben, diese Phantasien seien in den Berglern und ihren Gästen entstanden, »dank der Feuerhitze, die die Käsespeise Fondue in Leib und Seele bringt«. (Dieses Gericht habe im übrigen gerade hier durch den Greyerzerkäse seine Krone erhalten!)

Zwischen Grafenschloss und den uneinnehmbaren Vor- und Bollwerken, aus denen später das unabhängige Schloss St. Germain erwuchs, fanden um Fasnacht und andere Festzeiten die berühmten »Narrentage« statt. Ihre Seele war der Berater, Haushofmeister und Hofnarr des Grafen, Girard Chalamala – »das Gedächtnis des Hirtenvolkes«. Er wusste, wie der »Berggeist« die Jäger, die maßlos die Gemsen hetzten, die Felsen hinunterstürzte. Er erzählte von den märchenhaft schönen Bergfeen, von denen die Mädchen des Greyerzerlandes ihr Aussehen besitzen, wie sie die jungen Hirten in ihre Höhlen lockten: »Mit ihnen pflegten sie durch Jahrhunderte (!) die Liebe.«

Sehr viel wussten der große Dichter Chalamala und seine Nachfolger über die Kobolde oder Gnome, die in den Gängen unter den Schlossmauern und in Felsen »die Goldadern und die Kristallgrotten hüten«. Diese Überlieferungen sollen der Grund gewesen sein, dass sich noch lange »Alchimisten und geheimnisvolle Venediger« im Greyerzerlande einfanden, »um die Freundschaft der Unterirdischen zu gewinnen«.

Man vermutete sogar den Zusammenhang solcher Sagen mit der romantischen Dichtung, etwa der von Byron und dem Ehepaar Shelly, die in der Westschweiz entstand. So soll etwa die Geschichte um den schweizerischen Alchimisten und Magier, »den schweizerischen Edelmann Frankenstein«, nicht zuletzt dem Sagenkreis von Greyerz die Entstehung verdanken.

Schaut man die alten Mauern im Gewitter oder im Mondenschein an, scheint uns auch diese moderne Gestalt der Alpenmythen irgendwie verständlich.

Le royaume alpin des mythes

Sergius Golowin

Le château de Gruyères et ses environs était autrefois considéré comme un lieu privilégié pour donner naissance à toutes sortes d'histoires de monstres des montagnes, et l'on dit que l'Irlandais Beatus est lui-même venu ici pour mettre de l'ordre et enfermer les monstres dans des espaces souterrains. C'est également ici que se trouvent les portes donnant accès au royaume des grottes de l'amour peuplé par des fées et où règne la déesse Vénus en personne.

Au XIX^e siècle, un médecin a diagnostiqué que tous ces phantasmes n'étaient que les chimères des montagnards et de leurs hôtes apparaissant sous l'emprise de la « chaleur que la fondue au fromage procure au corps et à l'âme ». (On dit d'ailleurs que c'est précisément ici, grâce au fromage de Gruyères, que ce met a reçu ses titres de noblesse !)

Pendant la période du carnaval ainsi que d'autres fêtes, des « journées du fou » se déroulaient entre le château du comté et les bâtiments de fortification dont est issu par la suite le château St-Germain. Girard Chalamala, « mémoire du peuple des bergers », intendant à la cour et bouffon du comte, en était le personnage central. Lui seul savait que l'esprit de la montagne était capable de précipiter pardessus les rochers les chasseurs acculant les chamois. Il racontait l'histoire de fées des montagnes incroyablement belles, dont les filles du pays de Gruyères semblent d'ailleurs avoir gardé l'aspect physique, qui attiraient les jeunes bergers dans leurs grottes « afin de faire l'amour avec eux pendant des siècles ».

Le grand poète Chalamala et ses successeurs connaissaient beaucoup d'histoires de gnomes et de lutins qui, dans les galeries forées sous les enceintes du château et dans les rochers, « étaient chargés de garder les filons d'or et les grottes de cristal ». Ces récits sont apparemment à l'origine de la présence dans le pays de Gruyères de « nombreux alchimistes et de mystérieux Vénitiens venus ici pour tenter de sceller l'amitié avec les créatures souterraines ».

On a même évoqué l'hypothèse d'un lien direct entre ces récits et la poésie romantique telle que la pratiquaient en Suisse romande Lord Byron ou encore le couple Shelly. Ainsi, l'histoire du grand magicien et alchimiste suisse, un noble « Frankenstein » suisse, serait issue des légendes qu'on raconte dans la région de Gruyères.

Quand on observe les vieux murs pendant un orage ou au clair de lune, ce personnage moderne des mythes alpins nous paraît assez compatible.

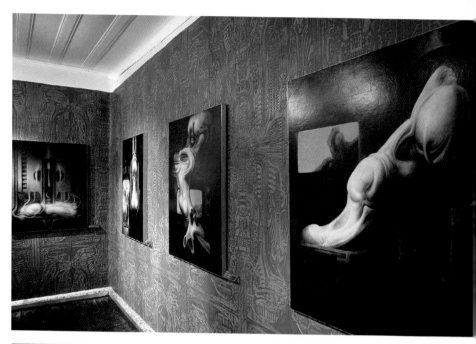

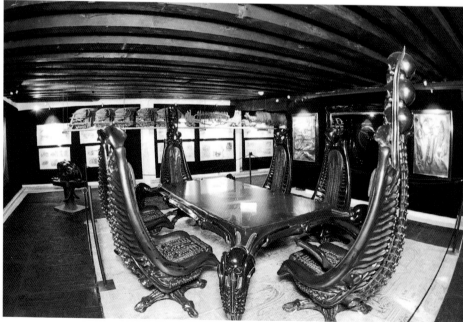

Top: Staircase landing on the 1st floor of the museum with oil paintings, area #3. Photo: © 2002 Alf
Bottom: Harkonen Environment in the 2nd floor of the museum, area #12. Photo: © 1998 Kyeni Mbiti

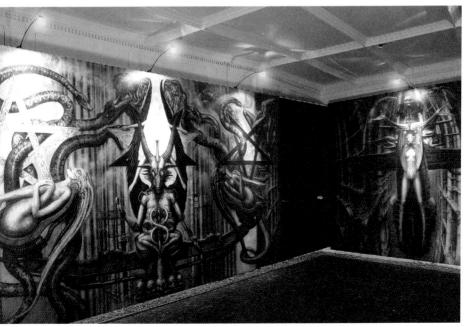

Top: Museum Gallery during the Günther Brus exhibition, 2001, area #18. Photo: © Wolfgang Holz. 159
Bottom: *The Spell Room* on the 1st floor of the museum, area #6. Photo: © 2001 Louis Stalder

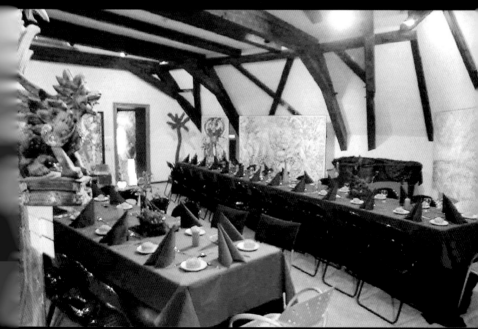

Top: Artworks on display from the HR Giger Collection: Ernst Fuchs, Balinese woodcuts, Hans Scherer, area #16.

Photo: © 2002 HR Giger. Bottom: Catered party in the Private Collection room for a banquet of 80 people, area #16.

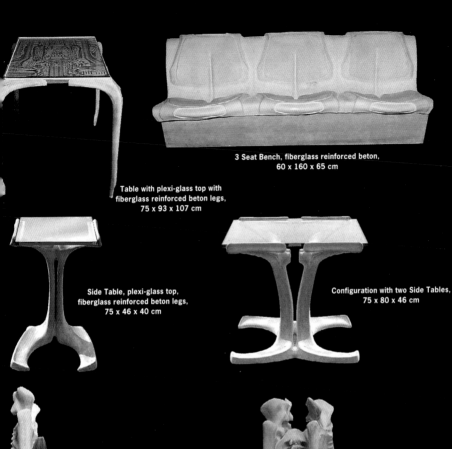

3 Seat Bench, fiberglass reinforced beton,
60 x 160 x 65 cm

Table with plexi-glass top with
fiberglass reinforced beton legs,
75 x 93 x 107 cm

Side Table, plexi-glass top,
fiberglass reinforced beton legs,
75 x 46 x 40 cm

Configuration with two Side Tables,
75 x 80 x 46 cm

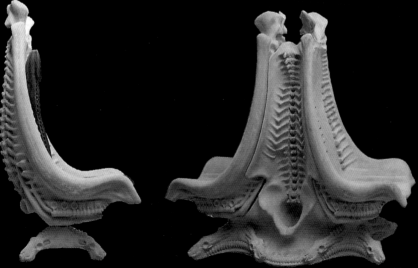

Harkonen Chair, fiberglass reinforced beton,
latex seat cushion, 151 x 72 x 68 cm

Harkonen Chair with Wardrobe element in between,
for the Museum Giger Bar
All photos: © 2002 Wolfgang Holz

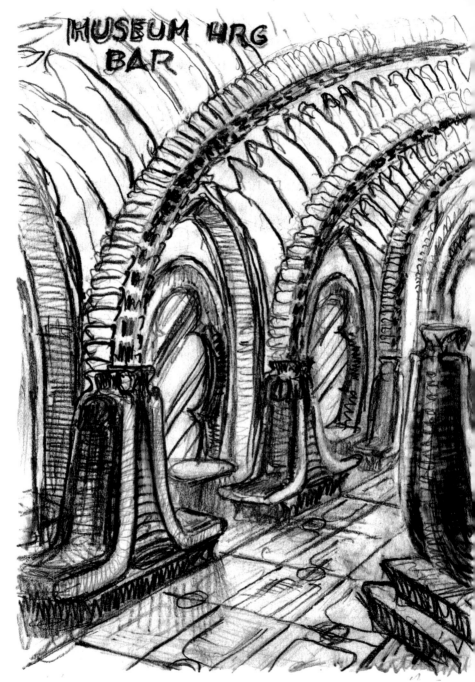

Sketch of left side of Museum Giger Bar, 2000.
Window booths, mirror windows and ceiling, limited edition of 500 giclee prints, 30 x 21 cm

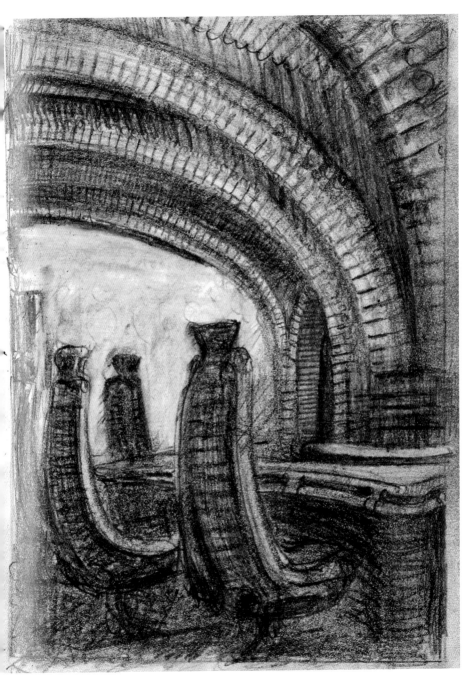

Sketch of right side of Museum Giger Bar, 2000.
Pencil on paper, 21 x 15 cm

A PROJECT IN GRUYERES

Giger Establishes His Museum in Gruyères

A Giger Museum in Gruyères? The formal application for permission to convert the Château Saint-Germain was published yesterday in the *La Feuille officielle*. The man behind the proposal is Swiss artist HR Giger himself, and he has highly original plans for the place! The result would be a wonderful bonus for Gruyères in general, and what's more, it may include an International Center for Fantastic Art, which has, yet, to be created.

Giger, who received an Oscar for his designs for the film *Alien*, is a contemporary master of the art of the Fantastic. He would like to establish a museum in Gruyères to exhibit his own artworks alongside his extensive private collection. It's a six- to seven-million-franc project, but a number of things need to happen before it sees the light of day.

Giger has his eye on the Château Saint-Germain, which currently belongs to François Dupré; the conversion application should make it clear whether planning permission is in the cards. The municipal council supports the plan, and the *Service des biens culturels* has given it the go-ahead. If this preliminary phase is successful, Giger would expect to buy the castle. Estimated conversion cost: approximately 4.7 million francs.

Three levels by train

This would be no ordinary museum. The vast space (8-9,000 m³) offers a surface area of 2,000 m² on three different floors. One unique feature would be a monorail ghost train to transport visitors through the museum, with its 'cars' based upon Giger's designs for a still unmade film, *The Train*. Also planned are a 'Museum Giger Bar', similar to the one the artist designed in Chur, a video hall, plus all the usual infrastructure required for a major museum.

English translation of French newspaper article published before the purchase of the Château St. Germain (see page 166).

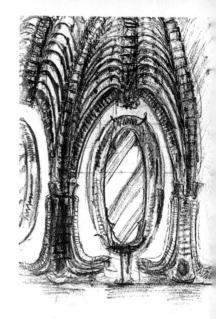

Sketch of the *Museum Giger Bar*, 2000.
View of mirror windows, pencil on paper, 21 x 15 cm

Floorplan of the *Museum Giger Bar*, 1999.
Pencil on paper, 30 x 21 cm

► **Construction in progress at the *Museum Giger Bar*.**
Photo: © 2002 Megan Rush

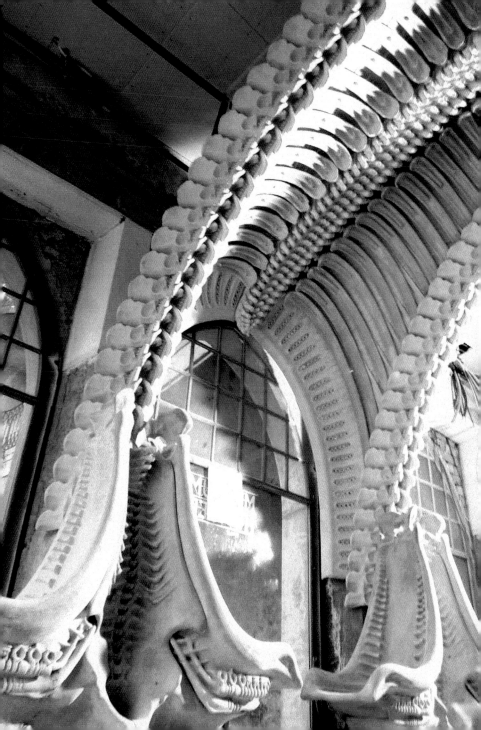

EN PROJET À GRUYÈRES

Giger pose son musée

Gruyères accueillera-t-elle un Musée Giger? La demande d'un permis de transformation du château Saint-Germain est parue hier dans «La Feuille officielle». Derrière ce projet se cache l'artiste suisse Hans-Ruedi Giger. Avec un concept muséographique particulièrement original! Atout formidable pour l'ensemble de la Gruyère, le musée pourrait être intégré dans un Centre international de l'art fantastique, encore à créer *(voir encadré)*.

Honoré d'un Oscar pour les décors du film «Alien», figure dominante de l'art fantastique contemporain, l'artiste zurichois Hans-Ruedi Giger souhaite créer à Gruyères un musée pour y exposer ses œuvres et celles de sa collection privée. Un projet de six ou sept millions qui se conjugue, pour l'instant, au conditionnel.

Dans la ligne de mire de l'artiste, le château Saint-Germain, actuelle propriété de François Dupré. La demande de transformation, parue hier, permettra de connaître les chances d'obtenir un permis. La commune de Gruyères soutient le projet. Le Service des biens culturels a donné son feu vert. Au terme de cette phase d'approche, l'artiste se porterait acquéreur du château Saint-Germain. Les transformations nécessaires sont estimées à 4,7 mio de francs.

Trois étages en train

Et le concept n'est pas banal! Dans ce gros volume de 8 à 9000 m³, et sur une surface de 2000 m², le musée occuperait trois niveaux. Originalité du projet, un train fantôme, porté par un monorail, transporterait le visiteur à travers les salles d'exposition. Un véhicule dont les «wagons» seraient des copies de ceux qui furent créés pour le film «The Train». Un «Giger Bar», semblable à celui qu'il a créé à Coire, mais aussi une salle vidéo et toutes les infrastructures indispensables à un musée sont projetés.

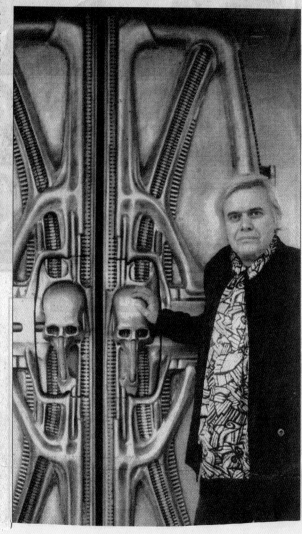

Newspaper article from *La Gruyère*, 1997, published before September 11, 1997 (purchase date of the Château St. Germain)

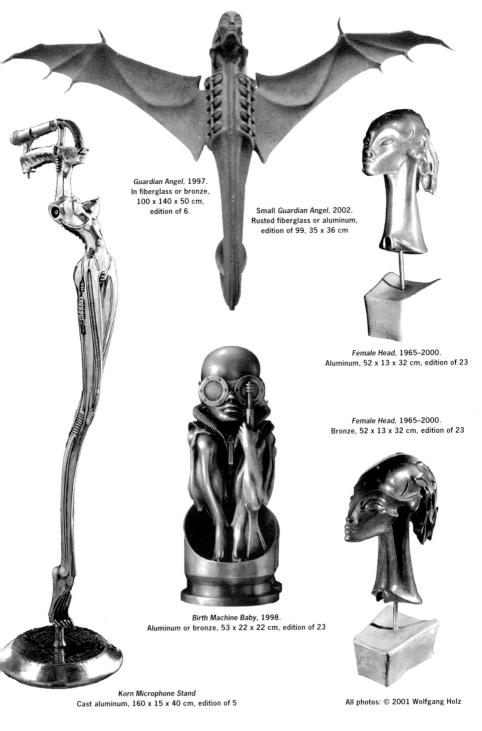

Guardian Angel, 1997.
In fiberglass or bronze,
100 x 140 x 50 cm,
edition of 6.

Small *Guardian Angel*, 2002.
Rusted fiberglass or aluminum,
edition of 99, 35 x 36 cm

Female Head, 1965–2000.
Aluminum, 52 x 13 x 32 cm, edition of 23

Female Head, 1965–2000.
Bronze, 52 x 13 x 32 cm, edition of 23

Birth Machine Baby, 1998.
Aluminum or bronze, 53 x 22 x 22 cm, edition of 23

Korn Microphone Stand
Cast aluminum, 160 x 15 x 40 cm, edition of 5

All photos: © 2001 Wolfgang Holz

HR. Giger, die Unterwelt und Greyerz

Erfreulicher Besucherstrom im Museum auf Schloss Saint-Germai

Vor rund einem Monat wurde der erste Teil des Museums mit Werken des Schweizer Künstlers HR. Giger eröffnet. Die FN nahmen einen Augenschein auf Schloss Saint-Germain in Greyerz.

Wer das Städtchen Greyerz besucht, erwartet im allgemeinen einheimische Folklore, Doppelrahm und Meringues. Seit vier Wochen beheimatet Greyerz aber eine dauernde Ausstellung, die nichts, aber auch gar nichts mit «heile Welt» zu tun hat: Giger ist hier, der Sichtbarmacher des Verdrängten, dieser Hofberichterstatter von der Unterwelt oder Messdiener des Grauens, wie er auch genannt wird.

Eingangs der Schlossanlage Greyerz befindet sich rechts das Schloss Saint-Germain. Der kürzlich darin eröffnete erste Teil zeigt auf drei Etagen einen Querschnitt durch das bildliche und plastische Werk des Bündner Künstlers. Giger ist allgegenwärtig: Fussboden, Stühle, Tische, die Eingangspartie, alles trägt seine unverkennbare Handschrift.

Geplant:
Schlossbahn und Giger-Bar

Giger kümmert sich auch um die weitere Ausgestaltung seines Museums: Noch in diesem Jahr soll die Aussentreppe sowie die Eingangspartie nach seinen Plänen erstellt werden. Mit Sicherheit wird die Treppe nicht aus geraden und rechtwinkligen Formen bestehen; Giger ist ja geradezu ein Verbieger starrer Formen.

Als weltweites Unikum ist eine Schlossbahn geplant. Die Besucher werden dannzumal in Zweierwagen durch das ganze Museum gefahren. Selbstverständlich ist das ein Giger-Zug, also fernab von sachlichen oder streng stromlinienartigen Formen. Eine «Giger-Bar» soll auch nach Greyerz kommen. Diese wird, nach Chur und Tokio, die dritte sein, in der man es sich, umgeben von Figuren wie aus dem Film «Alien», gutgehen las-

Ein Bündner lehrt das Greyerz das Fürchten: HR. Giger mit einem «Biomechanoiden» an der Ausstellungseröffnung Alain Wicht/a.

sen kann. Und nebst dem Innenausbau soll auch der Garten à la Giger gestaltet werden. Dem weiteren Ausbau stehen im Moment aber noch einige Rechtshändel im Wege. Die endgültige Eröffnung des Museums ist daher für das Jahr 2000 oder 2001 vorgesehen.

«Wir wollen
ein lebendiges Museum»

Wir treffen die Konservatorin des Museums, Prof. Dr. Barbara Gawrisiak,

im Gespräch mit einem amerika schen Touristen. Dieser erklärt ungläubig, er hätte nie erwartet, Greyerz dem Werk Gigers zu beg nen.

«Wir beabsichtigen, hier ein leb diges Museum zu errichten, mit vie kulturellen Ereignissen. Ich möc auch, dass alle, die etwas zu sagen h ben, bei uns ein- und ausgehen», fü Barbara Gawrisiak us. Sie kennt ger schon seit seiner Zeit an der Z cher Kunstgewerbeschule, also s den späten fünfziger Jahren und nennt das Museumsprojekt so etw wie einen gemeinsamen Traum v Giger und ihr. Frau Gawrisiak wol seit 40 Jahren in Greyerz; sie ist a mit der Gegend und deren Bew nern bestens vertraut. Sie ist ebenfa langjähriges Mitglied im Stiftungs Schloss Greyerz.

Diese Stiftung hat sich, unter Leitung von Etienne Chatton, intern tional einen ausgezeichneten Ruf Ausstellungen fantastischer Kuns worben. Daher war es nahelieg dass sich Barbara Gawrisiak engagi darum bemühte, dass das Giger-M seum in Greyerz eine dauerha Bleibe finden konnte.

«Der Besucherzulauf der ers paar Wochen hat unsere Erwartung übertroffen», freut sich Frau Gaw siak. Sie und Giger sind davon üb zeugt, dass das Museum derei selbsttragend wird.

Und Barbara Gawrisiak sieht Standort Greyerz noch einen weiter wichtigen Punkt: Mit Giger habe ni zuletzt ein Deutschschweizer se Zelte jenseits des Röstigrabens auf stellt.

Die FN werden in einem nächs «Magazin am Wochenende» die A stellung und die noch geplanten P jekte eingehend und bildlich vorst len.

PETER STÖFER

Öffnungszeiten Giger-Museum, Schloss Sa Germain, Greyerz, bis 30. September: tägl 9–18 Uhr; Oktober: 9–12 und 13–16.30 U November 9–12 und 13–17 Uhr.

Newspaper article from *Freiburger Nachrichten*, 1998

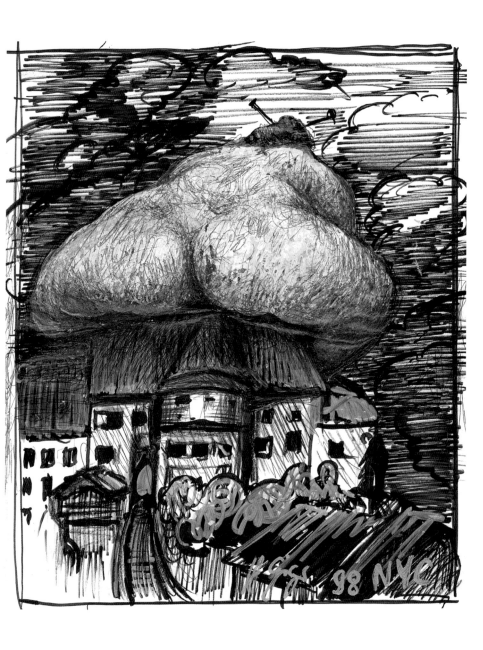

The Phantom of St. Germain, 1998.
Mixed media on paper, 30 x 30 cm

Le Phantom du St, Germain
en rodage

8 sketches each of *The Phantom of St. Germain*, 1998.
Ball point on paper, 21 x 15 cm

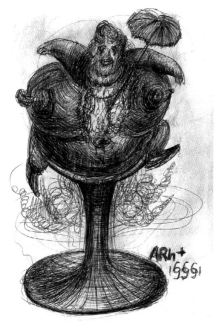

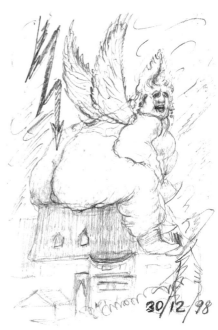

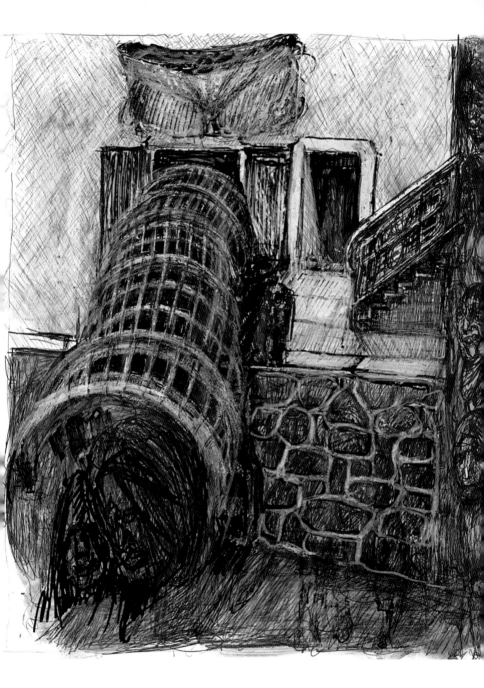

172 ▲ *The Phantom of St. Germain*, 1998. Mixed media on paper, 30 x 21 cm
▶ *Future Train I + II*. Pencil on paper, 30 x 30 cm

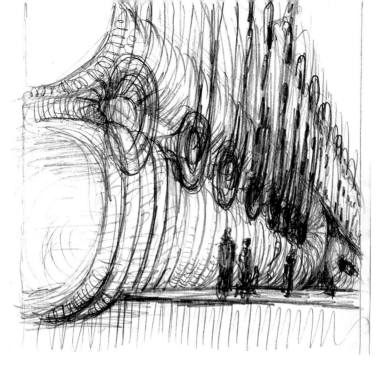

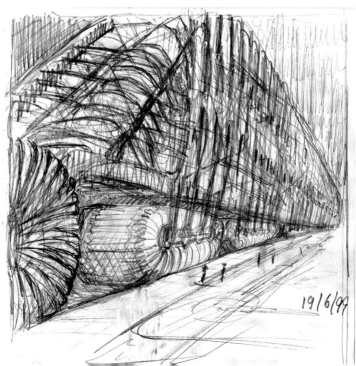

19/6/99

173

▲ Carmen. Photo: © 2001 Stephan Stucki

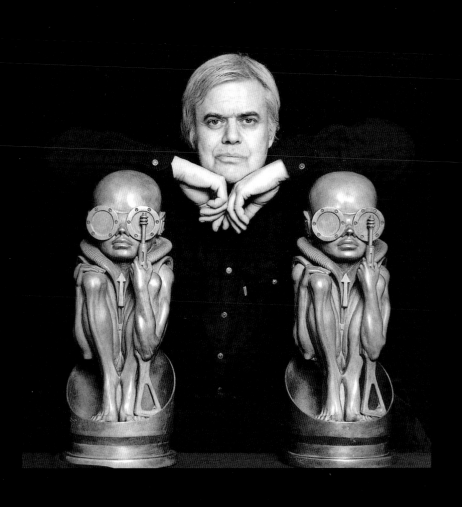

177

►► Pages 178/179: *Landscape XV*, Work No. 208, 1973. 70 x 100 cm, Acrylic on paper on wood

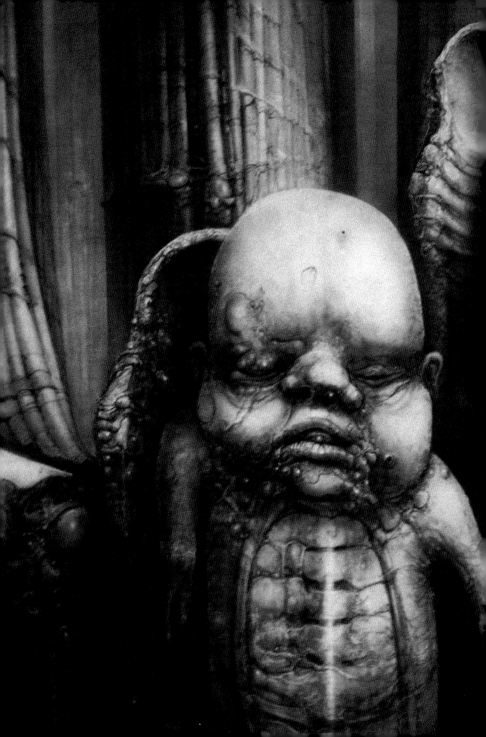

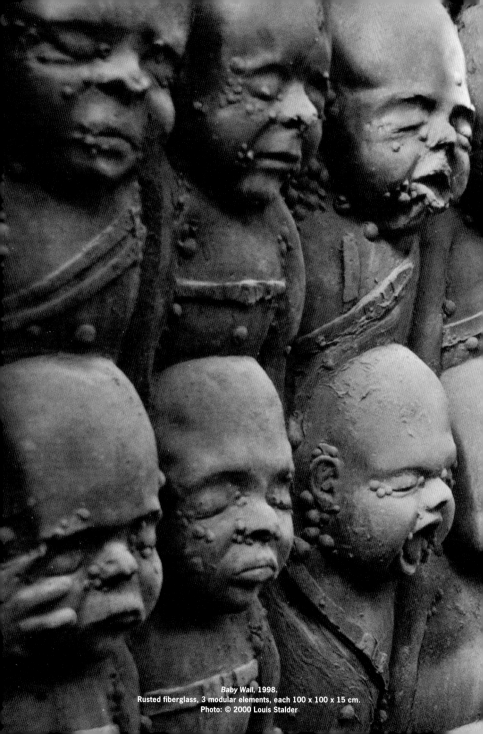

Baby Wall, 1998.
Rusted fiberglass, 3 modular elements, each 100 x 100 x 15 cm.
Photo: © 2000 Louis Stalder

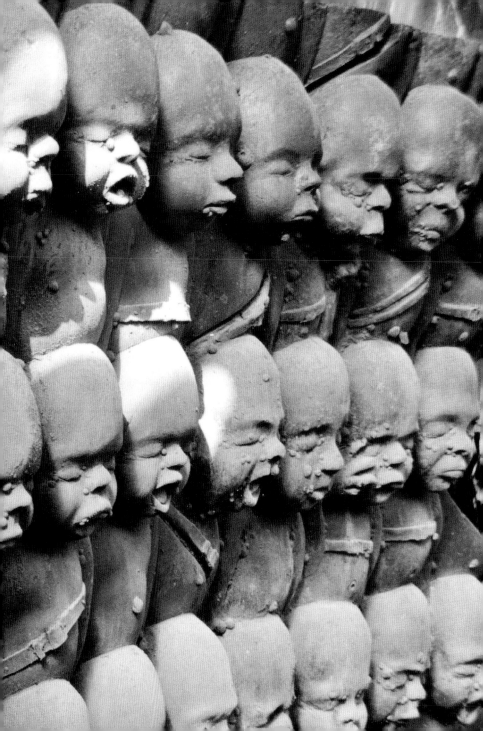

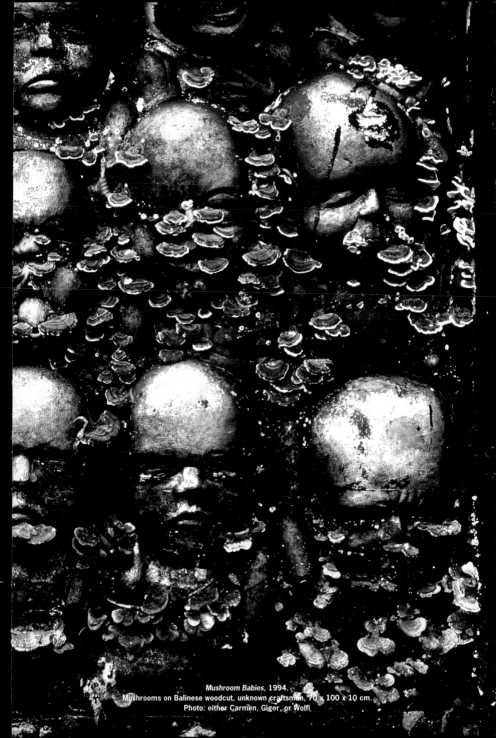

Mushroom Babies, 1994.
Mushrooms on Balinese woodcut, unknown craftsman, 70 x 100 x 10 cm.
Photo: either Carmen, Giger, or Wolfi

GORGE DE LA TAMINA

BAINS DE PFEFFERS

(S? GALL.)

Le Petit sc

184 Copperplate engraving of Tamina Canyon where, as a young boy, I often went for Sunday walks with my mother

Works and exhibitions

One man shows
1966
Zurich, Galerie Benno
1968
St. Gallen, Galerie vor der Klostermauer
1969
Zurich, Galerie Platte 27, "Biomechanoiden"
1970
Zurich, Galerie Bischofberger, "Passagen"
1971
Berne, Actionsgalerie (with Schwertberger)
1972
St. Gallen, Galerie Look (Dibi Däbi)
Biel, Galerie 57
Baden, Trudelhaus (with Schuhmacher)
Kassel, exhibition by the Kunstverein
1973
Zurich, Galerie Stummer und Hubschmid
Cologne, Inter Art Galerie Reich
1975
Chur, Bündner Kunsthaus, "Passagen-Tempel"
Zurich, Galerie Baviera, complete graphic works
Zurich, Meier's Gallery of Modern Art
1976
Frankfurt, Galerie Sydow-Zirkwitz
Amsterdam, Galerie Kamp
Paris, Galerie Bijan Aalam
Regensberg, Neue Wohngalerie, complete graphic works
Richterswil, Ugly Club, "The Second Celebration of the Four"
1977
Zurich, Zürcher Kunsthaus
Biel, Galerie Baviera
Paris, Galerie Bijan Aalam
1978
Glarus, Kunsthaus (with Claude Sandoz)
Büren a.A., Galerie Herzog, complete graphic works
1979 Zurich, Galerie Baviera, works for the film *Alien*
Amsterdam, Galerie Kamp
Paris, Galerie Bijan Aalam
1980
Cavigliano, Galerie Baviera, "HR Giger sul tema dell' erotismo"
Zurich, Modelia-Haus, works for the film *Alien*
Lausanne, Musée Cantonal des Beaux-Arts, works for the film *Alien*
New York, Hansen Galleries, works for the film *Alien*
1981
New York, The Museum of the Surreal and Fantastique Biel, Kunsthauskeller
1982
Winterthur, *N.Y. City* pictures and the Bijan Aalam collection
Paris, Kunsthalle Waaghaus
1983
Basle, Art 14'83; Munich, Galerie Hartmann; Zurich, Steinle; Bonn, Galerie Klein, with Martin Schwarz; Cologne, Galerie am Severinswall, with Martin Schwarz

1984
Pfäffikon SZ, Seedamm-Kulturzentrum, "Retrospektive"
Basle, Art 16'85, with Martin Schwarz; New York, Limelight, "The Dune you will never see"; Biel, Galerie 58, Silvia Steiner, with Martin Schwarz
1985
Sierre, Maison Pancrace de Courten, "Retrospective"
Zurich, Galerie a 16
Nuremberg, "Zukunftsräume"
1986
Büren zum Hof, Galerie Herzog
1987
Zurich, Werkstatt-Galerie, Paul Nievergelt
1988
Zurich, Galerie Art Magazin, "Drawings Expanded"
Berlin, Galerie Petersen Rorschach, Museum im Kornhaus, graphic works
Zug, Wickart, graphic works
New York, Psychedelic Solution Gallery, paintings and prints
St. Gallen, Stadttheater, "Essenzia-Symposium for Alchemy"
1989
Chur, Galerie Plana Terra, graphic works
1990
Chur, Bündner Kunsthaus, exhibition on the occasion of HR Giger's 50th birthday. Exhibition of the 12 HR Giger pictures in the museum's collection
Gruyères, Château de Gruyères, "Alien dans ses Meubles"
Wettlingen, Informatikschule, pictures and graphic works
Guarda, Restaurant Crush Alba, drawings for *The Mystery of San Gottardo*
Nyon, Gallery Carré Blanc, drawings
1991
Cluse, Macadam – la M.J.C. de Cluse, "Les Livres d'Esquisses"
Zurich, Galerie Art Magazin, *ARh+* book vernissage Basle, Art 22'91, Gallery Hilt, "One Man Show"
Davos, Painthouse Academy, Window 92, "HR Giger's Biomechanic Visions"
1992
Zurich, Museum Baviera, "Giger-Retrospektive"
1993
Zurich, Museum Baviera, retrospective and works for *Alien* and *Alien 3*
Lausanne, Galerie Humus, retrospective and exhibition of *Swiss Transit Tunnel* works
Büren zum Hof, Galerie Herzog
Furth, Galerie P17, drawings for *The Mystery of San Gottardo*
Burgdorf, Galerie Bertram and former Restaurant Krone, pictures and retrospective of sculptural works, including *Watch Abart* pieces
New York, Alexander Gallery, "Retro-NY", pictures and retrospective of sculptural works, in-

cluding *Watch Abart* pieces
1994
Zurich, Galerie Mangisch, "Watch Abart"
Locarno, Galerie Ecllisse
Zurich, Odeon, "Communication Art Zürich"
1995
Brussels, 13ème festival du film fantastique
Giessen, Kunsthalle, "Konfrontationen", with Sibylle Ruppert (works from the Paul Walter collection)
1996
Kreuzlingen, Loft, furniture
Milan, Arteutopia, "Visioni di fine millennio" (catalogue)
1997
Basle, Galerie Hilt, "Projekte"
Paris, Librairie Arkham, "Visions"
Lucerne, Galerie Artefides, originals sculptures, graphics
Chur, Fachhochschule für Gestaltung, "Visionen", sculptures, furniture
1998
Gruyères, Château Gruyères, "Private art collection of HR Giger"
Gruyères, Museum HR Giger, St. Germain, partial opening
New York, Restaurant "360"
"HR Giger – Sculptures & Prints"
Basle, Galerie Hilt, originals and portfolios
2000
Zurich, TV DRS at home with HRG, Turn of the Millennium
Zurich, Galerie a 16, sculptures, pictures, drawings, litho portfolio "Ein Fressen für den Psychiater"
Conte, Tattoo Convention, Paintings
Nuremberg, Galerie am Theater, exhibition "Ein Fressen für den Psychiater"
Thal, Wurster AG, exhibition in the Fuchsloch, furniture
2001
Zurich, Piccola Galleria d'arte, graphics
2002
New York City, Fuse Gallery, HR Giger/NYC
2002: Recent Sculptures & Prints

Group exhibitions
1962
Basle, Galerie Stürchler
1967
Zurich, Galerie Obere Zäune, "Macht der Maske"
Berne, Kunsthalle, "Science-Fiction"
1968
Zurich, Galerie Stummer & Hubschmid, "Hommage à Che"
Zurich, Galerie Obere Zäune, 5th anniversary show
Erlangen, Galerie Hartmut Beck
1969
Vienna, Künstl. Volkshochschule, "Junge Schweizer Maler"
Zurich, Wenighof, "Kritische Realismen"

Zurich, Helmhaus, "Phantastische Figuration in der Schweiz"
Zurich, Galerie Stummer und Hubschmid, "Edition 12x12"
Berlin/Zurich, "Zürcher Künstler"
1970
Basle, Galerie Katakombe
Basle, Galerie G.
Geneva, Galerie Aurora
Lausanne, Musée des Arts de la Ville, "L'Estampe en Suisse"
Kassel, Studio-Galerie des Kunstvereins
1971
New York, Cultural Center, "The Swiss Avant-Garde"
Geneva, "3e Salon de la jeune gravure suisse"
Zurich, Strauhof, "5 Kritiker zeigen Kunst"
Basle, Art 2'71
Paderborn, Pädagogische Hochschule, "Editionen"
Cologne, Internationale Kunst- und Informationsmesse
Zurich, Strauhof, "Zürcher Zeichner", Ars ad interim
Chur, Bündner Kunsthaus, "Neueingänge 70/71"
1972
Glarus, Galerie Crazy House
Zurich, Züspahallen, "Zürcher Künstler"
Zurich, "Freiheit für Griechenland"
Zurich, Strauhof, "Werk & Werkstatt"
Cracow, "Biennale internationale de la gravure"

Basle, Art 3'72
Lucerne, Verkehrshaus, "Künstler-Verkehr-Visionen"
Bradford, Third British International Print Biennale
Tel Aviv, "Contemporary Swiss Art"
Zurich, Jerusalem, Haifa, "Zürcher Künstler"
1973
Berne, Basle, Lugano, Lausanne, Geneva, "Tell 73"
Basle, Art 4'73
Zurich, Biennale im Kunsthaus, "Stadt in der Schweiz"
Schaffhausen, Museum zu Allerheiligen, "Kunstmacher 73"
Oberengstingen, "Spektrum 73"
Berne, Galerie für kleine Formate, "small size"
Düsseldorf, IKI, Internationaler Markt für aktuelle Kunst
1974
Winterthur, Geneva, Lugano, "Ambiente 74"
Zurich, Strauhof, "66 Werke suchen ihren Künstler"
Chur, Bündner Kunsthaus, "GSAMBA Graubünden"
Olten, Kunstverein, "Zürcher Fantasten"
Munich, Galerie Jasa GmbH & Co. Fine Art
Frankfurt, Galerie Sydow, inaugural exhibition
Basle, Art 5'74
Chur, Bündner Kunsthaus, "Tagtraum", together with C. Sandoz and W. Wegmüller

Zurich, Kunsthaus, "Tagtraum"
Winterthur, Kunstmuseum, "Tagtraum"
Olten, Kunstmuseum, "Tagtraum"
Paris, Galerie J.C. Gaubert, "400 Ans de Fantastique"
Zurich, Galerie Li Tobler, "Manon oder das lachsfarbene Boudoir"
Düsseldorf, Kunstmesse IKI 74
1975
Zurich, Galerie Li Tobler, "Schuhwerke"
Basle, Art 6'75
Paris, Galerie Bijan Aalam, "Le Diable"
1976
Nuremberg, Kunsthalle, "Schuhwerke"
Zurich, Villa Ulmberg, "Zürcher Künstler"
Amsterdam, Galerie Kamp, "Fantastisch Realisme"
Zurich, Strauhof, "Zwischen Konflikt und Idyll"
Zurich, Hamburg, Berne, Paris, S.R. Baviera, "DIN A4"
Paris, Galerie Espaces 76, "3 Espaces"
Paris, Galerie Bijan Aalam, "Le Vampire"
1977
Lausanne, Musée Cantonal des Beaux-Arts
Basle, Art 8'77
New York, Bronx Museum, "Images of Horror and Fantasy"
Tours, "Multiple 77"
Liège, Arts à Saint-André
Zurich, Galerie Baviera, "Echo vom Matterhorn"
Zurich, Galerie Stummer, "Kleinformate"

186 *Alien Attack*, advertisement for Subway restaurant franchises, noticed by HR Giger

Zurich, Strauhof, "Das Menschenbild"
Burgdorf, Galerie Bertram
Zurich, Züspa-Hallen, "Kunstszene Zürich"
Paris, Galerie Bijan Aalam, "Le Miroir"
1978
Vienna, Künstlerhaus am Karlsplatz, "Kunstszene Zurich"
Chur, Bündner Kunsthaus, "GSAMBA Graubünden"
Winterthur, Kunstmuseum, "3. Biennale der Schweizer Kunst"
Winterthur, "Aktualität Vergangenheit"
Zurich, Galerie Baviera, "Tagtraum"
Zurich, Centre Le Corbusier, "Atomkraftwerk-gegner-Komitee"
Basle, Art 9'78
Bochum, Museum, "Imagination"
1979
Olten, Kunsthaus Olten (Galerie Baviera), "Vorschlag für ein anderes Museum"
Basle, Art 10'79
Rennes, Maison de la culture, "L'Univers des Humanoides"
1980
Zurich, Kunsthaus Zürich, "Schweizer Museen sammeln Kunst"
Winterthur, Kunsthalle im Waaghaus, "Vorschlag für ein anderes Museum"
Basle, Art 11'80
Lausanne, Musée Cantonal des Beaux-Arts, "Schweizer Museen sammeln Kunst"
Zurich, Helmhaus, "Transport, Verkehr, Umwelt"
Los Angeles, Hansen Galleries, "Art Expo West"
Zug, Kunsthaus, "Die andere Sicht der Dinge"
Le Havre, Maison de la culture (Pro Helvetia), "Quelques Espaces Suisse 80"
New York, Hansen Galleries, "Art 1980", International Fair of Contemporary Art
Glarus, Kunsthaus, "Die andere Sicht der Dinge"
Lille, Palais Rameau, "Science au Future"
1981
Ohio, School of Art (Hansen Galleries), "Science Fiction and Fantasy Illustration"
Basle, Art 12'81
Chicago, The Picture Gallery, "Space Artistry"
1983
Munich, Galerie Hartmann, Villa Stuck, "Eros und Todestrieb"
Laax, Galeria d'art
Basle, Galerie J. Schottland
1984
Kassel, Orangerie, "Zukunftsräume"
1986
Nuremberg, "Der Traum vom Raum" (catalogue)
Zurich, Galerie Art Magazin, "Ausstellung Tutti Frutti"
Zurich, Galerie Art Magazin, "Fest der Toten 'Unter dem Vulkan'"
Dortmund, Museum am Ostwall, "Macht und Ohnmacht der Beziehungen" (catalogue)
Olten, Kunstmuseum, Collection Baviera"
Zurich, Galerie a 16, Fred Knecht
1987
Lausanne, Galerie Basta, "Fête des Morts"
Shibuya Seed Hall, 21-1, Udagawacho, Shibuya-ku, Tokyo
Shinsaibashi Parco Studio, 1-45, Shinsaibashi Suji, Minami-ku, Osaka. Saibu Hall, 2-3-1, Minooham, Otsu-shi.
Shiga Pref., SF exhibition featuring *Alien* works

in four museums in Tokyo and three other cities
1988
Martigny, Les Caves du Manoir, "Fête des Morts"
Frankfurt, Book Fair, Kunsthalle, Edition C
Zurich, Shedhalle, "Kunst Woher Wohin"
Zurich, Museum für Gestaltung, "Kunstszene Zürich"
1989
Frankfurt, Book Fair, Kunsthalle, Edition C
Zurich, Galerie Art Magazin, "Accrochage"
Yverdon, Château Aula Magma, "Les Amis d'Ailleurs"
Zurich, Galerie Art Magazin, "Fête des Morts"
1990
Zurich, Helmhaus, "Ankäufe 1988"
Geneva, MJC St. Gervais, "Ailleurs est proche"
Berlin, Haus der Kulturen der Welt, "Kunst und Krieg"
Paris, Galerie d'Art Dmochowski, "Les Visionnaires"
Montreux, Musée du Vieux Montreux, "Fête des Morts"
1991
Lausanne, Galerie Humus, "Les Inconnues"
Chur, Jugendhaus, "Comix-Ausstellung
Zurich, Helmhaus, "Verwandtschaften"
Yverdon, Maison d'Ailleurs, "Giger's Library Room"; converted prison cells with paintings, furnishings and *Alien* accessories Martigny, Le Manoir, "Fête des Morts"
1992
Seville, Expo 92, Papellon de Suiza, "Unerwartete Schweizer"
1993
Basle, MUBA, "Movie World", exhibition including HR
Giger's film designs (pictures and Harkonnen furniture)
Zurich, re-opening of Galerie Art Magazin
Zurich, Museum der Seele, "More Pricks than Kicks"
Gruyères, Château de Gruyères, "Le Tarot"
Zurich, Museum der Seele, "Day of the Dead"
1994
Zurich, Galerie Art Magazin
Zurich, Galerie a 16, "Ufo & Ifo"
Zurich, Galerie Mangisch, "Lucifers Rising"
Munich, Galerie Hartmann
Munich, Tempel, "Fetisch & Kult"
Venice, "Du Fantastique au Visionnaire"
Lausanne, Galerie Humus, "Le Sexe des Anges"
Bologna, Tattoo Convention
1995
Arbon, Schloss Arbon, "Migros-Säcke"
Zurich, Galerie Art Magazin, 10th anniversary show Zurich, Galerie Tumb, "Zyklorama"
Paris, Stardom Gallery, "Les Anges"
Yverdon, Maison d'Ailleurs, "Le Train Fantôme"
New York, Mary Anthony Galleries, "Synaesthesia"
New York, Psychedelic Solution Gallery
Lausanne, Galerie Rivolta, "Magie Noire"
Gruyères, Château de Gruyères, "Le Zodiaque des signes dans votre ciel"
Zurich, Kunststrasse, HR Giger's 3D images
Verona, "Abitare il Tempo, Delirium Design"
Zurich, Kunsthaus, "Die grosse Illusion. Die 7. Kunst auf der Suche nach den 6 anderen."
Vienna, Messepalast, "Invasion der

Außerirdischen", and in ten other German and Austrian cities Lausanne, Galerie Humus, "Rosée d'Eros"
Zurich, Galerie Tumb, "Unrat"
1996
Venice, Vienna, Barcelona, "Die grosse Illusion. Die
7. Kunst auf der Suche nach den 6 anderen."
Milan, Arteutopia, "Suoni & Visioni"
Frankfurt, Art
Zurich, Kunsthaus, "Erotika"
Berne, BEAexpo, Galerie Nika, "Kunst & Wein"
Lausanne, Musée d'art contemporain pornographique, "Deep inside"
Chur, Bündner Kunstmuseum "Übergänge – Kunst aus Graubünden 1936–1996" (Transitions – Art from Graubunden 1936–1996)
1997
Basle, Galerie Hilt, "Multiple Art"
Düsseldorf, Kunstmesse, "Art Multiple"
1998
Neustadt an der Weinstraße, Herrenhof, "Faden der Ariadne"
Basle, "Ziegel vom Dach"
Sapporo, Museum Otaru, "Phantastischer Realismus"
Bad Salzdetfurth, Schloßhof Bodenburg, "Europa auf dem Stier"
Zurich, Galerie Mangisch, "Gentechnik"
"Schloß St. Germain", purchase for the construction of a first HR Giger Museum 1997
New York, CFM Gallery, "International Artists' Peep Show"
1999
Bodenburg (Germany), Kunstgebäude im Schloßhof Bodenburg, Kunstverein Bad Salzdetfurth, "Vom Skarabäus zum New Beetle", sculptures and drawings
Essen, Messehallen, "Art Open", pictures, sculptures
Tell 99, Aarau (Switzerland), graphics
Poitiers, Futuroscope, "Utopia", originals, sculptures, graphics
Berne, Kulturhallen Dampfzentrale, "Cyborg Friction", drawings, sculptures
Basle, "Welten des Bewußtseins – Einsichten, Ausblicke", in honour of Albert Hofmann, portfolio "Ein Fressen für den Psychiater"
2000
Erlangen, "Phantastik am Ende der Zeit", pictures
Erlangen, Comic-Salon, "Passagen-Tempel"
Bad Rogaz (Switzerland), 1. Schweizerische Triennale der Skulptur
"Gebärmaschine" (Aluminium, 3-D)
Zurich, Züspa-Hallen, IFAS, Design for a blood dialysis machine for Reflotron
Zurich, Galerie Baviera, christening of the newly published Giger Tarot; author of the book: Akran
2001
Herrliberg (Switzerland), opening "Kulturschiene" organization: Marielen Uster and Stephan Stucki
Pfäffikon (Switzerland),Seedamm Kulturzentrum, "Gebaut, geschaut", "Passagen-Tempel"

Works in permanent collections/ on permanent display
Chur, Bündner Kunsthalle, paintings and sculptures.
Chur, Kalchbühlcenter, Giger Bar, furniture and

interior design by HR Giger, architect Thomas Domenig.

Tokyo, *Giger Bar*, 1988, Entrance and four level interior, designed by HR Giger (but not sculpted or constructed by HR Giger due to an unfortunate miscommunication). No longer in existence.

Yverdon, Maison d'Ailleurs, SF museum with "Giger's Library Room"; converted prison cells with paintings, furnishings and *Alien* accessories.

St. Gallen, Restaurant Haus zur letzten Laterne, *700 Jahre Warten auf CH-91* portfolio and sculptural works.

Los Angeles, Galerie Morpheus, *Fine Art of the Surreal & Fantastique*.

HR Giger Room in New York City, Limelight nightclub. VIP Room, interior design, sculptures and prints. 1998 through 2002, no longer in existence (one stolen table yet to be recovered).

Museum HR Giger in Château St. Germain, Gruyères, Switzerland. Established in 1997 as the permanent home of the most extensive collection of artworks by HR Giger.

Work in film, television and theatre

1967
High und Heimkiller, film contribution to U. Gwerder's "Poëtenz-Shau"; 16 mm, 11 min., magnetic sound, in collaboration with F.M. Murer

1968
Swiss-made, 2069, collaboration on a science fiction film by F.M. Murer; 35 mm in colour, 45 min., sound-on-film

1969
Early Morning, collaboration on a Peter Stein production in the Zurich Schauspielhaus

1972
Passagen, colour film about HR Giger by F.M. Murer for the German broadcasting corporation WDR, Cologne; 50 min., sound-on-film, special prize for Best TV Film at the Mannheim film festival

1973
Tagtraum, colour film by Jean-Jacques Wittmer about the psychedelic meeting of the three artists C. Sandoz, W. Wegmüller and HR Giger in Sottens; Basle, 28 min., magnetic sound

1975
Giger's Necronomicon, colour film on the work of HR Giger from 1972–75 by J.-J. Wittmer and HR Giger; 16 mm, 40 min.

1976
Décor designs for A. Jodorowsky's 70-mm colour film *Dune*, after the prize-winning book of the same title by Frank Herbert (film later realized by David Lynch without HR Giger)

1977
Giger's Second Celebration of the Four, film fragment by J.-J. Wittmer and HR Giger; 16 mm, magnetic sound, 5 min.

1978
Alien, 117 min., horror science fiction motion picture by Ridley Scott after the screenplay by Dan O'Bannon, Brandywine prod., Los Angeles, 20th Century Fox, Los Angeles/London

1979
Giger's Alien, documentary film on Giger's work for Alien; 16 mm in colour, 34 min., magnetic sound. Produced by M. Bonzanigo, HR Giger and J.-J. Wittmer

1981
HR Giger's Dream Quest, by Robert Kopuit; BCM video recording on 1" tape; 40 min., interview and video animation; Koo-Koo, promotion film by HR Giger for Debbie Harry, c. 6 min.

1982
A new face of Debbie Harry, documentary film by F.M. Murer, magnetic sound, 30 min.

1986
Poltergeist II, 87 min., motion picture by Brian Gibson after the screenplay by Michael Grais and Mark Viktor, MGM prod., Los Angeles
HR Giger designs the "Prix Tell", prize for Swiss artists awarded annually by the Swiss TV corporation DRS

1988
Teito Monogatari, 135 min., motion picture by Akio Jitsusoji after the book by Hiroshi Aramata, Japanese prod.

1990
Alien 3, 112 min., motion picture by David Fincher, 20th Century Fox, Los Angeles
The Mystery of San Gottardo, own motion picture project by HR Giger (in development)

1991
Alien 1-3, documentary by Paul Bernard, includes material and interviews with HR Giger. Prod. CBS/ 20th Century Fox
Alien 1, laser disc, includes documentary films of and an interview with HR Giger
Horror Hall of Fame Awards, includes documentary film by HR Giger

1992
Satanskopf, film for the German TV series "Ungelöste Geheimnisse" (Unsolved Mysteries), drawing upon a short story of the occult by HRG
"Wall to Wall", BBC documentary on cyberpunk films featuring interviews with HR Giger, William Gibson and Bruce Sterling
"Omnibus", HR Giger interviewed on director Ridley Scott; BBC, London
Giger's Passage to the Id, 30 min., documentary by Altro Lahtela and Juhani Nurmi for Finnish television
Sex, Drugs and Giger, 16 mm colour film, 4 ½ min., animation by Sandra Beretta and Bätsch for the Solothurn film festival

1993
"Brother to Shadows". *The Alien World of HR Giger*, documentary by Morpheus Int. dir. by David Frame and prod. by James R. Cowan and Clara Höricht-Frame (in development)

1995
Species, 110 min., horror science fiction film by Roger Donaldson after the screenplay by Denis Feldman, prod. by Frank Mancuso jr. for MGM, Los Angeles
Benissimo, 6'04", ballet for 5 dancers in a 3D installation of Giger pictures. Written and directed by Max Sieber. Prod. by the Swiss TV corporation DRS

1996
Kondom des Grauens, 118 min., HR Giger as Creative Consultant, directed by Martin Walz from the cartoon comic by Ralf König. Producers: Ralph S. Dietrich and Harald Reichebner fo Elite Intertainment Group

2000
Zurich, Kunsthaus, Tell Saga, appearance as oracle in film *C-Files* by Com & Com

Prizes and awards

Inkpot Award, San Diego Comic Convention, 1979
Academy Award, Oscar for Visual Effects in *Alien*, 1980
Readercon Small Press Award, best interior illustrator and best jacket illustration, Los Angeles, Morpheus International, 1991
The Ink-credible Tattoo Award, New York, Tattoo Convention, 1993
Merit Award, Grisons, 1994
Vargas Award, Air Brush Art, New York, 1998

TV-interviews and documentary films

ZDF, Heute und Morgen "Zwei Künstler sehen unsere Welt: Pfeiffer und Giger", 1978/79
DRS, TAF, 1979
ORF, Kintop, 1979
DRS, Rendez-vous, 1979
ZDF, A propos Film, 16.10.79
TF1, Temp X "Giger's Alien", 1980
ORF, Café Zentral, 1980
DRS, Film-Szene Schweiz, 29. 9.80
SSR, Zone Bleue "Bruno Weber", 10.1980
DRS, Karussell, 1981
"Giger's Dream Quest", 40', 1981
DRS, Tagesschau "ART 12'81", 1981
ORF, Musik-Szene "Debbie Harry", 10.1981
BBC 1, "Debbie Harry", 28.7.81
ORF, Magazin Okay "HR Giger-Portrait", 23.5.82
DRS, Kassensturz, 1984
Sidney, The Occult Experience, 1985, by Nevill Drury
SSR, L'aventure surréelle, 27', 1984/85, by Gilber Bovay
3SAT, "Das phantastische Universum des HR Giger", 44' 47", 1986
ZDF, "Das phantastische Universum des HR Giger", 44' 47", 1986
ZAK, 1987
ZDF, Engel, Teufel und Dämonen, 19.7.87
DRS, Sonntags-Magazin "Gastro Styling U. Steinle", 8.11.87
DRS, Engel, Teufel und Dämonen, 1989
TF1, Créateurs Studio Hollywood, 10.5.89
TSR, Viva "Gens de la Lune", 100', 1990
DRS, Kultur Aktuell "Migros-Tragtaschen", 22.4.90, 19.50
France, "Les livres d'esquisses de HR Giger", 1991
DRS, Dynamix, 1992
₃Sat, "Giger-Bar", 1992
BBC, Omnibus, interview with HR Giger about R. Scott, 1992
BBC, Wall to Wall "Documentary on Cyberpunk",1992
Finnish TV, "Giger's Passage to the Id", 30', 1992
Teleclub, Close Up "Alien III",1/3.9.92
RTV, 36', 11.6.92
RTL Plus, Explosiv Magazin, 12.11.92
RTL+, Ungelöste Geheimnisse "Satanskopf", 20', 13.12.92
Press Kit, "Alien III", 1993
BBC, Man Machine, 1993
DRS, Fragment "Magie und Tarot", 14.1.93
DRS, TAF "Necronomicon", 15.2.93
DRS, TAF "Horoskop", 1993
DRS, Zehn vor Zehn "Satanismus", 2.3.94
DRS, Tagesschau "Pin-Festival Films", 2,5',

9.4.94
DRS, TAF-Bazar "Mondaine N.Y.C.-Watch",
13.4.94
S Plus, City Arte, 26.5.94
RTV, Alien-Swatch "Ausstellung Mangisch
Zürich", 30.5.–5.6.94
DRS, Zehn vor Zehn "Haus zur letzten Laterne",
1.7.94
DRS, Aktuell "Haus zur letzten Laterne", 1994
ZDF, Aspekte "Fetisch und Kult", 1994
SCI-FI-Channel, Trader, 12.12.94, 23.54
R.T.B.F., Téléjournal "Festival du Film
Fantastique Bruxelles", 3.1995
B.R.T.N., Ziggurat "Festival du Film Fantastique
Bruxelles", 3.1995
Télébruxelles, Travelling "Festival du Film
Fantastique Bruxelles", 3.1995
VT4, émission cinéma "Festival du Film
Fantastique Bruxelles", 3.1995
VOX, Wahre Liebe, 1995
Zuri 1, Akasha, 30.6.95
Zuri 1, Telebazar "Bits & Grips", 0.2', 11.7.95,
19.00
DRS 4, CH-Magazin, 13.0', 5.10.95
Tele Züri, Zip, 12.10.95
Tele Züri, Steinfels Live, 29.10.95
DRS 4, Gesundheit "Schlaf", 15.11.95
DRS, Zebra, 1995
Tele M1, Magazin, 23.2.96
Star TV, transmission of "Trilogie HRG", 1998

Museum HR Giger
Château St. Germain
CH–1663 Gruyères

1997
September 11: medieval castle bought by HRG
at auction
1998
June 20 (Fête de la Ste Jeanne): Inauguration of
the Museum HR Giger (partial opening). Director:
Professor Barbara Gawrysiak, Architect: Roger
Cottier
December 29: Dedication of the new exhibition
rooms, opening of the permanent exhibition
"Fantastic Art" (private collection HR Giger)
1999
December 11: Exhibition "Fred Engelbert
Knecht" in the expanded museum area
2000
August 4: Opening of the museum gallery, exhi-
bition with linoprints by François Burland
2001
April 6, museum gallery: Exhibition "Günter
Brus", works from the private collection ob HR
Giger; opening of the museum bar
2002
March 9, museum gallery: Exhibition "Claude
Sandoz", works of the late 1960s

Original graphics and portfolios
Ein Fressen für den Psychiater, 1966. Artist's
cardboard portfolio, screen print, 12 A4 repro-
ductions, drawings, map print. Portfolio signed
and numbered in an edition of 50. 42 x 31 cm
(approx. 30 copies printed). Printed by HR
Giger/Lichtpausanstalt Zurich.
Biomechanoiden, 1969. Portfolio of 8 screen
prints, black on silver, all signed and numbered

in an edition of 100 + XX. 100 x 80 cm (partially
destroyed by fire). Published by Bischofberger,
Zurich. Printed by Steiner, Zurich.
Trip-Tychon, 1970. Portfolio of 34 colour screen
prints, all signed and numbered in an edition of
100. 100 x 70 cm (partially destroyed by fire).
Published by Bischofberger, Zurich. Printed by
Silkprint, Zurich.
Passagen, 1971. Portfolio of 4 multi-coloured
serigraphs, all signed and numbered in an edi-
tion of 70 + XX. 90 x 70 cm (partially destroyed
by fire). Published by Bischofberger, Zurich.
Printed by Silkprint, Zurich.
Second Celebration of the Four, 1977.
Clothbound presentation box with embossed
title and 8 fold-out sheets, all issues signed and
numbered in an edition of 150, of which nos.
1–10 contain a hand-finished photo (original). 42
x 40 cm. Printed by A. Uldry, Hinterkappelen.
Alien, 1978. Portfolio of 6 screen prints in four
colours, all signed and numbered in an edition of
350. 70 x 100 cm, 100 portfolios released for
sale. Published by HR Giger and 20th Century
Fox. Printed by A. Uldry, Hinterkappelen.
Erotomechanics, 1980. Portfolio of 6 screen
prints in eight colours, all signed and numbered
in an edition of 300. 70 x 100 cm. Published by
HR Giger. Printed by A. Uldry, Hinterkappelen.
N.Y. City, 1982. Portfolio of 5 screen prints in
eight colours, all signed and numbered in an edi-
tion of 350. Published by Ugly Publishing,
Richterswil. Printed by A. Uldry, Hinterkappelen.
Pilot in Cockpit and *Alien Egg*, Version II, 1978,
in an edition of 1000, signed and numbered,
$19^{1}/_{2}$" x 27". Limited edition: Dark Horse, 1991
E.L.P II, Brain Salad Surgery, record cover,
$26^{1}/_{2}$" x $22^{1}/_{2}$", 1973, + Debbie Harry, *Koo
Koo*, triptych, $21^{1}/_{2}$" x 34", 1981, LP cover art
coll., 1991. 10,000 prints, of which 200 are
signed and numbered.
E.L.P IX, 28" x 28" (picture 24" x 24") and
Biomechanoid, 28" x 40" (picture 24" x 24"),
1991. Set of 24 colour prints, signed and num-
bered in an edition of 495. Published by
Morpheus International.
700 Jahre warten auf CH–91, 1991. Accordion-
folded portfolio of 50 original lithographs, all
signed and numbered (nos. 1-75 on special pa-
per; nos. 76-300 on ordinary paper), in an edi-
tion of 300. Published by HR Giger. Printed by
Walo Steiner, Asp.
HR Giger's Baphomet Tarot, 1992. Portfolio
book of 24 zinc lithographs of drawings, in an
edition of 99. Printed by Walo Steiner, Asp.
Stier, Fisch and *Zodiac-Brunnen*, 1993. Zinc
plate lithographs in five colours. Published by
Morpheus International, Los Angeles. Printed by
Walo Steiner, Asp.
Sil Tritychion, © HR Giger + MGM, 1995. Two-
colour screen print, 90 x 120 cm, in an edition
of 1/290 + EA. Published by Morpheus
International, Los Angeles. Printed by A. Uldry,
Hinterkappelen.
Species hinter den Kulissen, © HR Giger +
MGM, 1995. Six-colour screen print, 90 x 120
cm. Edition A: 170 x 120 cm, 1/350 + EA, c.
200 commercially available, all signed and num-
bered. Edition B: 100 x 70 cm, 1/400 + EA,
not commercially available, all signed and num-
bered. Published by MGM and HR Giger. Printed

by A. Uldry, Hinterkappelen.
Teiltötungsmaschine, 1997, etching, 85.5 x
64.5 cm, printed by Benedikt Taschen Verlag
Alchymische Hochzeit and *Engel vom Haus zur
letzten Latern*, 1997, eight-colour zinc-plate li-
thograph, 69 x 49 cm, 99 signed and numbered
prints, printed by Walo Steiner, Densbüren.
Ein Fressen für den Psychiater, 1999, expanded
remainders from 1965 (No. 16 to 50), two-co-
lour lithographs, signed and numbered portfolio,
printed by Walo Steiner.
Production of the "Alu-Eloxale" from eight pic-
tures from the 1960s in an edition containing 23
prints each, 2000.
Large-format poster depicting six various cate-
gories of profession (contracted by Berufsper-
sonal AG [Professional personnel]), edition of
100 signed and numbered prints, Edition: Mu-
seum HR Giger, 2001.

Various projects
Video clip by Odessa-Film C für Pioneer, Japan,
1985
Giger Bar, Tokyo, extending over four floors,
1988
Birth Machine/9 mm Giger, 1988. Poured
bronze sculpture, 50.8 x 20.3 x 20.3 cm,
signed and numbered in an edition of 23 sculp-
tures based on *Bullet-Baby* in Work No. 25, *Birth
Machine*, 1967. HR Giger/ARh+ Editions, New
York
Baphomet – Das Tarot der Unterwelt. Pack of ta-
rot cards designed by HR Giger/Akron for AG
Müller, CH–8212 Neuhausen a. R., Switzerland.
Edition with book, 1993; edition with abridged
book, 1993. Edition with abridged book and CD,
1995. German, English and French
Giger Bar, Kalchbühlcenter, Chur, 1992
Dark Seed. Award-winning computer game em-
ploying images based on HR Giger's works.
Cyberdreams, Los Angeles, 1992
Screensaver, employing images based on HR
Giger's works. Cyberdreams, Los Angeles,
1995
Dark Seed II. Computer game employing images
based on HR Giger's works. Cyberdreams, Los
Angeles, 1996
The HR Giger Calendar of the Fantastique, publi-
shed annually since 1993 by Morpheus
International, Los Angeles
HR Giger Set. Folder comprising 1996 3D calen-
dar, blankbook, addressbook and postcard-
book. Benedikt Taschen Verlag, Cologne 1995
HR Giger 3D Calendar 1996. Special edition as
portfolio, signed and numbered, in an edition of
300 and 100 artist's copies, Benedikt Taschen
Verlag, 1995
HR Giger's Species Design. Special leather-
bound edition including zinc lithograph; Printed
by W. Steiner, Asp 1996
HR Giger's Zodiac-Brunnen (in development)
Giger Internet Pin, 1997. Silver-clad copper pin
of the HR Giger Museum International
Membership Club. Diameter: 40 mm with engra-
ved membership number.
www.Giger.com, e-mail:
WebAgent@HRGiger.com (Thomas Riehm)
Miniature Zodiac Signs, 1997. Silver, each in an
edition of 23. Aquarius, Aries, Cancer, Virgo,
Libra, Scorpio, Sagittarius, Capricorn, Gemini,

Leo, Pisces, Taurus, each 1/5 of the original size. Atelier HR Giger, Zurich
HR Giger Watches, Li II, Landscape XIX, by Morpheus International, Los Angeles, 1998
New York City, Limelight Club, dedication of the VIP Giger Room, 1998
Zurich–Los Angeles, microphone stands for the music group Korn, 2000
Basle, Orbit-Messe, Computer virus for "Open Systems", 2000
Neuchâtel, Festival international du film fantastique, design of the awards, 2000
Gruyères, Château St. Germain, bar of the Museum HR Giger, design for six arm-leg-biomechanoids, poster exhibition in Zurich for Berufspersonal AG
HR Giger Diary 1996, 1998, 2001, TASCHEN GmbH

Books on and by HR Giger

ARh+, by HR Giger, Walter Zürcher Verlag, Gutendorf 1971 (out of print)
Passagen, by HR Giger, Bündner Kunsthaus, Chur, 1974 (out of print)
Catalogue to the Giger exhibition, Galerie Sydow-Zirkwitz. Text by Horst A. Glaser, Frankfurt, 1976 (out of print)
HR Giger's Necronomicon, Sphinx Verlag, Basle, 1977 and 1978; new editions as *HR Giger's Necronomicon 1*, Edition C, Zurich 1984, and Edition C, Zug 1988 (all softcover) and 1991 (first hardcover edition). Licensed editions: Humanoid Assoc., Paris, 1977 (out of print), Big O, London, 1980 (out of print), Treville, Tokyo, 1987, and Morpheus International, L.A., 1991 and 1992
Giger's Alien, Sphinx Verlag, Basle; Edition Baal, Paris; Big O, London, 1980 (softcover, all out of

print); Treville, Tokyo, 1987. New editions: Edition C, Zug, 1989, 1992, 1995 (hardcover); Titan Books, London and Morpheus International, L.A., 1990
HR Giger's New York City, Sphinx Verlag, Basle, 1981; Ugly Publishing, Richterswil, 1981 and Edition Baal, Paris, 1981 (all out of print), Treville, Tokyo, 1987
HR Giger, Retrospektive 1964–1984, ABC Verlag, Zurich, 1984 (out of print)
HR Giger's Necronomicon 2, Edition C, Zurich, 1985 (in France distributed with a booklet of the text in French by Edition Baal, Paris (out of print)). New edition by Edition C, Zug 1988 (softcover) and 1992 (first hardcover edition). Licensed editions: Treville, Tokyo, 1987; Morpheus International, Los Angeles, 1992
HR Giger's Biomechanics, Edition C, Zug, 1988 (softcover). Licensed editions: Treville, Tokyo, 1989; Morpheus Int., Los Angeles, 1990 and 1992
HR Giger ARh+, Taschen, Cologne, 1991. English, German, Italian, Spanish, Dutch, Swedish
HR Giger Posterbook. Portfolio of 6 prints in four colours. Taschen, Cologne, 1991
HR Giger Skizzenbuch 1985, Museum Baviera, Zurich, 1992
HR Giger Postcardbook, Taschen, Cologne, 1993
HR Giger's Necronomicon 1 + 2. Collector's edition, German, 500 copies bound in black Pecorex, embossed, signed and numbered, and including the original lithograph *Back to Mother* (printed by Walo Steiner), Edition C, Zurich, 1985; edition of 666 bound in black leather in a presentation box, signed and numbered with an original lithograph on the title page (printed by

Walo Steiner), with the first 23 copies including a hologram (produced by K hne & Partner, Switzerland). Published by Morpheus International, Los Angeles, 1990
Giger's Watch Abart '93. Catalogue of the exhibition in New York and Burgdorf. HR Giger and Arh+ Publications N.Y.C., Leslie Barany
HR Giger's Species Design, Morpheus International, Los Angeles, 1995; Edition C, Zug, 1995; Titan Books, London, 1995; Treville, Tokyo, 1995
HR Giger's Film Design, Edition C, Zug, 1996. Licensed editions: Morpheus Int., Los Angeles, 1996; Titan Books, London, 1996; Treville, Tokyo, 1996 (in preparation)
HR Giger Visioni di fine millennio, catalogue of the exhibition in Milan at the Palazzo Bagatti Valsecchi, hardcover deluxe edition A: 1-70 signed and numbered with a CD von Shine; B: 71-170, signed and numbered, 1996.
www HR Giger com, Benedikt Taschen Verlag, Cologne 1996 (German). English, French, Spanish, Italian, Dutch and Portuguese edition 1997.
HR Giger Retrospective 1964–1984, Morpheus International, Los Angeles, new English and German edition, 1998
The Mystery of St. Gotthardo, Benedikt Taschen Verlag GmbH, Cologne, 1998
Alien Diary, Museum Baviera, Zurich, 1998

www.HRGiger.com
www.HRGigerMuseum.com
www.HRGigerAgent.com
www.Giger.com
www.LittleGiger.com

Front cover: *Birth Machine*, 1999. Edition of 5, in aluminum, baby casts by Polich Artworks, gun fabricated by Erwin Ammann, 200 x 140 x 25 cm.
Photo: © 2000 HR Giger

Back cover: *Nubian Queen*, 2002.
Edition of 6, cast aluminum, 183 cm, 12kg.
Background: *Way of the Magician*, detail: Work no. 264, 1975. 240 x 280 cm.
Photo: © 2002 Marc Adrian Villas

Pages 2/3: HR Giger on costume painted Harley Davidson, owner Scott Sternick, NYC.
Photo: © 1998 Panja Jürgens, from the book *Wings of Peace* by Panja Jürgens, Edition Knesebeck

Pages 4/5: Preliminary sketch for *Reign of Fire* dragon.
© 2000 HR Giger. Film realized without HR Giger.

© 2002 TASCHEN GmbH
Hohenzollernring 53, D–50672 Köln
www.taschen.com

Text on pages 6–11: © Leslie Barany, New York
Text on pages 12–41: © 2000 Stanislav Grof, Mill Valley
Text on pages 56 and 128: © 2001 Herbert M. Hurka, Merzhausen
Text on pages 156 and 157: © 2001 Sergius Golowin, Allmendingen
All other texts: © 2001 HR Giger, Zurich

Producer: HR Giger, Zurich
Editor: Sonja Altmeppen, Cologne
Layout: HR Giger and Carmen, Zurich
Graphic Design: Claudia Frey, Cologne; Wolfgang Holz, Zurich
English Editor: Leslie Barany, New York
Cover Design: Claudia Frey, Angelika Taschen, Cologne

German translation: Clara Drechsler, Cologne; Urs Thoenen, Zurich (preface)
English translation: Sandra Hathaway, New York
French translation: Bijan Aalam, Paris; Daniel Roche, Paris (text by Stanislav Grof)

Printed in Italy
ISBN 3–8228–1723–6

www HR Giger com
HR Giger
Hardcover, 240 pp. / € 19.99 /
$ 29.99 / £ 16.99 / ¥ 3.900

HR Giger ARh+
Softcover, Basic Art Series,
96 pp. / € 6.99 / $ 9.99 /
£ 4.99 / ¥ 1.250

HR Giger
Softcover, Portfolio, 32 pp. /
€ 6.99 / $ 9.99 / £ 4.99 /
¥ 1.250

"These books are beautiful objects, well-designed and lucid." —*Le Monde*, Paris, on the ICONS series

"Buy them all and add some pleasure to your life."

★

ICONS